DISCIPLES OF LIGHT

PHOTOGRAPHS IN THE BREWSTER ALBUM

GRAHAM SMITH

THE J. PAUL GETTY MUSEUM, MALIBU

1990

To Alison Morrison-Low,
Robert Smart, and Sara Stevenson,
who know some things others do not

Copyright © 1990 The J. Paul Getty Museum

Library of Congress Cataloging-in-
Publication Data

Smith, Graham, 1942–
 Disciples of light : photographs in the
 Brewster album / Graham Smith.
 p. cm.
 Includes bibliographical references.
 ISBN 0-89236-158-1 :
 1. Photograph collections—California—
 Malibu—Catalogs. 2. Brewster, David,
 Sir, 1781–1868—Photograph collections—
 Catalogs. 3. J. Paul Getty Museum—
 Catalogs. I. J. Paul Getty Museum.
 II. Title.
 TR654.S555 1990
 779′.074—dc20 89-24563
 CIP

The photographs reproduced as color
plates in this volume have been increased
in size from the originals by approximately
15 percent.

Jacket: John Adamson, *Isabella Thomson,*
circa 1845. Brewster Album (.67).

CONTENTS

LIST OF PLATES

1. JOHN ADAMSON, *Self-Portrait*, 1843/44. Brewster Album (.184).

2. WILLIAM HENRY FOX TALBOT, *Lady Elisabeth Feilding*, August 1841. Brewster Album (.51).

3. THOMAS RODGER, *Group Portrait*, circa 1850; JOHN OR ROBERT ADAMSON, *The South Entrance to St. Salvator's College Chapel, St. Andrews*, 1842/43. Brewster Album (.5, .6).

4. J. ADAMSON, *Distant View of St. Andrews from the East*, circa 1845. Brewster Album (.35).

5. J. OR R. ADAMSON, *Sir George Campbell*, 1842. Brewster Album (.52).

6. J. ADAMSON, *Isabella Thomson*, circa 1845. Brewster Album (.67).

7. J. ADAMSON, *James Thomson*, circa 1845. Brewster Album (.143).

8. J. ADAMSON, *An Athlete*, circa 1850. Brewster Album (.173).

9. SIR JOHN HERSCHEL, *Engraved Portrait of a Young Woman*, 1842. Brewster Album (.84).

10. UNIDENTIFIED PHOTOGRAPHER, *Mrs. Adair Craigie, Mrs. James Brewster, Adair Craigie, and Sir David Brewster*, circa 1847. Brewster Album (.58).

FOREWORD

When the Getty Museum established a collection of photographs in 1984, among the greatest of its first acquisitions was an album assembled by Sir David Brewster of photographs made between 1839 and 1850, at the dawn of photography. The album contains almost two hundred pictures, from the simplest photogenic drawings to more advanced paper prints, by the principal Scottish practitioners of Talbot's "new art." It was put together by a man who himself participated in the development of photography, who knew everybody and saw everything, and who took pleasure in bringing people and ideas together. Because Talbot's English patent on a method for recording photographic images on paper did not apply to Scotland, Brewster and his friends at St. Andrews were free to adapt Talbot's invention. Brewster passed information to others and taught them techniques. One pupil, John Adamson, instructed his brother Robert, who soon became half of a famous partnership with the painter David Octavius Hill. In exchange for his generosity to the others, Brewster received examples of their work. Those photographs, testimony to a thrilling time of discovery and collaboration, make up the Brewster Album.

For many of us who look at these dim pictures with eyes conditioned by the clarity and tonal richness of later photographs, there will be puzzlement. It takes effort to imagine how fresh and startling these pieces of paper looked when they were new, each a technical experiment and a further conquest of the visual world. Graham Smith's text offers a tour of "the headquarters of the calotype," Brewster's St. Andrews, and thereby helps us locate the images and understand their significance. He introduces the methodical and passionate men who made them, reviving some of the excitement of those years and giving the reticent pictures new life. We are grateful to have had Professor Smith's company at the Getty Museum and to have learned so much about early photography in Scotland from him. I am proud that his work can bear our imprint.

John Walsh
Director

9

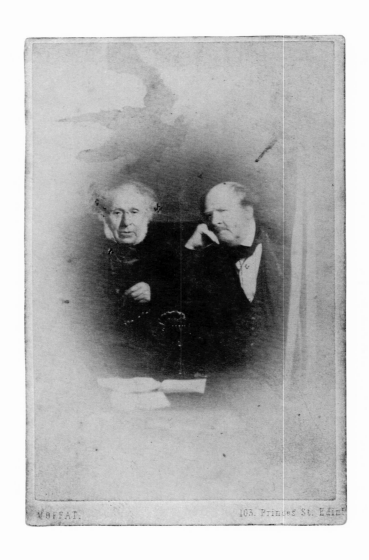

Figure 1. JOHN MOFFAT, *Sir David Brewster and William Henry Fox Talbot*, March 1864. Location unknown. Photo courtesy Science Museum, London.

INTRODUCTION

The years from about 1730 to 1790, generally known as the Scottish Enlightenment, were remarkable for their artistic, intellectual, scientific, and technical vitality. Described by Tobias Smollett as "a hotbed of genius," in this period Edinburgh numbered among its "men of genius and learning" the philosopher David Hume; the founder of the discipline of economics, Adam Smith; the geologist James Hutton; the chemist James Black; the inventor of the steam engine, James Watt; the architects Robert and James Adam; and many others.[1]

Scotland's intellectual vitality did not cease at the end of the eighteenth century, however. Nor was it limited to Edinburgh. The first half of the nineteenth century was also a period of great intellectual ferment, culminating, in the ecclesiastical sphere, in the Disruption of the Church of Scotland and the establishment of the Free Presbyterian Church in May 1843.[2] This period also saw the reform and revitalization of the Scottish universities and innovations in research and communication in the natural sciences. The latter were effected by the establishment of new forums, such as the annual meetings of the British Association for the Advancement of Science, formed in 1831, and through the publication of scientific journals, such as the *Edinburgh Philosophical Journal* and the *Edinburgh Journal of Science*.[3]

As the seat of Scotland's oldest university, St. Andrews, the principal setting for much of the narrative that follows, naturally participated in this intellectual excitement. That it did so with the energy and results described below was due in large part to the appointment of Sir David Brewster (frontis.) as principal of the United Colleges of St. Salvator and St. Leonard in 1838. As a result of his presence, the university was propelled to international prominence in the area of the natural sciences, and, by virtue of his personality, St. Andrews itself acquired an energy that was virtually combustible.

A product of the Scottish Enlightenment, Brewster (1781–1868) was a devout Evangelical, an eminent physicist, a prodigious editor of and contributor to scientific journals, a prolific author of scientific papers and studies in the history of science, and one of the first scientists after Sir Isaac Newton to be honored with a knighthood.[4] By the time of his appointment as principal of the United Colleges, he enjoyed an international reputation as one of the foremost experimental scientists of the era. Some years after the event, describing her father's reception at the British Association's meeting held in Manchester in July 1842, Brewster's daughter, Mrs. Margaret Gordon, gave a vivid sense of his eminence: "It was pleasant to see the honour and distinction which attended him. 'There he is—that's Brewster!' were constantly recur-

ring whispers, and it was a well-filled hemisphere in which he moved as a star of the first magnitude."[5]

Brewster's principal research was in optics and on the polarization of light, and the latter preoccupation accounts in part for his intense interest in photography from the time of its virtually simultaneous announcement in Paris and London in 1839 to his death in 1868. Brewster also was a close friend of William Henry Fox Talbot (1800–1877), the inventor of negative–positive paper photography, and corresponded regularly with him between 1839 and 1843, the period of Talbot's most intensive photographic research. Their friendship and mutual interest evidently remained lively as late as 1864, when they both participated in two experiments held at a meeting of the Photographic Society of Scotland to demonstrate the "Use of the Light of Magnesium Wire in Combustion, as a Photographic Agent." In the second experiment Brewster and Talbot sat for a double portrait, "illuminated from the combustion of magnesium," which was taken by the Edinburgh photographer John Moffat (1819–1894) (fig. 1). According to a report of the meeting that appeared in the *Photographic Journal* for March 15, 1864, "the likeness of each of the eminent sitters [was] excellent."[6]

In addition to being passionately interested in Talbot's discoveries, Brewster energetically promoted negative–positive paper photography in Scotland in the years between 1839 and 1848. In St. Andrews he encouraged photographic experiment, exhibited photographs by friends and colleagues, and lectured on developments in the "new art." His "Photogenic Drawing, or Drawing by the Agency of Light," published anonymously in the *Edinburgh Review* for January 1843,[7] is an ambitious, wide-ranging account of the development of photography to that date. Brewster also was the catalyst in bringing about the photographic partnership of Robert Adamson, one of Talbot's St. Andrews disciples, and the Edinburgh painter David Octavius Hill, a collaboration that resulted in the great flowering of photography in Edinburgh between June 1843 and Adamson's death in 1848.[8]

Brewster's involvement with photographers was not limited to Talbot, the St. Andrews group, and Hill and Adamson, however. In *The Home Life of Sir David Brewster*, his daughter suggests that her father's "connection with photography and photographers might well furnish a chapter of his life in competent hands," stating that "a large correspondence was kept up with . . . M. Claudet, Mr. Buckle, Paul Pretsch, Messrs. Ross and Thomson, and other eminent photographers" in addition to Talbot. Mrs. Gordon also records that her father "made many experiments in the art, though not able to give sufficient time to master its difficulties," and recalls that "a new photograph was to the last a joy to him."[9]

The so-called Brewster Album provides a tangible record of Sir David's involvement with photography. A leather-bound volume of some eighty-three folios, it

contains almost two hundred photographs ranging in date from 1839 to the 1850s, with the majority from the 1840s.[10] There is an extensive series of photographs taken by Talbot, including several photogenic drawings and a number of early examples of the calotype,[11] and many important images by, or attributable to, Sir Hugh Lyon Playfair, John and Robert Adamson, and Captain Henry Brewster, Talbot's principal St. Andrews disciples. The album also contains smaller groups of photographs and single images by a wide variety of early practitioners of photography, including Sir John Herschel, Henry Collen, Michael Pakenham Edgeworth, Nevil Story-Maskelyne, and Frances Monteith. In addition, it contains several drawings and popular prints (these are not illustrated or discussed in the present study, however).

It is likely that Brewster's first wife, Juliet, began to compile the album in October 1842. This is suggested by a passage in a letter from Brewster to Talbot in which he writes: "I am anxious to have a few more of your works, as I have distributed them very liberally, and my wife is making up a book of specimens."[12] The majority of the identifying inscriptions accompanying the photographs appear to have been written by Brewster himself over an extended period, since it is sometimes evident that he went back to add information in order to bring a caption up to date.[13] In some cases, too, notes were inserted by another hand, perhaps Mrs. Brewster's.

The album is organized in a casual but not entirely disorderly fashion. Sometimes images by one photographer are grouped together, and occasionally an effort was made to place portraits of different members of a family on facing pages. On the whole, however, there appears to have been remarkably little interest in arranging the photographs according to photographer or in establishing any chronological sequence or thematic continuity. The general sense of casualness is heightened by the fact that some photographs have been detached and others mounted in their places, sometimes without canceling the original inscriptions.

The chapters that follow aim to describe the context in which the Brewster Album was created. To set the stage for the discussion of the early history of photography in Scotland, the first chapter provides a brief account of Talbot's invention of the photo-genic drawing and calotype processes. To illustrate this history most effectively and to distinguish it from the specifically Scottish narrative, images have been selected from the extensive holdings of Talbot material in the Getty Museum's collection apart from his photographs in the Brewster Album. The second chapter provides a history of the translation of Talbot's invention of negative–positive paper photography into Scotland and particularly its dissemination in St. Andrews. This chapter, which draws extensively on the minutes of the St. Andrews Literary and Philosophical Society, at whose meetings photographs by Talbot and others were regularly exhibited and discussed between 1839 and 1844, is illustrated with photographs by Talbot preserved in the Brewster

Album that may well have been shown at those meetings. The diverse backgrounds and interests of the early experimental photographers in St. Andrews are also described. In the third chapter the same period is examined from a rather different point of view, in order to recount the difficulties experienced by Talbot's St. Andrews disciples in their efforts to master his calotype process. This section draws heavily on Brewster's extensive correspondence with Talbot.[14] The fourth chapter attempts to characterize the various subjects photographed by the St. Andrews group and discusses a number of the principal images by them that are preserved in the Brewster Album. Finally, a brief fifth chapter discusses some of the images in the album that were given or sent to Brewster by photographers other than those active in St. Andrews.

WILLIAM HENRY FOX TALBOT
AND THE INVENTION OF PHOTOGRAPHY

Like Brewster, William Henry Fox Talbot was fascinated by light.[15] In fact, thirty-two of the forty-two scientific papers he published during his lifetime deal with aspects of light or optics.[16] The astronomer Sir John Herschel (1792–1871), who independently invented photography in January 1839 and who corresponded frequently with Talbot between February 1 and April 27 of that year, shared Talbot's preoccupation.[17] In an extraordinary letter written to his wife in August 1841, Herschel exclaims, "*Light* was my first love!" and laments, "In an evil hour I quitted her for those brute & heavy bodies which, tumbling along thro' ether, startle her from her deep recesses and drive her trembling and sensitive into our view."[18] On the one hand, Talbot and Herschel responded to light in a mystical, romantic fashion. On the other, they recognized light's nature as an agent capable of generating chemical reaction. It was this combination of poetic appreciation and scientific understanding that prepared Talbot and Herschel for the thinking and experimentation that led to the invention of photography.

Talbot's description of the events that culminated in his first photographic experiments vividly illustrates this conjunction of the poetic and the scientific.[19] He begins his "Brief Historical Sketch of the Invention of the Art" by describing his "fruitless attempts," in October 1833, to take sketches of Lake Como, first with the camera lucida and subsequently with the camera obscura.[20] The melancholy traces left on the paper by his "faithless pencil" led Talbot to ruminate on the "inimitable beauty" of the images thrown on the paper by the camera lens, images he describes romantically as "fairy pictures, creations of a moment, and destined as rapidly to fade away." Still in a poetic frame of mind, he reflects upon "how charming it would be if it were possible to cause these natural images to imprint themselves durably, and remain fixed upon the paper!" In the next sentence ("And why should it not be possible?"), the pragmatic aspect of the natural philosopher reasserts itself, interrupting the romantic reverie. The next paragraph, in which Talbot analyzes the problem and proposes a possible solution, is stunning in its confidence, clarity, and simplicity:

> The picture, divested of the ideas which accompany it, and considered only
> in its ultimate nature, is but a succession or variety of stronger lights thrown
> upon one part of the paper, and of deeper shadows on another. Now
> Light, where it exists, can exert an action, and, in certain circumstances,

does exert one sufficient to cause changes in material bodies. Suppose, then, such an action could be exerted on the paper; and suppose the paper could be visibly changed by it. In that case surely some effect must result having a general resemblance to the cause which produced it: so that the variegated scene of light and shade might leave its image or impression behind, stronger or weaker on different parts of the paper according to the strength or weakness of the light which had acted there.

Soon after returning to England from the Continent in January 1834, Talbot entered into a "long and complicated, but interesting series of experiments" in an effort to realize his theory. He began his search for a method of making paper sensitive to light with a solution of silver nitrate, since he knew that "nitrate of silver was changed or decomposed by Light." He found this solution to be disappointingly insensitive. Next he tried silver chloride, but also found that to be relatively insensitive. In the spring of 1834, however, Talbot discovered that an "imperfect" chloride or "subchloride" of silver was much more sensitive to light, and he succeeded in obtaining "distinct and very pleasing images of such things as leaves, lace, and other flat objects of complicated forms and outlines." These were achieved by laying the object on a sensitized sheet of paper, covering both with plate glass, and exposing them to sunshine. Having found that he could increase the sensitivity of his paper by using it in a moist state and employing multiple washes, Talbot succeeded in producing "lilliputian" pictures in the camera obscura in the summer of 1835. "Though very pretty, [these] were . . . quite miniatures" and required a magnifying glass to examine them properly. Larger pictures were difficult to produce because of the paper's tendency to be "acted on irregularly." This was the point to which Talbot had brought his "new art" when the *Gazette de France* for January 6, 1839, reported Louis-Jacques-Mandé Daguerre's invention of photography.[21]

Talbot reacted immediately in an effort to establish his independent invention of photography. On January 25 he exhibited a group of photogenic drawings at the Royal Institution in London. A notice of the exhibition, which appeared in the *Mechanics Magazine* on February 9, indicates that his invention at first met with some skepticism: "By some the discovery of this use of sunshine was thought to be moonshine, but we are happy to say that it appears likely to be turned to some practical purpose."[22] Also in late January, Talbot wrote to Herschel inviting him to see his photogenic drawings:

Having a paper to be read next week before the Royal Society, respecting a new Art of Design which I discovered about five years ago, viz. the possibility of fixing upon paper the image formed by a Camera Obscura, or rather, I

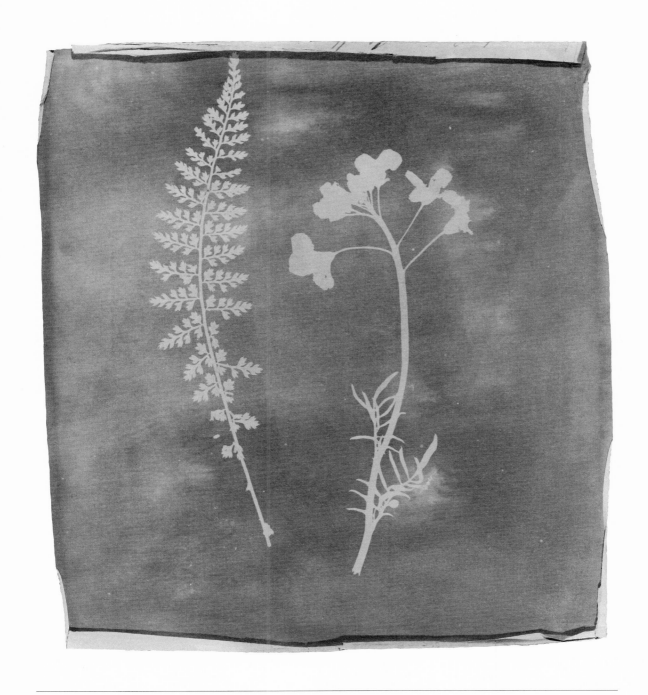

Figure 2. WILLIAM HENRY FOX TALBOT, *Botanical Specimens*, April 1839. H: 18.5 cm (7⅝ in.); W: 16.6 cm (6½ in.). Malibu, The J. Paul Getty Museum 84.XM.893.2.

should say, causing it to *fix itself*, I should be most happy to show to you specimens of this curious process. If you could not make it convenient to call here, Slough has now become so accessible by the railway, that I would take a drive there any day if you would appoint the hour.[23]

Since Herschel was ill and could not go to London, Talbot visited his friend in Slough on February 1, the day after he read "Some Account of the Art of Photogenic Drawing, or the process by which natural objects may be made to delineate themselves without the aid of the artist's pencil" to the Royal Society. Three weeks later, on February 21, Talbot gave the same group full details of his process in a paper entitled "An Account of the Processes employed in Photogenic Drawing." A few days afterward, in a letter to James David Forbes in Edinburgh, John Phillips, professor of geology at King's College, London, mentioned: "Every body here is or has been amazed with Talbot's Photogenic drawings which are very pretty & seem to point to a large class of inquiries from which perhaps a better process than that now used may arise."[24]

In a letter to the editor of the *Literary Gazette* written on January 30 and published on February 2, Talbot refers to the photogenic drawings he had exhibited at the Royal Institution as follows:

The specimens of this art which I exhibited at the Royal Institution, though consisting only of what I happened to have with me in Town are yet sufficient to give a general idea of it, and to shew the wide range of its applicability. Among them were pictures of flowers and leaves; a pattern of lace; figures taken from painted glass; a view of Venice copied from an engraving; some images formed by the Solar Microscope, viz. a slice of wood very highly magnified, exhibiting the pores of two kinds, one set much smaller than the other, and more numerous. Another Microscopic sketch exhibiting the reticulations on the wing of an insect.

Finally: various pictures, representing the architecture of my house in the country; all these made with the Camera Obscura in the summer of 1835.

With regard to the last group, Talbot added: "And this I believe to be the first instance on record, of a house having painted its own portrait."

The majority of Talbot's earliest "specimens" evidently were made by placing objects directly on light-sensitive paper, with the views of Lacock Abbey, Talbot's home in Wiltshire, being the only ones taken in the camera obscura. This distinction still held true in August 1839, when he exhibited ninety-three photogenic drawings at the

meeting of the British Association for the Advancement of Science at Birmingham. Only twenty-one of these were camera pictures, all representing Lacock Abbey.[25]

A number of photogenic drawings in the Getty Museum date from the months immediately after Talbot's announcement of his invention and can be linked directly to the list of subjects given by him in the *Literary Gazette*. There are several photographs of flowers and leaves, a number of compositions with lace, a remarkable series of negatives and "re-transfers" from painted glass, and at least one photogenic drawing of Talbot's "house in the country," Lacock Abbey. The image of Lacock, too faint to reproduce here, appears to represent Sharington's Tower at the east end of the south facade.[26] Talbot's inscription on the verso of the vanished positive reads: *Lacock Abbey / self-represented in the Camera Obscura / H. F. Talbot photogr. / May 1839*. The idea that Lacock Abbey was "self-represented in the camera obscura" is consistent with Talbot's earlier statement that his house "painted it own portrait."

A particularly beautiful and well-preserved early photogenic drawing depicts two delicate plants that arch toward each other as if swayed by soft contrary breezes (fig. 2). Inscribed on the verso in Talbot's handwriting *H. F. Talbot photogr / April 1839*, the photograph was contained in a folding envelope bearing the inscription *The Marchioness of Lansdowne, with Mr. Talbot's Compts.*[27] Born Lady Louisa Emma Fox-Strangways, the marchioness was Talbot's aunt on his mother's side. This, then, is a personal early presentation photograph sent by Talbot to a close relative. His family came to expect such gifts. In September 1841, after a visit from the same marchioness, who left Lacock Abbey with a large number of calotypes, Lady Elisabeth Feilding, Talbot's mother, wrote in some irritation to Constance Talbot, "[I]t is proper that this sort of *shoplifting* or swindling should be made known to the owner."[28]

Other photogenic drawings in the Museum's collection give a sense of the range of effects and colors possible with the process, even in the months just after Talbot announced his discovery. One, dated 1839 by the photographer, is a delightful arrangement of a fragment of lace, folded at the corners, combined with three fragile sprigs of moss (fig. 3). This image illustrates most effectively the ability of photogenic drawing to make "distinct and very pleasing images of such things as leaves, lace, and other flat objects of complicated forms and outlines." Presumably, it was a similar photograph, without the sprigs of moss, that prompted Talbot's former housemaster at Harrow to write in May 1839:

> My Dear Talbot,
> You are an arrant cheat or, at best an aider and abetter in deception. Before
> opening your packet of Photogenic drawings, I was so completely taken in
> by your lace-picture that like a dutiful husband, I was actually handing it

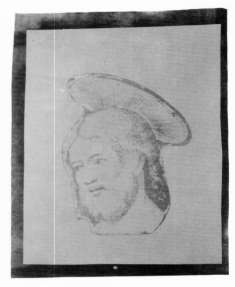

Figure 3. TALBOT, *Lace and Botanical Specimens*, 1839. H: 16.3 cm (6⁷⁄₁₆ in.); W: 20.6 cm (8⅛ in.). Malibu, The J. Paul Getty Museum 85.XM.150.10.

Figure 4. TALBOT, *The Head of Christ*, 1839. H: 5.7 cm (2¼ in.); W: 7.1 cm (2¹³⁄₁₆ in.). Malibu, The J. Paul Getty Museum 84.XM.1002.45.

over to Mrs. Butler as a lace pattern—intended for her,—before I discovered my mistake. And then the leaves! And the Abbey tower![29]

It is evident from these examples and from the list of photogenic drawings exhibited by Talbot at the Royal Institution that, at least in part, his early subject matter reflected his lifelong interest in botany, demonstrated first by his youthful publication, *The Flora and Fauna of Harrow*, published in 1812. It is clear, too, that the complex shapes of the leaves, ferns, and flowers were well adapted to illustrating the ability of the "new art" to represent rapidly "a multitude of minute details." Presumably, this was also the reason for Talbot's interest in photographing lace, the intricate patterns of which would have challenged the most patient and skillful draftsman. His inclusion of a negative image of lace in the fifth fascicle of *The Pencil of Nature*, published in December 1845, indicates that he continued to identify this aspect of photogenic drawing as one of the method's most significant features.[30]

A striking series of negatives and a positive depicting the head of Christ (see figs. 4, 5) illustrates another class of photogenic drawing made by Talbot in 1839:

Figure 5. TALBOT, *The Head of Christ*, 1839. H: 20.8 cm (8 ¼ in.); W: 17 cm (6 ¾ in.). Malibu, The J. Paul Getty Museum 84.XM.1002.46.

"figures taken from painted glass."[31] The negatives are dramatic and explosive in color and, as a group, bring to mind Andy Warhol's serial images of Marilyn Monroe or Mao Tse-tung. Most extraordinary and evocative, however, is the ghostly fashion in which Christ's head represents itself by "the mere action of Light." Talbot apparently had the painted glass to hand at Lacock Abbey, and so it would probably be unwise to put too much emphasis on the mystical nature of the subject. Nevertheless, it is tempting to believe that he intuitively drew some parallels between his own light-induced miracles and the Holy Shroud preserved in Turin on which Christ's body was believed miraculously to have drawn itself.

These incunabula from the first months of the public history of photography possess a beauty deriving from their color, composition, and imagery and from the associations they carry by virtue of being some of the earliest photographs ever made. In one sense, however, their beauty is inherent in their experimental nature. Talbot emphasized that his images were produced by the "mere action of Light upon sensitive paper," and it is evident that he felt there was a certain beauty in the economy and simplicity of his process. The view that early experimental photography possessed an intrinsic beauty or "virtue" as a result of its chemical nature was expressed by Talbot's mother in a letter accompanying a gift of the second, third, and fourth fascicles of *The Pencil of Nature*.[32] Mentioning that there appeared to be "a progressive improvement in each number, which will naturally continue till the art is *perfectionné*," Lady Elisabeth continues: "But after all the merit is not so much in the beauty of the *results* as in the *original* idea of producing any impression by a wonderful *chemical* process." Despite this emphasis on the medium's chemical nature and despite Talbot's insistence that his photographs were produced "without any aid whatever from the artist's pencil," it is important to recognize that the artist's hand is very much in evidence in the relative placement of the objects on the paper—for example, in the gentle manipulation of plant stem and lace folds.

Talbot continued his photographic experiments during 1839 and 1840 with the assistance and active participation of his wife, Constance. In part because he succeeded in increasing the sensitivity and reliability of his paper, and in part because he acquired better cameras, most of which were supplied by the London instrument-maker Andrew Ross, Talbot made steady progress without introducing any radical changes.[33] He was assisted in the spring of 1840 by the weather's being "the finest and most settled since the birth of photography."[34] In fact, one of the notebooks Talbot kept shows that he made almost two hundred photographs between the beginning of March and the end of October, often taking three different subjects on the same day.[35] Almost all of these were camera pictures. Views of Lacock Abbey predominate, but it is apparent that Talbot also took his cameras away from home. Entries in his notebook for April 14 and 25 list photogenic drawings of Bowood, Lord Lansdowne's country seat near Lacock

Figure 6. TALBOT, *Bust of Venus*, November 1840. H: 12.3 cm (4⅞ in.); W: 7.8 cm (3 1/16 in.). Malibu, The J. Paul Getty Museum 84.XM.1002.37.

Figure 7. TALBOT, *Bust of Patroclus*, September 1841. H: 15.3 cm (6 in.); W: 9.3 cm (3 11/16 in.). Malibu, The J. Paul Getty Museum 84.XM.1002.6.

Abbey, while that for July 29 records two photographs taken at the Botanical Gardens in Oxford. At Lacock Talbot captured various still-life subjects ranging from interior table settings to the carriages, carts, and tools of the estate. An important group of images depicts garden statuary and sculptures such as the *Patroclus*, a *Venus*, an *Apollo*, a *Diogenes*, an *Eve*, a bust of Napoleon, and a *Rape of the Sabines*.[36]

A flattering notice in the *Literary Gazette* for May 16, 1840, gives an indica-

tion of the range of Talbot's subject matter and of the steady improvement in his results:

> We have been gratified by an examination of a series of photogenic drawings, which Mr. Fox Talbot has produced during his spring residence in the country; and certainly they are not only beautiful in themselves, but highly interesting in regard to art. The representation of objects is perfect. Various views of Lacock Abbey, the seat of Mr. Talbot; of Bowood; of trees; of old walls and buildings, with implements of husbandry; of carriages; of tables covered with breakfast things; of busts and statues; and, in short, of every matter from a botanical specimen to a fine landscape, from an ancient record to an ancient abbey, are given with a fidelity that is altogether wonderful.

Talbot's friend Herschel was also highly enthusiastic about the development of his process. On June 19, 1840, he thanked Talbot for some "very, very beautiful photographs," continuing: "It is quite delightful to see the art proceed under your hands in this way. Had you suddenly a twelve month ago been shown them, how you *would* have jumped & clapped hands (i.e. if you ever do such a thing)."[37]

Talbot returned to many of the same subjects in 1841 and subsequent years. Consequently, it is difficult to date these photographs with certainty. There are, however, two dated negatives of subjects in this group in the Museum's collection. The first, a delicate lemon-yellow negative of a bust of Venus with the face shown in profile (fig. 6), is inscribed *Nov. 26, 1840* by Talbot, while the other, a dramatic three-quarter view of the *Patroclus* (fig. 7), is inscribed *8 Sept. 1841*. These and other early images of sculpture indicate that Talbot was already interested in the possibility of photographic representation of movement and dramatic expression, elements that were far beyond the capabilities of the medium at that time.

The Museum also possesses a number of images of Lacock Abbey and its service buildings which appear to correspond to views taken by Talbot during the summer and autumn of 1840. There are negatives and positives of the abbey's south and west facades and of the stable courtyard as well as detail views of the west facade and the cloisters.[38] One small, irregularly cut negative of the south facade looking west may be the *Abbey looking West* listed by Talbot in one of his notebooks on March 21, 1840.[39] Similarly, an unmounted negative in the collection may be linked with a photogenic drawing of the east and north side of the court recorded as having been taken on May 22.[40]

Early in September of the same year, in a letter to Herschel, Talbot wrote that he had been able to give only "desultory and divided attention" to photography during the summer and that the new art remained "in status quo."[41] A memorandum of

Figure 8. TALBOT, *Footman at Carriage Door*, October 1840. H: 16.3 cm (6⅜ in.); W: 21 cm (8¼ in.). Malibu, The J. Paul Getty Museum 84.XM.1002.15.

photographs taken on October 6 indicates that, in the interval, there had been dramatic advances, however. The October 6 subjects were *Diogenes, without sun*, taken with an exposure time of seventeen minutes; *trees, Lady E's garden*; *C's portrait, without sun*, taken with a five-minute exposure; and *terrace door into cloister. C's portrait, without sun*, the first mention of a "live" portrait (as distinct from the "portraits" of the *Patroclus*), is followed by a series of references to further photographs of Constance Talbot taken between October 8 and 13.[42] Talbot also photographed Amelina Petit, his children's governess, on October 13. The following day he recorded a large photograph, *Footman at carriage door*, taken with an exposure time of three minutes. Presumably, this is the majestic image of Talbot's footman wearing the livery of the sheriff of Wiltshire (fig. 8).[43] The

relatively brief exposure times and the addition of portraiture to his repertoire clearly indicate Talbot's progress.

In fact, late in September 1840 he had experimented with a solution of gallic acid, silver nitrate, and acetic acid and discovered what Herschel was to call "the sleeping picture."[44] Essentially, Talbot discovered that an invisible, or latent, image was formed on paper sensitized with his gallic acid solution after a comparatively brief exposure in the camera. This hidden image could be developed subsequently by a second application of Talbot's "exciting fluid."[45] He describes his new technique in a letter written to Jean-Baptiste Biot, a secretary of the Académie des Sciences in Paris, on February 1, 1841: "I lay a sheet of paper in the camera, remove it after a few moments, study it carefully and cannot establish the faintest hint of an image. The picture is nevertheless there in absolute perfection, but absolutely invisible. . . . I shall show you how I can make the image appear in a perfectly simple manner as if by magic. This is really the most wonderful thing you can possibly imagine; the first time it happened I was truly dumbfounded."[46]

Talbot communicated this discovery to the public in two letters published in the *Literary Gazette* on February 5 and 19, 1841, respectively. On February 8 he took out a patent on the new process, to which he gave the name *calotype* (from the Greek *kalos*, meaning beautiful). In the February 19 letter Talbot again describes his excitement on witnessing the appearance of the invisible image: "I know of few things in the range of science more surprising than the gradual appearance of the picture on the blank sheet, especially the first time the experiment is witnessed."[47] Finally, he describes his process in detail in a paper entitled "An account of some recent improvements in photography" read to the Royal Society on June 10, 1841. In a sense, Talbot's discovery and publication of the calotype process marks the end of the experimental phase of his photography, since within months of announcing his new system he was capable of producing photographs that remain unsurpassed in the history of the medium for their beauty, grandeur, and technical assurance.

The Introduction of Photography into Scotland

Talbot sent examples of his "new art" to Scotland a matter of days after he exhibited his photogenic drawings in London on January 25, 1839, and he communicated his subsequent improvements to the photogenic drawing process and his discovery of the calotype equally promptly. His quickness in this respect was due largely to his friendship with Brewster. In fact, in the first four years of the history of photography, from February 1839 until July 1843, Brewster was inexhaustible in promoting Talbot's discovery, initially among friends and colleagues in St. Andrews and subsequently in Edinburgh. The establishment of negative–positive photography in Scotland was largely a result of his enthusiasm.[48]

In August 1836, before a meeting of the British Association for the Advancement of Science in Bristol, Brewster spent a week among the "ruins grey" of Lacock Abbey.[49] This visit evidently was a success, since he and Talbot corresponded regularly in the following months on a variety of scientific topics. The first reference to photography only occurs in a letter of February 12, 1839, however. In this document Brewster thanks Talbot for his "kind attention in sending me your Photogenic specimens which I shall return in a few days after showing them to Lord Gray and some of my friends here who felt a deep interest in the new art" and goes on to say, "They are very interesting especially the lace one."[50] One of three faint photogenic drawings of lace in the Brewster Album (84.XZ.574.21, .54, .106) may be that mentioned in this letter.[51] On March 14 Brewster acknowledged another "beautiful photograph," continuing:

> I would have returned sooner the other specimens, but Prof[essor] Forbes wrote me to beg that I would allow him to have a sight of them; and requested, if I could not use that freedom without your permission, that I would keep your specimens till he applied for your permission. I did not hesitate to comply with his request, and after receiving them back I kept them for a few days to show to our Literary and Philosophical Society here who were much gratified with the sight of them.[52]

In fact, a letter written three weeks earlier by Brewster to the same Professor Forbes confirms that Talbot's photogenic drawings were circulated rapidly and excited considerable interest. Brewster explains that he had been unable to send Talbot's photographs to Forbes since "the specimens of the Black Art[53] have been paying visits at Kinfauns' Castle of Scone" and adds, "They are, as Mr. Talbot himself says, poor specimens, . . . all

his good ones being at Lacock Abbey." Brewster goes on: "I must show them to our Society here on Monday next, & return them to Mr. Talbot by that Evening's Post, so that you would oblige me by having them here on Saturday or Sunday evening."[54] Forbes evidently returned the photographs as requested, since "specimens of drawings executed by Mr. Fox Talbot, by the Photogenic paper by the Solar Rays" were exhibited at the St. Andrews Literary and Philosophical Society meeting on March 4.[55]

Formed in April 1838, soon after Brewster's appointment as principal, the St. Andrews Literary and Philosophical Society interested itself in a wide variety of subjects including archaeology, medicine, natural history, and optics. This variety reflected the diverse nature of the members, who were drawn from the faculty of the university and from the professional classes in the town. The society's eclectic nature is also evident from the communications read by its members and from the gifts made to its museum, established at the first meeting with "John Adamson, Esq., Surgeon" as curator.[56] Among the gifts recorded in the minutes of the November 1838 meeting are a "Fish from Australia called the Sea Hedgehog," a silver coin of King Robert III, the "shoe of a Chinese lady," three bottles of snakes, "a fox from Fifeshire," and "20 aquatic Birds from St. Andrews Bay."[57] The fox and seabirds, donated by John Adamson himself, were commemorated four years later in a small photograph by his brother Robert.[58]

The society clearly provided an outlet for Sir David's energy and a vehicle for his diverse interests. He read communications with daunting frequency and saw to it that photography became one of the areas of inquiry laid before its members. In fact, the meetings provided regular occasions for the exhibition and discussion of the earliest photographs taken in Britain, first by Talbot and Thomas Davidson, the Edinburgh instrument-maker,[59] and subsequently by Hugh Lyon Playfair, John and Robert Adamson, Henry Craigie Brewster, and Sir David himself. Works by photographers such as Antoine Claudet, who opened a daguerreotype studio in London in June 1841, and Henry Collen, to whom Talbot sold a license to calotype professionally in that city in August 1841, were also shown.[60]

With the exception of Sir David himself, the senior member of the St. Andrews group unquestionably was Hugh Lyon Playfair (fig. 9 [.4]),[61] who had a distinguished career in India before settling in St. Andrews and becoming addicted to photography.[62] The fact that "in music he was . . . proficient on several instruments"[63] helps to explain the manner in which he chose to be portrayed. Born in St. Andrews in 1776, he served with distinction in the Bengal Artillery of the East India Company between 1804 and 1834, attaining the rank of major. In India Playfair showed "great natural abilities, indomitable perseverance, and amazing adaptation of means to ends."[64] These qualities also characterized his career in retirement, both as a photographer and as provost of St. Andrews, a position he held from November 1842 until his death in 1861.

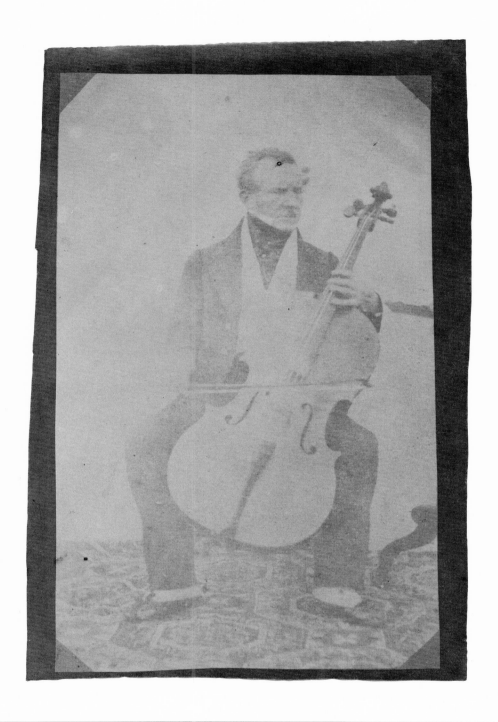

Figure 9. UNIDENTIFIED PHOTOGRAPHER, *Major Hugh Lyon Playfair*, circa 1843. Brewster Album (.4).

Brewster and Playfair lived in comparative harmony as neighbors in St. Andrews, although their "close neighbourhood and some similarity of temperament occasionally produced clouds in the horizon."[65] In their relations with the outside world, however, they appear to have been irascible characters with a talent for controversy. Within a few months of his appointment as principal, Brewster had the university in a state of turmoil, and in 1843 an attempt was made to depose him.[66] When Henry Cockburn, the eminent circuit judge, visited St. Andrews in April 1844, he characterized the situation nicely:

> Sir David Brewster! He lives in St. Andrews and presides over its principal college, yet no one speaks to him! With a beautiful taste for science, he has a stronger taste for making enemies of friends. Amiable and agreeable in society, try him with a piece of business, or with opposition, and he is instantly, and obstinately, fractious to the extent of something like insanity. With all arms extended to receive a man of whom they were proud a few years ago, there is scarcely a hand that he can now shake.[67]

Playfair's tenure as provost also was turbulent, earning him the sobriquets "Playfalse" and "Playfoul."[68] The benevolent autocracy he established in fact had a good deal in common with his command of Dumdum in India. His character was complicated, however, by a "plentiful fund of the dryest of dry humour." Playfair combined "proficiency in all sorts of manly sports" with broad interests in the arts and sciences.[69] He had a keen and practical interest in architecture, for example. His garden, which was open to the public, contained scale models of the tallest buildings in the world, a pagoda ninety feet high, and a variety of automata, including a crocodile, "fiddling bears, dancing masters, [and] gentlemen practising the bowing art."[70] The pagoda is just visible in a small, ghostly calotype in the Brewster Album (.60).

John Adamson (pl. 1), curator of the Literary and Philosophical Society Museum from 1838 until his death in 1870, was the eldest son in a large family born to Rachel and Alexander Adamson at Burnside, a farm close to the village of Boarhills, about five miles east of St. Andrews.[71] Consequently, Burnside and the surrounding countryside are the subjects of many early photographs by John and his brother Robert.[72] Born in 1810 and educated at St. Andrews and Edinburgh, John Adamson qualified as a licentiate of the Royal College of Surgeons, Edinburgh, in 1829. He continued his

Plate 1. JOHN ADAMSON, *Self-Portrait*, 1843/44. Brewster Album (.184).

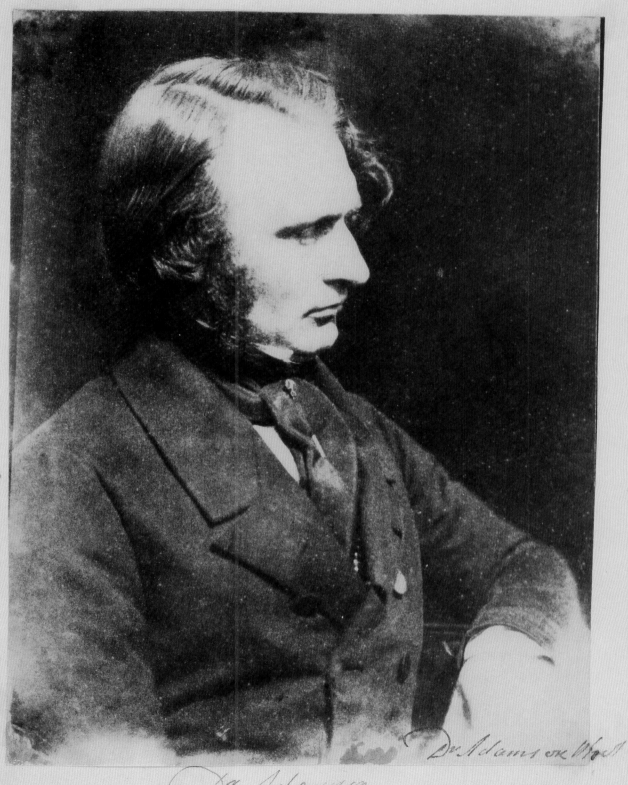

Dr Adamson Dr Adamson West

W. H. F. Talbot

Lady Elizabeth Feilding
Mr Talbot's Mother

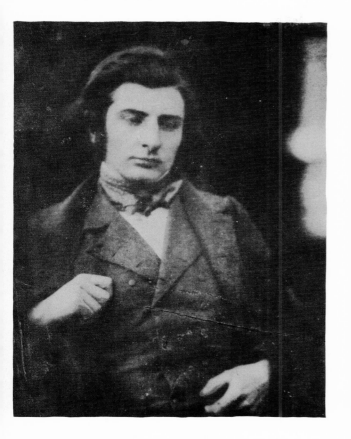

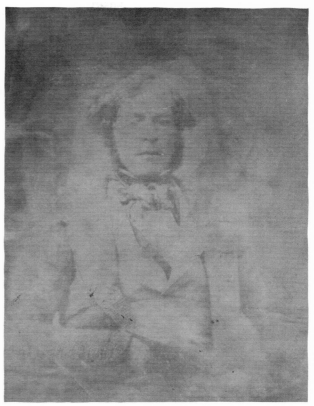

Figure 10. ATTRIBUTED TO JOHN ADAMSON, *Robert Adamson*, 1843/44. Adamson Album. Edinburgh, National Museums of Scotland 1942.1.1. Photo: National Museums of Scotland.

Figure 11. HENRY CRAIGIE BREWSTER, *Self-Portrait*, 1842/43. Princeton University Library, Graphic Arts Collection. Photo: Princeton University Library.

studies in the medical schools of Paris and traveled to China as a ship's surgeon, returning to St. Andrews in 1835 to establish a practice.[73] In addition to serving as curator of its museum, Adamson regularly read communications to the Literary and Philosophical Society on such topics as epidemic fever and mortality rates in Fife. A letter published in the *St. Andrews Gazette* at the time of his death describes him as a "keen student, an

Plate 2. WILLIAM HENRY FOX TALBOT, *Lady Elisabeth Feilding*, August 1841. Brewster Album (.51).

ardent cultivater of physical science, and especially that portion of it which pertains to sanitary reform, the lessening of human suffering, and the prolongation of life," but no mention is made of his contributions to photography.[74]

Despite his fame as the partner of David Octavius Hill, Robert Adamson (fig. 10) is a less defined personality than his elder brother. Born in 1821, in August 1842 he was or had been "educating as an engineer."[75] He did not belong to the Literary and Philosophical Society. It was his brother who was responsible for involving Robert Adamson in photography and promoting him with Brewster and Talbot. Portraits of him reveal a frailty confirmed by his early death in 1848 and lend support to the suggestion that he was "drilled in the art [of photography]"[76] by his brother to provide him with a profession compatible with his weak constitution.

Another member of the St. Andrews group, Henry Craigie Brewster (1816–1905), was Sir David's fourth and youngest son (fig. 11).[77] A captain in the 76th Regiment of Foot, he was named an honorary and corresponding member of the Literary and Philosophical Society in November 1840.[78] In a letter written to Talbot in July 1842, Sir David mentions that his youngest son was on leave from his regiment at Newry.[79] During this leave Henry Brewster participated in the group's photographic activities; Sir David mentions his work with that of the Adamsons and Major Playfair in an article on photography published in the *Edinburgh Review* in January 1843.[80] A quarter of a century later, in *The Home Life of Sir David Brewster*, Mrs. Gordon recalled that her brother practiced photography under his father's "superintendence" when home on leave, adding that "it was one of his father's means of relaxation from heavier work to take positives from the negatives of his son and others." Henry Brewster continued to practice photography after his return to his regiment in October 1842, and in May 1843 Sir David exhibited a group of his calotype portraits at the Literary and Philosophical Society.

That Henry Brewster's involvement in photography was relatively brief is suggested by the fact that he sent home pen sketches from later postings in the Mediterranean.[81] He eventually commanded the 76th Regiment of Foot, being promoted to lieutenant colonel in 1863 and retiring in 1872 with the honorary rank of major general.[82] A brief obituary, from the *Times* for September 21, 1905, records that he was "an enthusiastic golfer and had a wide circle of friends both in England and in Scotland" but does not mention his activity as a photographer.

The St. Andrews group of photographers had not yet come together, however, when Sir David had his second showing of photographs at the Literary and Philosophical Society, exhibiting further "beautiful specimens of Photogenic Drawings executed by Mr. Talbot" at the meeting held in July 1839.[83] (Indeed, Robert Adamson and Henry Brewster did not join Talbot's original disciples—Playfair, John Adamson, and Sir David himself—until 1842.) A head of Christ in the Brewster Album (fig. 12 [.2])

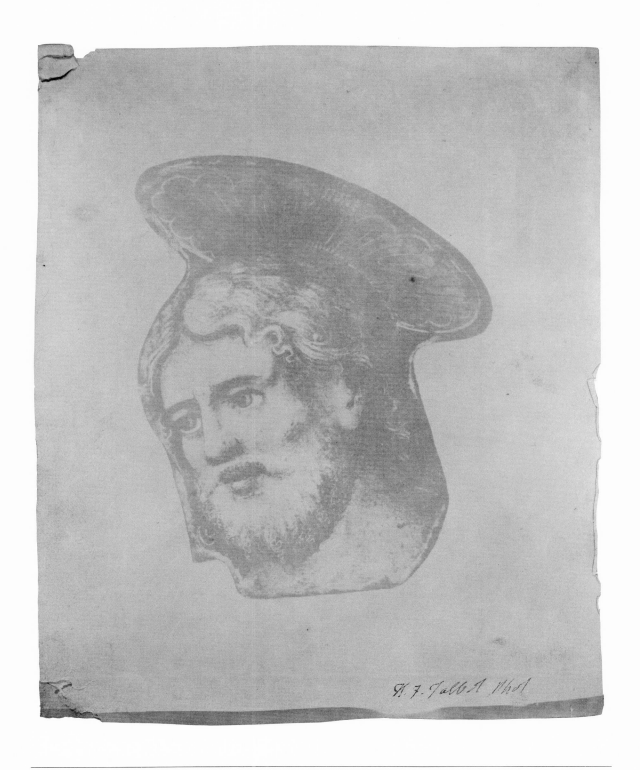

Figure 12. TALBOT, *Head of Christ*, May 1839. Brewster Album (.2).

Figure 13. TALBOT, *A Sculpture of Diogenes in an Architectural Niche*, September/October 1840. Brewster Album (.47).

Figure 14. TALBOT, *Section of the South Front of Lacock Abbey*, March 21, 1840. Brewster Album (.62).

may have been one of the specimens shown at the July 1839 meeting, since it is inscribed by Talbot on the verso *from old painted glass. / H. F. Talbot photogr. / May 1839*. In July 1840 Brewster exhibited a daguerreotype "executed by Mr. Davidson Optician Royal Exchange Edinb[urgh], and likewise many specimens of Photogenic Drawings, executed under the management of Mr. Fox Talbot, of Lacock Abbey, the inventor of this beautiful art with a description of the method he adopted."[84] "Fine specimens of the *Daguerreotype* and *Photogenic* drawings" by Davidson and Talbot, respectively, were shown at the society's November meeting.[85]

A number of images in the Brewster Album can be connected with subjects photographed by Talbot during the spring, summer, and autumn of 1840 and may have been among the items exhibited at the July and November meetings. For example, there is a small photograph of a table with a teapot, candlestick, and toast rack (.27), similar but not identical to a series of such domestic still lifes taken by Talbot during March, April, and May 1840. There is also a view of an architectural niche in the Hall of

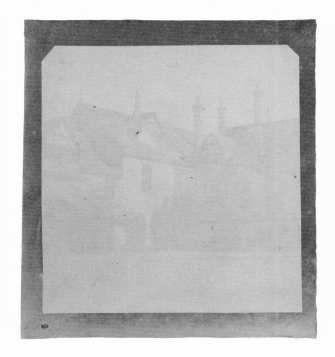

Figure 15. TALBOT, *The Courtyard at Lacock Abbey*, 1841/42. Brewster Album (.87).

Figure 16. TALBOT, *Nicolaas Henneman*, 1842/43. Brewster Album (.182).

Lacock Abbey containing a sculpture of Diogenes with his lantern (fig. 13 [.47]). This may be identified with one or the other of the entries made by Talbot in his notebook on September 29 and October 6. One of the images of the *Patroclus* in the album (.66) may be related to the extensive series of views Talbot took between July and August 1840.[86] Finally, a near view of a harp with a piano and a section of bookshelves in the background (.50) may be associated with two photographs taken on October 16 with exposures of twenty and twenty-one minutes, respectively.[87] The album also contains several images of Lacock Abbey and its service buildings which appear to correspond to views taken by Talbot during this period. A small one preserved in two prints (see fig. 14 [.18, .62]) almost certainly is the *Middle window S. front* recorded by Talbot on March 21. Likewise, a small positive view of the stable courtyard (fig. 15 [.87]) may be linked with a photogenic drawing of the east and north side of the court recorded as having been taken on May 22.

On March 1, 1841, Brewster showed "New specimens of Photography" to the society.[88] At the April meeting the instrument-maker Thomas Davidson "exhibited

Daguerre's apparatus for obtaining impressions of objects in the camera obscura" and discussed various improvements for taking portraits. At that meeting's close he "exhibited the process itself by taking a view of the New College Buildings."[89] The following month Davidson returned with a "new and improved *camera obscura* for taking Daguerreotype drawings and portraits and exhibited numerous specimens taken by Major Playfair and himself."[90] In July Brewster exhibited "many fine specimens of Calotype or Photographic Pictures, and explained the Process by which they were executed." It was at this meeting that Talbot was elected an honorary member of the society.[91] A portrait by him in the Brewster Album of his mother, Lady Elisabeth Feilding, with an umbrella (pl. 2 [.51]) probably was one of these early calotypes. A small lilac-colored portrait of Nicolaas Henneman, Talbot's valet and photographic assistant (fig. 16 [.182]), may also date from this period. Davidson brought another new camera to the October meeting, Brewster suggested further improvements to the process, and "a number of very fine Daguerreotype and Calotype drawings were exhibited executed by Major Playfair and Mr. Adamson."[92] The secretary perhaps showed a trace of exhaustion when he recorded in the minutes of the November meeting that Brewster exhibited a "great number of Photogenic Drawings" and instructed the members that they were "henceforth to be called *Talbotype* instead of *Calotype*."[93]

In November 1841 Major Playfair visited London, preceded by a letter from Brewster introducing him to Talbot.[94] We do not know whether Playfair met Talbot, but he did meet Antoine Claudet and, on his return to St. Andrews, exhibited "Daguerreotypes by Mons. Claudet of the Adelaide Gallery, London, by his new and rapid *photogenic* process" at the society's first meeting in 1842.[95] In February Playfair presented "a variety of portraits, and groups of ladies and gentlemen residing in St. Andrews, taken by himself since last meeting by the Daguerreotype process, and using the chloride of iodine, whereby the process is limited to from 5 to 10 seconds." He also showed an electrotype portrait of Claudet and "a small tablet sent by [him] to show the effects which different colours in glass have, when impressed upon the silver-plate through the camera,—thus affording a guide to parties in dressing to sit for their portrait."[96] Temporarily, at least, it seems that the initiative had passed from Brewster to Playfair and from the talbotype to the daguerreotype. Brewster was back in full spate in November, however, reading a communication on latent light and exhibiting "a plate of glass on which he had impressed a portrait which appeared only when the plate was breathed upon."[97]

Perhaps most members of the society had heard enough about photography, for there is a lull in the group's minutes until April 1843, when John Adamson read a letter from a Mr. Furlong describing "a new mode for *preparing iodized paper for the calotype*."[98] Like Robert Adamson, Furlong is a poorly defined figure who did not belong to the society. He appears to have come to St. Andrews in 1840 or 1841 as assistant to

Professor of Chemistry Arthur Connell and in 1841 was enrolled as a nonmatriculating student in Brewster's class on the philosophy of the senses.[99] Brewster refers to him in letters written to Talbot in October and November 1841, and in March 1842 Furlong himself wrote to Talbot requesting information regarding the fixing of positives and asking how to achieve "the beautiful lilac" color of Talbot's calotypes.[100] We catch a glimpse of Furlong with Robert Adamson and another, unidentified figure standing on the bridge over Kenley Water, the stream that meanders past Burnside, in a small calotype in the Brewster Album (.75). The leafless trees indicate that the photograph was taken in the autumn or winter, probably between October 1842 and January 1843.

Brewster refers to Furlong again in a letter written to Talbot in November 1843, identifying him as the author of the negative of a panorama of St. Andrews taken from St. Regulus Tower. The details of Brewster's description suggest that the photograph may be a view of North Street with St. Salvator's College, New College, and St. Andrews Bay which previously was attributed to the Adamsons or to Hill and Adamson.[101] Furlong surfaced again in March 1855, as W. Holland Furlong of Dublin, when he contributed a letter to the *Journal of the Photographic Society of London* claiming to have discovered and published a method of preparing iodized paper by a single wash in 1841.[102] Responding to a claim by a Mr. C. J. Jordan that *he* had discovered the process in 1848, Furlong asserted that "so far back as *seven years* prior to the date of Mr. Jordan's paper, viz. in 1841," he had "discovered *and published* the same process" himself. According to Furlong, "I was at that time resident in St. Andrews, and showed my process to Sir David Brewster, through whom I communicated it to the Literary and Philosophical Society of St. Andrews, in a brief memoir which was afterwards printed in their Transactions." Presumably, this is the paper John Adamson read to the society in April 1843.[103] In January 1856 Furlong contributed an elaborate letter on the calotype process to *Photographic Notes* in which he describes himself as "one of the very first who tried, and successfully varied the Calotype process as promulgated by Mr. Talbot" and refers to his "friend and co-experimentalist, Dr. Adamson, of St. Andrews."[104]

Sir David Brewster showed "two series of calotype portraits" at the society's meeting in May 1843, "the one executed by Mr. Henry Collen London, and the other by Capt. Brewster 76th Regiment."[105] In February 1844 John Adamson "exhibited beautiful calotypes, some executed by his brother Mr. Robert Adamson."[106] Finally, in April 1845, Brewster sent thirty-six calotypes by Talbot "for the inspection of the members."[107] In toto, these references in the society's minutes establish that Talbot's calotype process achieved ascendancy in St. Andrews despite the group's early successes with the daguerreotype. This outcome, by no means an inevitable one, was largely due to Brewster's untiring proselytizing on behalf of his friend's "new art."

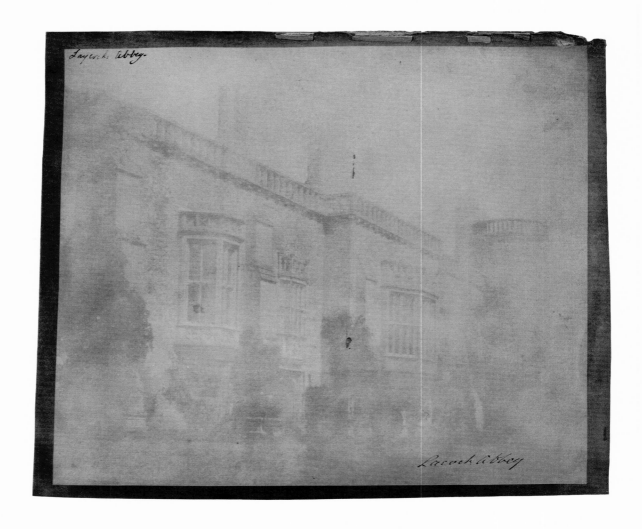

Figure 17. TALBOT, *The South Front of Lacock Abbey with Sharington's Tower*, 1839/40. Brewster Album (.48).

BREWSTER, TALBOT, AND THE ST. ANDREWS DISCIPLES

 Brewster's unflagging interest in Talbot's photographic investigations is evident from the numerous letters he wrote to Talbot between February 1839 and July 1843, regularly acknowledging receipt of photogenic drawings and calotypes and in some instances referring to particular images. This is the case with a letter dated January 20, 1840, in which Brewster writes, "The larger drawing of Lacock Abbey is particularly interesting to me both as a specimen of the great power of the art, and as recalling the many happy hours I spent within its walls."[108] A large salt-fixed print in the Brewster Album representing the south front of the abbey with Sharington's Tower may be the photograph to which Brewster was referring (fig. 17 [.48]). Other letters request details of the chemical solutions Talbot used, and yet others ask for assistance on matters such as the fixing of positives or the procedure for copying them. These documents also form a chronicle of the photographers who gathered around Brewster in St. Andrews, describing their disappointments, their progress, and their eventual successes.

 Brewster's early interest was sharpened by Talbot's discovery of the calotype process in the autumn of 1840. He congratulated Talbot in a letter dated October 18, writing: "I am delighted to hear of your discovery which I consider a very great one. The only difficulty now will be, & I am sure your genius will overcome this also, to get a paper having such a surface as to preserve those sharp lines and minute markings which are so beautiful in the Daguerreotype."[109] The letters that follow acknowledge calotypes sent by Talbot and discuss how best to protect his discovery. After several months Talbot described his new process in two letters, which Brewster acknowledged on May 5 and May 15, 1841, respectively. Brewster was absent from St. Andrews for some weeks but wrote again on June 12 describing plans to attempt the calotype process himself.[110] This was followed on July 26 by a sad letter that begins, "I regret to say that I have entirely failed in your Calotype process, and so have two of my friends, Major Playfair and Dr. Adamson to whom I communicated it." Despite assistance from Professor of Chemistry Arthur Connell, Brewster and Playfair "could get nothing like a good picture." Sir David goes on to say that Playfair had since tried the process "repeatedly and patiently" without success and that Adamson, "who is a good Chemist, and successful with the Daguerreotype has also failed, and says that the paper when ready for the camera became black in the dark." Brewster closes with several questions and a plea: "If you can help us out of these difficulties we shall follow minutely your instructions."[111] He wrote again the following day, enclosing "some of the *disjecta membra Photographorum*, which will show you how completely your process has baffled us."[112]

By October 1841 John Adamson had succeeded in producing "a few good photographs" but still had difficulty fixing his positive prints.[113] Despite continuing difficulties, on October 27 Brewster could describe St. Andrews to Talbot as "the headquarters (always excepting Lacock Abbey) of the Talbotype." He went on to say, "Our Chemical Professor's assistant is now at work and successful, so that without counting myself you have three ardent disciples," identifying the third one as Furlong, who had executed "an admirable portrait of a relative in Ireland." A paragraph later, Brewster informed Talbot that "Mr. Furlong, like Dr. Adamson, has failed in fixing the Positive Talbotype" and "does not succeed by washing after the Gallo-nitrate."[114] Brewster mentions Furlong again in a letter written to Talbot ten days later: "I enclose a negative Talbotype done in Ireland by Mr. Furlong who has now begun the art here. His positive ones will not stand. I wish . . . that you would send me a *Positive* one taken from the enclosed." In the same letter he says that success continued to evade Playfair despite his "indomitable" patience. Brewster concludes, "I hope . . . we shall overcome the difficulties."[115]

Furlong's letter to Talbot asking how to achieve "the beautiful lilac" color of the latter's calotypes deserves to be quoted in full.[116] Addressed "McFarlane's Lodge, Union St., St. Andrews" and sent to Talbot at Lacock Abbey, it reads:

> Sir
> Though personally unknown to you, I take the liberty of addressing a few
> lines to you on the subject of your beautiful discovery of the calotype. Sir
> David Brewster some months ago sent you a negative picture which I made
> in the County of Wicklow and which you were kind enough to Positive for
> me. I have never been able to preserve the Positives without making them a
> disagreeable red colour very unlike the beautiful lilac of your Positive
> pictures. Will you be kind enough to let me know how you prepare and
> preserve your Chloride pictures what strength of Nitrate of Silver solution
> and what strength of the preserving solution
>
> I am
> Sir
> Your Obedient Serv[an]t
> W. H. Furlong

Plate 3. THOMAS RODGER, *Group Portrait*, circa 1850; JOHN OR ROBERT ADAMSON, *The South Entrance to St. Salvator's College Chapel, St. Andrews*, 1842/43. Brewster Album (.5, .6).

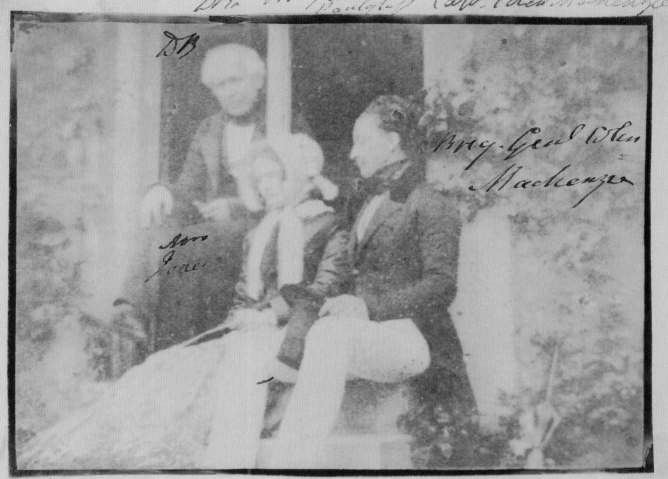

DB

Brig. Genl Colin = Mackenzie

Mrs Jones

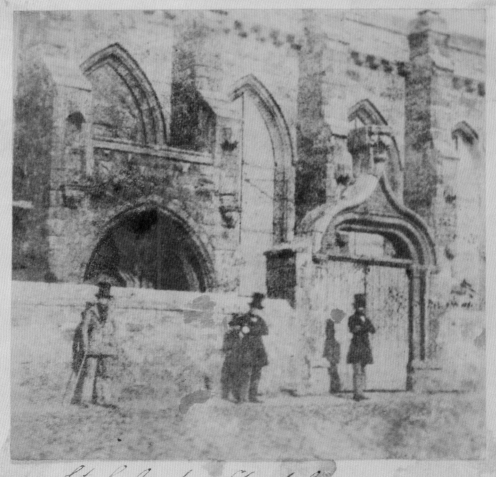

St Baldred's Chapel

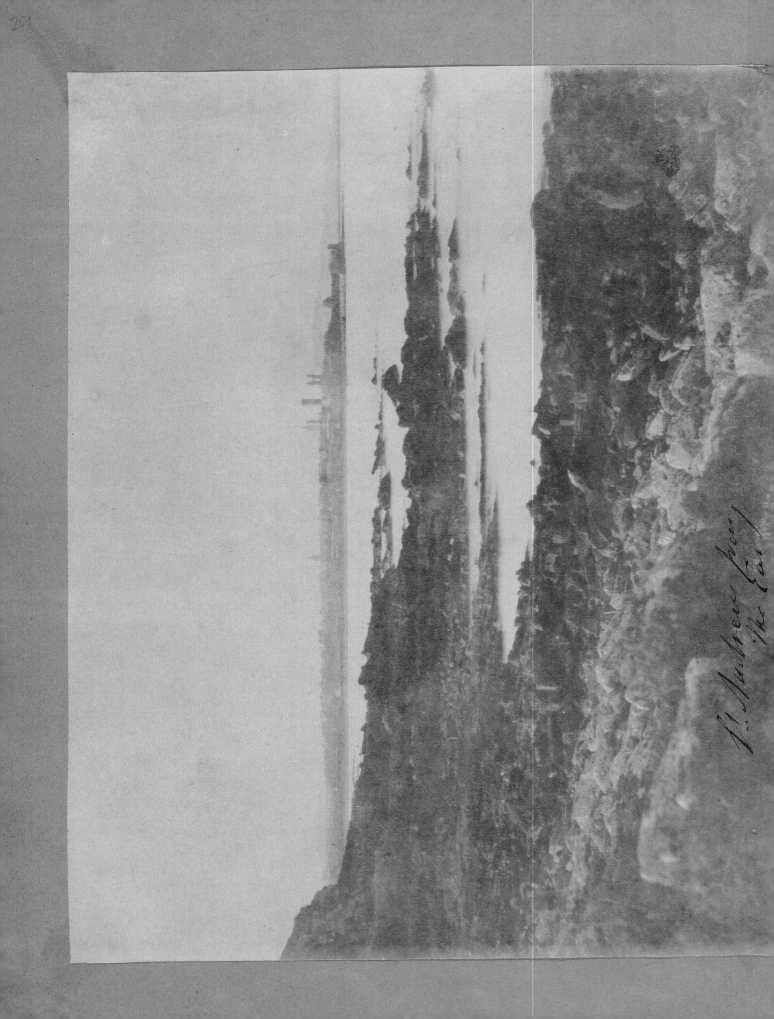

Talbot appears to have responded, since in a letter of March 29, 1842, Brewster mentions a direct positive Talbot had sent to Furlong and asks for a specimen to exhibit in his own annual lecture on photography for the Literary and Philosophical Society.[117]

Beginning in November 1841, Brewster was able to send to Talbot specimens of John Adamson's successful talbotypes, one of which contained a "woe-begone figure" of Brewster himself.[118] The following April he could even suggest that portraits by Adamson and Furlong were in some respects superior to Talbot's own, writing: "[T]he Draperies seem better brought out in theirs than in yours; arising perhaps from the sitters putting on lighter dresses." Seven months later Brewster revisited Lacock Abbey, traveling there from Leamington Spa after the British Association's annual meeting, which had been held in Manchester. A letter written by Constance Talbot to Lady Elisabeth Feilding on July 18 confirms that Brewster and Talbot derived great pleasure from each other's company:

> You are perfectly right in supposing Sir David Brewster to pass his time
> pleasantly here. He wants nothing beyond the pleasure of conversing with
> Henry discussing their respective discoveries & various subjects connected
> with Science. I am quite amazed to find scarcely a momentary pause occurs
> in their discourse. Henry seems to possess new life & I feel certain that were
> he to mix more frequently with his own friends we should never see him
> droop in the way which now so continually annoys us.

She continues, "He has almost promised to go next week to Leamington and take a picture of Warwick Castle with Sir David." Unfortunately, this expedition did not materialize. On July 22, after Brewster had returned to Leamington, he wrote to Talbot to say that he would not be able to participate, "although [I] had anticipated much pleasure from being your photographical assistant," explaining that he was obliged to return to St. Andrews to join his youngest son, Henry Craigie Brewster, who had received a leave from his regiment at Newry.[119]

Talbot appears to have written to Brewster in August 1842 informing him of plans to visit Scotland. Brewster responded in a jocular fashion: "I am sorry that you have occasion to set any value upon fresh air, but very glad that you think of seeking for it in the Highlands where you cannot fail to find it. Even in the Lowlands here at St. Andrews the air is singularly fresh and salubrious in the months of July, August and

Plate 4. J. ADAMSON, *Distant View of St. Andrews from the East*, circa 1845. Brewster Album (.35).

September." He went on to urge Talbot to visit St. Andrews, "the Headquarters of the Calotype," inviting him to take up quarters "among the Ghostly ruins of St. Leonard's College." Almost as an afterthought, Brewster mentioned that "Mr. Adamson has now resolved to practice the Calotype in Scotland, and is making preparations for beginning it." The letter ends with the terse sentence, "The enclosed paper from Major Playfair speaks for itself."[120]

Major Playfair's "paper" was a detailed memorandum entitled "Calotype as attempted at St. Andrews up to 15 August 1842." It lists the "ingredients" used and describes the process of producing fixed negatives and positive copies, ending on a frustrated note: "We cannot succeed by the above process either in obtaining a clear sharp picture (such as taken by Mr. Talbot) or of fixing them with any degree of permanency *and* Humbly pray for further information as a reward for most laborious application and disapp[ointed] expectation for upwards of 12 months."[121] The major's cover note to Brewster is more outspoken and shows that even his indomitable patience had been exhausted: "If your friend Mr. Talbot will condescend to peruse these notes & give us any new light on the subject—we may go on—But with the *present light* we cannot advance one step & I regret to say that the Daguerreotype must have infinitely the ascendancy unless this art is more easily attainable—With the other I never have a single failure—with this I never have any thing else."[122] The fact that the major's crisis of faith should have coincided with Robert Adamson's decision to practice the calotype professionally suggests that Talbot's first disciples were now working independently of each other.

On October 22, in a long letter touching on a variety of topics related to photography, Sir David tells Talbot that Henry Craigie Brewster is "now practising the Calotype with great success at Cork with his Reg[imen]t" and adds that he hopes soon to send some of his son's works. After mentioning his own experiments using tinted paper for positives, Brewster gives an account of his son's "many successful exp[erimen]ts in applying oil to the negatives," noting "the quickness w[ith] which it gives a positive in the darkest day" and describing the results as "resembling the finest aquatints." Brewster also refers to a self-portrait by his son that "has been thought by Dr Adamson and Major Playfair the best portrait done here."[123] In the same letter he informs Talbot that "Mr. Adamson has arrived at great perfection in the art, and his brother the Doctor is preparing a little book containing his best works which I shall send to you soon." Eleven days later, on November 2, Brewster mentioned that "Dr Adamson was here today with his little book of Calotype Gems for you, but he still requires to get a good positive of one of me before he can send it."[124] On November 9 John Adamson did, in fact, send Talbot his small album of calotypes, writing: "I take the liberty of sending you a few calotypes executed by myself and brother, in testimony of the great

pleasure we have derived from your discovery—I hope they will not be devoid of interest from the objects which they picture, whatever may be their rank as specimens of the art."[125] This tartan-covered album, including four portraits selected from the Adamsons' "best work," is still preserved at Lacock Abbey. Appropriately, its frontispiece is a portrait of Sir David Brewster.[126]

The Tartan Album represents a turning point in the history of the calotype in St. Andrews. Intended as it was to demonstrate the Adamsons' mastery of the "new art," it marks the end of the first, experimental phase of photography in that city, as does Brewster's announcement in his article on photography in the *Edinburgh Review* of January 1843 that "Mr. Adamson, whose skill and experience in photography is very great, is about to practice the art professionally in our northern metropolis."[127] In fact, Robert Adamson moved to Edinburgh early in May 1843 "to prosecute, as a Profession, the Calotype."[128] By the beginning of July he and David Octavius Hill were about to enter into partnership, with elaborate plans for the new medium's application.[129] A commercial and professional element thus was introduced into the history of photography in Scotland that was at odds with its origins in the sphere of scholarly enquiry and scientific experiment.

Figure 18. UNIDENTIFIED PHOTOGRAPHER, *The West Front and South Aisle of St. Andrews Cathedral from the Northeast,* circa 1843. Brewster Album (.73).

THE CALOTYPE IN ST. ANDREWS

In addition to chronicling the history of paper photography in St. Andrews, the Brewster letters reveal Sir David's vision of the potential of Talbot's "new art." In October 1840, for example, he speaks of applying it to the "grand and precipitous coasts" of St. Andrews and to "our beautiful ruins here which are well adapted for the purpose."[130] The possibility of possessing photographic likenesses of friends and colleagues also clearly fascinated him. "I shall be very anxious to hear of your success with Portraits," he wrote Talbot on October 18, 1840, adding, "Do send me one of yourself." On October 23 he declared himself "delighted with the specimens" Talbot had sent him, adding, "but I long for a Portrait"; Talbot evidently obliged, since in a letter of November 8 Brewster mentions that he is returning two portraits. To portraits, antiquities, and local scenery the Adamsons added other subjects, calotyping informal, rustic scenes at Burnside and photographing the vernacular architecture of St. Andrews as well as its medieval ruins.

The ancient ecclesiastical capital of Scotland and the seat of its oldest university, St. Andrews is rich in architectural remains and redolent with historical associations.[131] Brewster declared the study and preservation of the antiquities of St. Andrews to be the responsibility of the Literary and Philosophical Society at its second meeting, and in December 1839 the society intervened to prevent the Commissioners of Her Majesty's Woods and Forests from selling the Abbey Wall, with its towers and gateways, to private individuals and businesses. The members of the society were rightly concerned that such a sale would lead to the dismantling of the ancient boundaries of the cathedral.[132] Perhaps the most articulate meditation on "the fragments of St. Andrews" is Henry Cockburn's, written in April 1844:

> There is no spot in Scotland equally full of historical interest. . . . There is
> no place in this country over which the Genius of Antiquity lingers so
> impressively. The architectural wrecks that have been spared are in them-
> selves too far gone. They are literally ruins, or rather the ruins of ruins.
> Few of them have left even their outlines more than discoverable. But this
> improves the mysteriousness of the fragments, some of which, moreover,
> dignify parts of otherwise paltry streets, in which they appear to have been
> left for no other purpose except that of protesting against modern
> encroachment.[133]

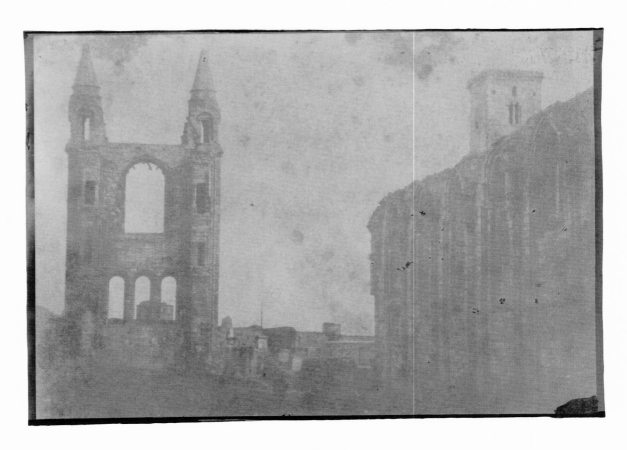

Figure 19. ATTRIBUTED TO WILLIAM HOLLAND FURLONG, *The East Gable and South Aisle of St. Andrews Cathedral with St. Regulus Tower, from the Northwest,* circa 1843. Brewster Album (.85).

Cockburn's historical and romantic view of St. Andrews is summed up in the sentence: "On the whole it is the best Pompeii in Scotland."[134] A diametrically opposed view was expressed by the author of an early biography of Major Playfair who intoned: "[F]ilth and ruinous neglect . . . bid fair to entomb St. Andrews as completely as did the lava torrents Herculaneum or Pompeii of old."[135] The modernization and improvement of St. Andrews from November 1842 on were spearheaded by none other than Playfair himself, who approached the enterprise with a self-confidence and single-mindedness reminiscent of Pope Julius II when he destroyed old St. Peter's. In the three decades of his provostship, Playfair succeeded in transforming the town into "the gay yet dignified Scarborough of Scotland."[136] It is in this context that the early architectural photographs taken by the St. Andrews group must be understood.

A small calotype of St. Salvator's College Chapel by John or Robert

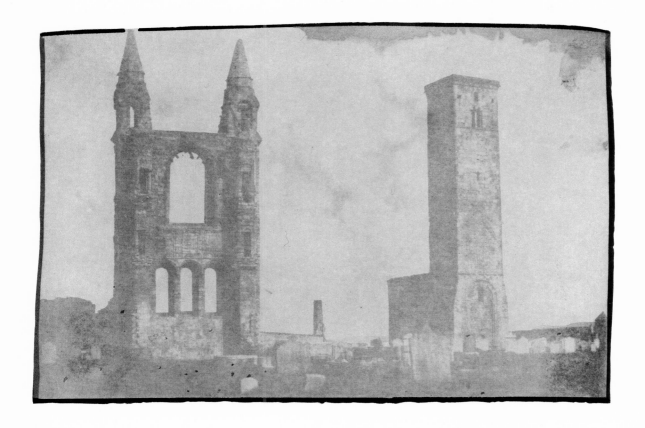

Figure 20. FURLONG, *St. Regulus Tower and the East Gable of St. Andrews Cathedral from the Northwest*, 1843/44. Brewster Album (.102).

Adamson preserved in the Brewster Album (pl. 3 [.6])[137] is typical of the earliest photographs of the architectural and historical relics of St. Andrews. The gateway and entrance portal of the chapel almost fill the image and dwarf the three figures occupying the near foreground. The contrast in scale between figures and architecture conveys an impression of monumentality and evokes the grandeur of Scotland's past in a manner that recalls the small views of Rome executed by Piranesi a century earlier. The brooding quality of the image also implies a communion between present and past. In fact, not only the chapel but also the space before it presents a "memorial of the past from . . . being the scene of some remarkable event of history."[138] The area in the left foreground marks the site of the burning of Patrick Hamilton,[139] one of the martyrs of the Scottish Reformation, and presumably generated a pleasurable frisson in the 1840s as it still does today. In addition to the small view of the chapel, the Brewster Album

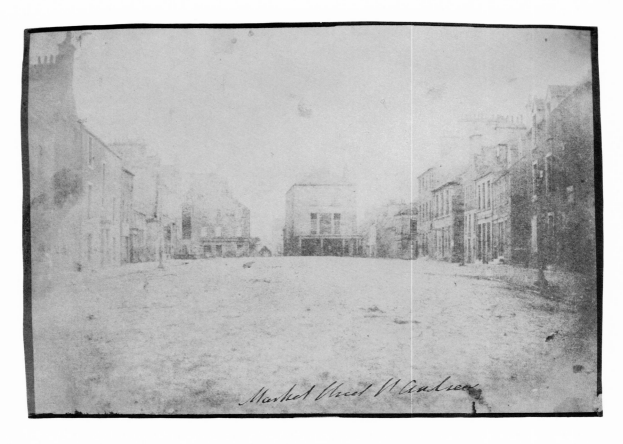

Figure 21. ATTRIBUTED TO J. ADAMSON, *Market Street, St. Andrews, with the Old Tollbooth, Looking West*, circa 1843. Brewster Album (.77).

includes some of the cathedral and of St. Regulus Tower (.45, .78). It also contains several slightly larger views of the cathedral and Cardinal Beaton's Castle which must date from 1842–44 and which may be by the Adamsons, Furlong, or Henry Brewster (see figs. 18–20 [.73, .85, .102]).[140]

A larger-format photograph in the album provides a general view of Market Street in St. Andrews, looking west to the old Tollbooth or Town Hall (fig. 21 [.77]). Probably by John Adamson, the image is striking in part because of the exceptionally low viewpoint, which suggests that the camera was placed directly on the cobbled street. Although the composition converges on the Town Hall, the fact that the vacant foreground records the site of the martyrdom of Paul Craw in 1433[141] is of primary importance. Because it stood in the middle of the street, as was the tradition with Scottish tollbooths, Major Playfair targeted the Town Hall for demolition soon after he became

Figure 22. ROBERT ADAMSON, *Fishergate, St. Andrews*, 1842/43. Adamson Album. Edinburgh, National Museums of Scotland 1942.1.1. Photo: National Museums of Scotland.

Figure 23. R. ADAMSON, *St. Andrews from the East*, 1842/43. Adamson Scrapbook. Edinburgh, National Museums of Scotland 1942.1.2. Photo: National Museums of Scotland.

provost. Without knowing the identity of the author of the photograph, it is impossible to know whether it was intended to make a case for the preservation or destruction of the building or whether it simply records it. Regardless, it is a silent witness to Playfair's program of urban renewal; the Town Hall is at once "self-represented" and "self-preserved."[142]

 This view of St. Andrews may belong to a group of what might be termed documentary photographs from the medium's earliest experimental phase. A related view in the Adamson Album preserved in the National Museums of Scotland, Edinburgh, is Robert Adamson's extraordinary small depiction of a section of the fisher quarter on North Street at the corner of Castle Wynd (fig. 22).[143] Described in 1849 as a "region of putridity and stagnation," North Street was one of the principal areas to which Playfair directed attention in his efforts to improve living conditions in St. Andrews.[144] His efforts to rescue this neighborhood's population from its "state of filth, misery and degradation"[145] were not universally appreciated, though it is reasonable to suppose that this photograph was intended to record a social problem and that the photographer supported Playfair's position. We have seen that John Adamson was concerned with

sanitary conditions and their relation to mortality; he certainly would have been sensitive to the danger of an outbreak of cholera from the piles of mussel shells and accumulated filth in North Street.[146]

As early as September or October 1842, John and Robert Adamson took their camera out of town to record the "grand and precipitous" coastline between St. Andrews and Burnside. A small image by Robert Adamson in the Adamson Scrapbook, also preserved in the National Museums of Scotland, shows a distant view of St. Andrews taken from a point on the cliffs a little over a mile from the center of town (fig. 23).[147] Another early calotype in the scrapbook represents the Rock and Spindle, a geological curiosity located in a sheltered cove almost midway between St. Andrews and Boarhills, and several small views record the wooded scenery around Burnside.[148]

A splendid print in the Brewster Album (pl. 4 [.35]) is linked to this group of photographs, although its size implies that it must be dated after May 1843, when the St. Andrews group acquired a larger-format camera. Most likely taken by John Adamson, the view is similar to that in the earlier small calotype. It differs, however, in having been taken at sea level, perhaps from the cove containing the Rock and Spindle. Large rocks seem to press against the lens, and the low viewpoint suggests that the camera was balanced directly on a similar boulder. In the distance St. Andrews seems just another projection into the North Sea, distinguished only by St. Regulus Tower and the steeples of the cathedral and St. Salvator's Chapel. The distance involved in going to take this view or others in this group is not great, but the inconvenience must have been considerable. Apart from the need to prepare photographic paper at some distance from the subject,[149] the Adamsons' eagerness to clamber over slippery, seaweed-covered rocks in search of a view suggests that their readiness to experiment was combined with a youthful spirit of adventure. The same might be said of Furlong, who had taken his camera to the top of St. Regulus Tower by July 1843.[150]

Hill and Adamson's magnificent portraits of members of Edinburgh society and dour ministers of the Free Church of Scotland, taken during the second period in Scottish photography between 1843 and 1847, have created the understandable but misleading impression that the partners invented portrait photography in Scotland.[151] As we have seen, this was not the case. Two groups of small portraits taken by John and Robert Adamson in 1842 and 1843 and preserved in the Adamson Scrapbook illustrate well the evocative character of the early likenesses (figs. 24, 25).[152] Despite their modest size and deceptively simple compositions, they reveal the diverse characters, moods, and stations of their subjects. Particularly remarkable is the fact that the sitters appear variously relaxed, pensive, and lively in spite of the lengthy exposure times and cramped circumstances of the sittings. The powerful, strangely haunting character of these small images is due, at least in part, to the photographers' naïveté regarding tradi-

Figure 24. J. OR R. ADAMSON, *Four Portraits of Women*, 1842/43. Adamson Scrapbook. Edinburgh, National Museums of Scotland 1942.1.2. Photo: National Museums of Scotland.

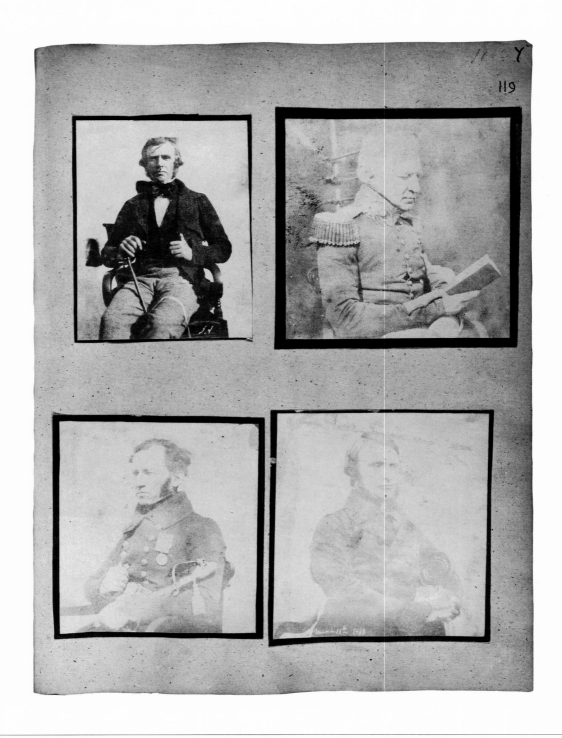

Figure 25. J. or R. Adamson, *Four Portraits of Men*, 1842/43. Adamson Scrapbook. Edinburgh, National Museums of Scotland 1942.1.2. Photo: National Museums of Scotland.

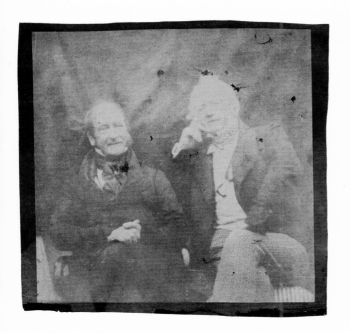

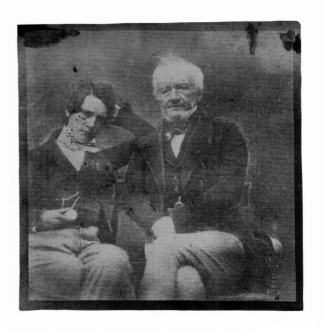

Figure 26. J. ADAMSON, *Lord Campbell and Sir George Campbell*, 1842. Brewster Album (.38).

Figure 27. J. OR R. ADAMSON, *Sir George Campbell and His Son, George*, 1842. Brewster Album (.8).

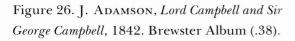

tional Scottish portrait painting. Generally, though not invariably, it is precisely this directness that distinguishes the early, experimental portraits by the St. Andrews group from those taken in Edinburgh by Hill and Adamson.

Two of the most striking portraits in the Brewster Album are those representing Lord John Campbell with Sir George Campbell (fig. 26 [.38]) and Sir George Campbell with his son, George (fig. 27 [.8]). A note in Brewster's handwriting identifies the sitters in the former and gives the information *Dr Ad. Phot.*, thus identifying it as John Adamson's work. Brewster mentions this portrait in a letter to Talbot dated October 29, 1842, writing that "some of the positives are perfect Rembrandts."[153] Other examples of the portrait of Sir George and his son, preserved in the Adamson Album and Scrapbook, have Robert Adamson's initials inscribed in the negatives at the lower right corners and are dated May and August 1842, respectively.[154]

Sir George and Baron Campbell were the eldest and second sons of the Reverend Dr. George Campbell, minister of Cupar near St. Andrews.[155] Born in 1788, George spent his early career in India as an assistant surgeon with the East India Company. He retired to Fife in 1823 and was knighted in 1833. Born a year after his brother, John Campbell was a student at St. Andrews at the age of eleven and subsequently

pursued a career in law in England. He entered the House of Commons in 1830 and became lord chancellor of Ireland in 1841. He held the latter appointment for only six weeks, however, until the fall of Lord Melbourne's government. John Campbell became lord chief justice of England in 1850 and, in 1859, lord chancellor. Described as "a man of pushing character" who "possessed in a supreme degree the art of getting on," he was an ambitious and not entirely attractive figure.[156] Whatever his failings as a public figure, in private life he was "rich in fine traits," however.[157] "A most affectionate friend and father," the apparently more appealing Sir George Campbell had "a close and fraternal intimacy" with his eminent brother.[158] Indeed, John Adamson's double portrait conveys a remarkable impression of conviviality, closeness, and vitality. He evidently succeeded in persuading his subjects to relax and enjoy the experience of being photographed and consequently captured the "play of features" and "living expression" sadly lacking in the "absolutely fearful" likenesses produced by contemporary daguerreotypists.[159] Brewster's allusion to Rembrandt is certainly apposite with regard to the treatment of light and shadow in Adamson's image, although the jovial, relaxed mood also brings to mind paintings by Frans Hals.

The Brewster Album also contains a single portrait of Sir George Campbell (pl. 5 [.52]) which appears to be an enlargement taken by rephotographing the relevant detail in the double portrait. It is worth noting here that Sir John Herschel had developed a method of making positive enlargements and reductions from photogenic drawing negatives as early as March 1839.[160]

The portrait of Sir George Campbell and his son nicely commemorates the former as "a most affectionate . . . father."[161] Young George Campbell is especially striking, appearing to challenge both camera and photographer. He meets the eye of the camera with an unflinching gaze, at the same time turning his watch toward the lens as if to deflect its challenge. The latter motif recalls certain Italian Renaissance portraits by Sandro Botticelli and Agnolo Bronzino in which the sitter displays a medallion or some similar object as an attribute and talisman. In this case the explanation of the motif may be quite mundane, since it is possible that young George Campbell was helping Robert Adamson time the exposure.[162]

Another particularly attractive St. Andrews portrait in the Brewster Album is the small lilac-colored photograph representing the Thomson sisters (.26). William Thomson of Priorletham is recorded in the census of June 1841 as living on Bell Street in St. Andrews with his wife, five sons, and three daughters: Isabella, Mar-

Plate 5. J. or R. ADAMSON, *Sir George Campbell*, 1842. Brewster Album (.52).

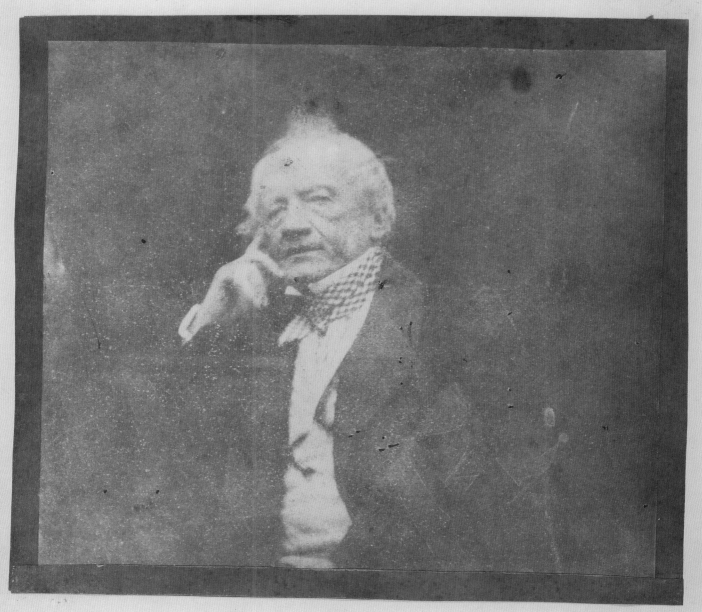

Sir George Campbell

Miss Thomson
St Andrews

And murmurings from the infirmity of love

garet, and Laura, who were fifteen, twelve, and eleven at the time. One of the original members of the Literary and Philosophical Society, Thomson attended the early meetings regularly and took the chair on one occasion.[163] A physician and a near neighbor of John Adamson, to whose family his own was linked in a variety of ways, Thomson and his wife probably remained warm friends with the Adamsons until they emigrated to Australia in 1846. This delightful double portrait depicts Isabella and Margaret—as is indicated by an inscription by John Adamson that accompanies another example of the image, preserved in the Tartan Album at Lacock Abbey[164]—and must have been taken a year after the census. It suggests the sisters' intimacy, records their poise and healthy, well-groomed beauty, and communicates something of the warmth of the relationship between Margaret and the photographer. Perhaps because she was older, Isabella appears more reserved and introspective.[165]

Isabella Thomson is portrayed again, a year or two later and probably by John Adamson, in a larger-format photograph in the Brewster Album (jacket; pl. 6 [.67]). In this case the compositional elements and mood have parallels in portrait painting, though they probably derive more directly from contemporary keepsake images of the kind published in *Heath's Book of Beauty*.[166] Despite its conventional aspects, this portrait possesses both a freshness and a slightly disquieting quality that stem from its improvised character. No attempt was made to conceal the fact that Isabella was seated outdoors and that a blanket or curtain was hung behind her to provide a dark background.[167] In fact, the incongruity of the setting and the obviousness of the props strangely enhance her beauty and drawing-room elegance. This sense of improvisation is absent, however, in two splendid portraits from the same period by John Adamson, representing the stern patriarch, Dr. Thomson, himself (fig. 28 [.142]) and his eldest son, James (pl. 7 [.143]).

A final and highly unusual photograph by John Adamson is that of a male athlete, clad only in shorts and sandals (pl. 8 [.173]). His clenched fists and muscular torso might suggest that he is a pugilist, but the forward-leaning pose and stance indicate that he is a runner. Perhaps the sandals were intended to give the tableau an aura of antiquity, and perhaps the runner was intended to be a modern Pheidippides. Regardless of his identity or activity, Adamson seemingly intended the photograph to serve as an anatomical study and perhaps as an aid to artists. This is suggested by a closely related photograph of the same figure preserved in the Adamson Album.[168]

Very little is known about Captain Henry Craigie Brewster's photographic

Plate 6. J. ADAMSON, *Isabella Thomson*, circa 1845. Brewster Album (.67).

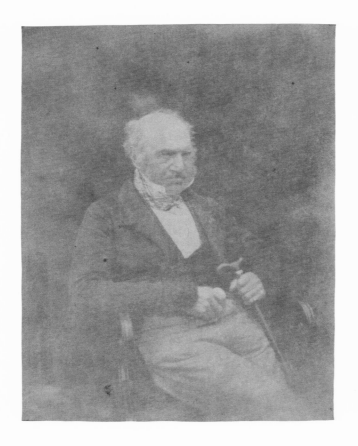

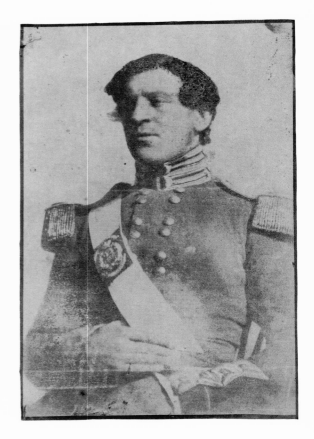

Figure 28. J. ADAMSON, *Dr. William Thomson*, circa 1845. Brewster Album (.142).

Figure 29. H. BREWSTER, *Portrait of Mr. Barton*, October 1843/45. Brewster Album (.122).

efforts during the summer and early autumn of 1842 apart from the fact that he partici-
pated in the activities of the St. Andrews group. A portrait of John Adamson preserved
in the Adamson Album can be securely attributed to him and dated September 1842,[169]
and it is likely that Brewster's self-portrait (fig. 11) dates from about the same time.
Indeed, John Adamson and Henry Brewster appear to be wearing the same tweed jacket
in the two portraits. Because of its primitive character and the sitter's identity, a virtually
illegible portrait in the Brewster Album can probably be placed in the period of Brew-
ster's activity in St. Andrews. This is the lilac-colored image identified by inscriptions in
Sir David's handwriting as a portrait of Miss Mary Playfair, one of the major's four
daughters (.40).

Most of the photographs by Henry Brewster preserved in the Brewster
Album depict his fellow-officers in the 76th Regiment of Foot (.23, .63, .72, .108, .112–

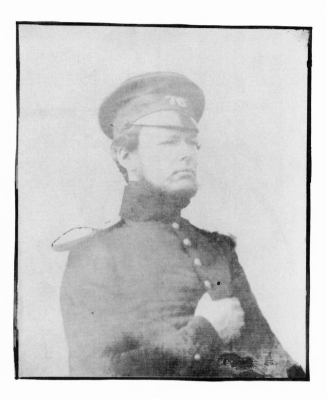

Figure 30. H. BREWSTER, *Mr. Barton*, circa 1843. Brewster Album (.108).

Figure 31. H. BREWSTER, *Major Martin*, circa 1843. Brewster Album (.112).

.114, .117, .122) and appear to have been taken in Ireland, presumably between October 1842, when he returned to his regiment stationed at Cork with a "fine camera from Davidson,"[170] and May 1, 1843, when Sir David exhibited a group of them at the Literary and Philosophical Society.[171] Presumably because of their military identity, Captain Brewster's sitters exhibit a braggadocio that contrasts dramatically with the serenity and sensitivity of portraits by the Adamsons.

Four of Henry Brewster's portraits depict William Hugh Barton (.23, .72, .108, .122), an ensign in the 76th from 1840 to 1843 and lieutenant from 1843 to 1851,[172] when he retired from the regiment. Especially fine are two examples in which Barton is shown half-length, with his torso at a slight angle to the picture plane (figs. 29, 30 [.122, .108]), a format recalling antique and Renaissance portrait busts. He is depicted three-quarter face with the left side in deep shadow to emphasize his fine nose and strong

Figure 32. H. BREWSTER, *Cork Barracks*, circa 1843. Brewster Album (.13).

chin. Though he wears civilian tweeds in the smaller portrait, he assumes a military pose by thrusting his thumb into his waistcoat. In the larger portrait he wears dress uniform, epitomizing the righteous majesty of a mid-nineteenth-century British officer. Similar in character and composition is Brewster's portrait of Robert Fanshawe Martin (fig. 31 [.112]), the third son of Admiral of the Fleet Sir Thomas Byam Martin and a major in the 76th from 1840 until shortly before his death in 1846.[173]

The Brewster Album also contains a number of architectural views by Captain Brewster of army barracks at Cork and Buttevant in the south of Ireland (.13, .14, .22, .63, .110, .111). Particularly striking is one identified as the guardroom of Cork Barracks (fig. 32 [.13]). The skewed views of the architectural elements and dramatic

Plate 7. J. ADAMSON, *James Thomson*, circa 1845. Brewster Album (.143).

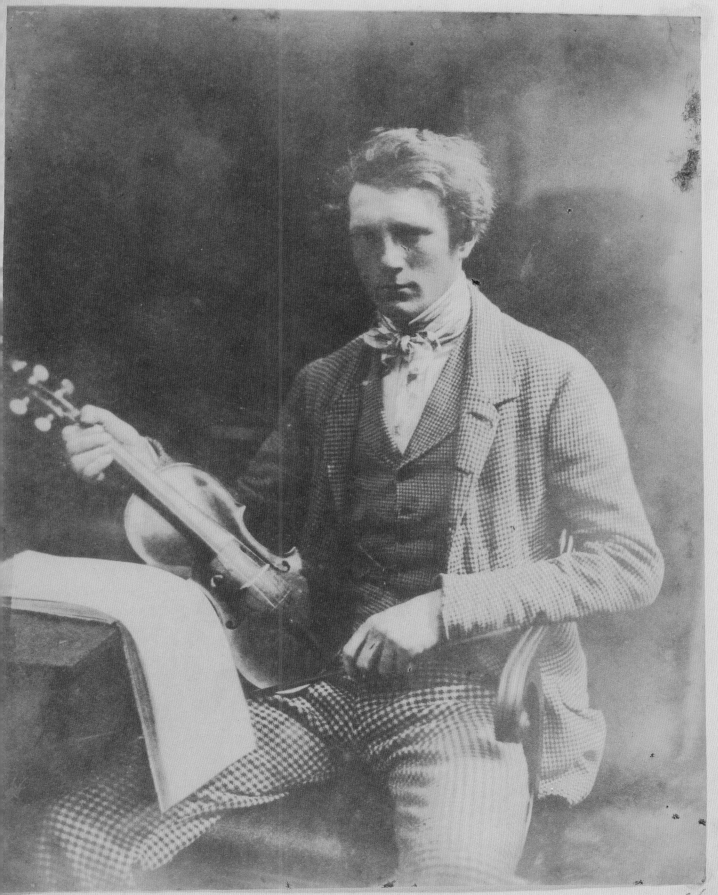

145

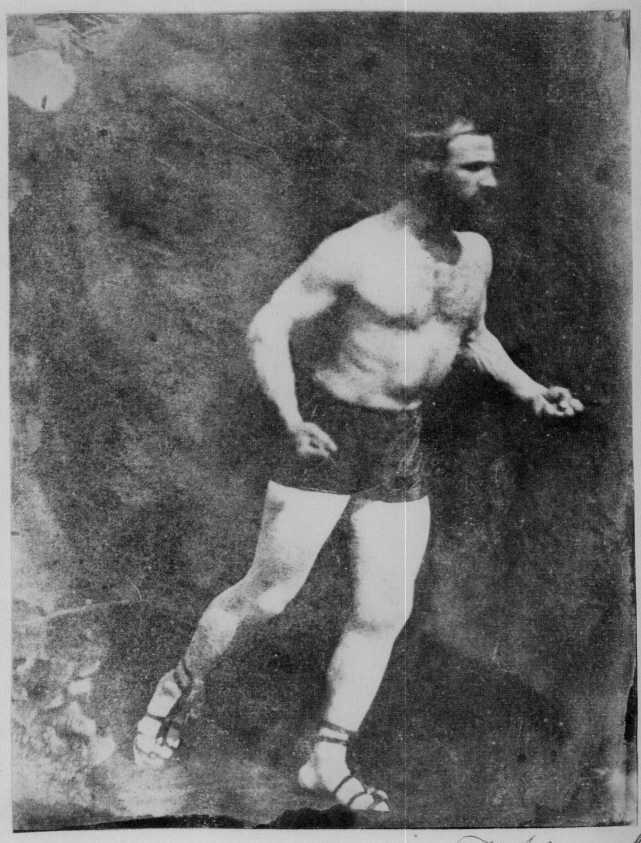

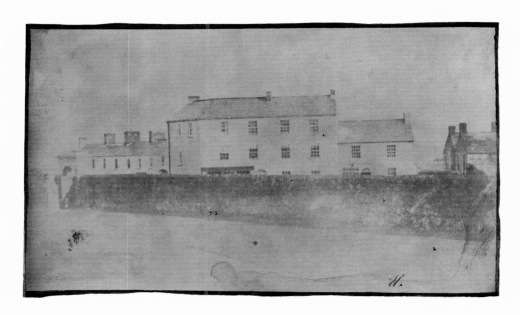

Figure 33. H. BREWSTER, *Buttevant*, circa 1843. Brewster Album (.14).

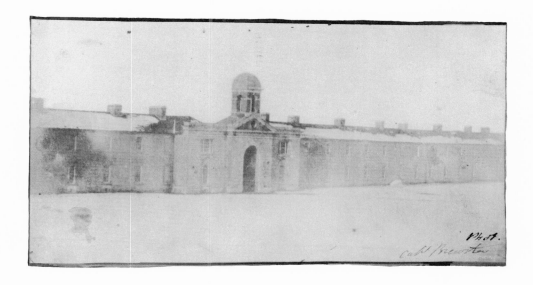

Figure 34. H. BREWSTER, *Buttevant Barracks*, circa 1843. Brewster Album (.111).

Plate 8. J. ADAMSON, *An Athlete*, circa 1850. Brewster Album (.173).

contrasts of light and shade combine to form an image of unusual visual complexity and mystery. A view of houses outside the barracks at Buttevant (fig. 33 [.14]) exhibits a similar inclination to abstract composition. Behind the dark ribbon of the wall, the roofs and facades of the buildings seem strangely weightless and flattened, creating a curious tension between surface and depth. The element of abstraction is also pronounced in a view of Buttevant Barracks in which snow on the roofs seems to undermine the physical nature of the buildings (fig. 34 [.111]).[174]

The photographs produced by Talbot's disciples in St. Andrews are diverse in character and style like the individuals who made them, but they also form a coherent group in the sense that they are all products of a shared exploration of the intricacies and idiosyncracies of the new medium. With the exception of those by Captain Brewster, these images derive a thematic unity from their St. Andrews subject matter, and all of them are linked historically by the person of Sir David Brewster. Their exploratory nature is the most important unifying element, however. Taken when the medium itself was inherently experimental, the photographs are tangible records of the investigations that Talbot's "new art" prompted Sir David, Playfair, the Adamsons, Furlong, and Captain Brewster to pursue. Through them we can share something of the elation and wonder that the first photographs generated in the St. Andrews group. This sense of radical innovation distinguishes the achievement of this group from that of Robert Adamson and David Octavius Hill in Edinburgh immediately afterward.

OTHER PHOTOGRAPHERS REPRESENTED
IN THE BREWSTER ALBUM

In addition to photographs by Talbot and his St. Andrews disciples, the Brewster Album contains a miscellany of images by other early photographers, some of whom are identifiable and others not. Among the former is Sir John Herschel, represented by a single cyanotype reproducing an engraving of a young woman (pl. 9 [.84]).[175] Brewster himself mentions this photograph in a letter to Talbot dated November 18, 1843: "Mr. M. P. Edgeworth shewed me, and indeed has left with me one of Sir John Hershel's Cyanotypes made by Sir John." He goes on to say: "It is taken from an engraving, and is tolerably sharp but by no means pleasing."[176] In fact, the striking lapis color gives the image a sumptuous quality that is dramatic, strangely beautiful, and by no means displeasing to a modern eye.

The album also contains an interesting series of photographs taken by the same M. P. Edgeworth mentioned by Brewster in connection with Herschel's cyanotype (see figs. 35–37 [.89–.94]). The youngest son of Richard Lovell Edgeworth of Edgeworthstown, a village near Longford in Ireland, Michael Pakenham Edgeworth went to India in 1830 to begin a distinguished career in the Bengal Civil Service and as a botanist.[177] His involvement in both botany and photography and his knowledge of Herschel's cyanotype process link him with another botanist-photographer, Anna Atkins, and it is possible that his interest in the new medium was inspired in part by plans to employ it in his research in India.[178] Pakenham Edgeworth's interest in photography is confirmed, at least implicitly, by the existence of a fine portrait of him by John Adamson in the Brewster Album (fig. 38 [.25]) which probably was taken during his visit to St. Andrews in November 1843.

The six photographs by Pakenham Edgeworth preserved in the Brewster Album represent the family house and grounds and the church at Edgeworthstown and must date from between 1842 and 1846, when he was home on furlough from India. The bare trees indicate that they were taken during the autumn or winter. It is tempting to think that Pakenham Edgeworth gave Brewster this group in November 1843 when he gave him Herschel's cyanotype. Pakenham Edgeworth's friendship with Brewster and his family is confirmed visually by an unattributed group portrait in the Brewster Album in which he appears with Sir David, Lady Brewster, their daughter, and Mary Playfair (.120). They appear to have been photographed in the garden of St. Leonards, the house Brewster bought in St. Andrews soon after his appointment as

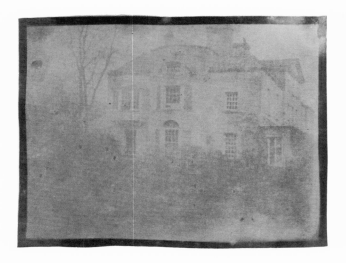

Figure 35. MICHAEL PAKENHAM EDGEWORTH, *Edgeworth House*, 1843/44. Brewster Album (.90).

Figure 36. EDGEWORTH, *The Church at Edgeworths-town*, 1843/44. Brewster Album (.91).

principal of the United Colleges; the abundant foliage indicates that the photograph was taken during the spring or summer.[179]

In fact, several references in *The Home Life of Sir David Brewster* indicate that the Brewsters and the Edgeworths were friends of long standing. Brewster met Maria Edgeworth, Michael Pakenham Edgeworth's half-sister, when she visited Scotland in 1823, thus marking the beginning of "a most cordial friendship." According to Brewster's daughter, he and Miss Edgeworth carried on "a close and lively correspondence," which she describes as "almost the only long voluntary correspondence of general interest which he ever entered into *con amore*."[180] Brewster, in fact, visited Edgeworthstown in 1827 and in a letter to his wife wrote that "a more extraordinary family for talents, mutual affection, and everything that can interest, I could not have conceived."[181] In light of these family associations, it is quite possible that Michael Pakenham Edgeworth visited St. Andrews more than once during his furlough. This is made all the more likely by the fact that in 1846, before returning to India, he married the daughter of a Dr. Macpherson of King's College, Aberdeen.[182]

Two photographs in the Brewster Album provide visual evidence of Brewster's contact with another early practitioner of paper photography (see fig. 39 [.155, .156]). Depicting a country church and a house largely obscured by two great trees, they are identified by Brewster as having been taken by Nevil Story-Maskelyne. Distantly related to Talbot by marriage, Maskelyne began to practice photography in the

Figure 37. EDGEWORTH, *Beech Tree at Edgeworthstown*, 1843/44. Brewster Album (.93).

early 1840s while an undergraduate at Oxford. His daughter later recalled that it was during an Oxford vacation that he "learned to make, with a cigar-box for a camera, and sensitized paper for negatives, those beautifully designed photographs which still survive, in perfect condition, at Basset Down." She went on to say that it was at Basset Down, the family home in Wiltshire, that Maskelyne "worked out for the first time how to make achromatic photographs, in which the yellows and greens of nature would not be unduly darkened in tone" and added that from there "he would ride over to Lacock Abbey, twenty miles away, to compare notes with the veteran pioneer in photography, Henry Fox Talbot."[183] That Maskelyne was much concerned with developing the sensitivity of his negatives to green light is evident from his photograph of Basset Down in the Brewster Album. Taken in 1846, it was intended to demonstrate the greater sensitivity to green light of bromide of silver as opposed to iodide.[184]

Maskelyne was introduced by Talbot to Sir David Brewster in London in the spring of 1847.[185] The next day Maskelyne showed his photographs to Brewster, who was "charmed with them," and to Talbot, who described one landscape view as "a Gainsborough in beauty." According to Maskelyne, both "[said] they never saw such Photo-

71

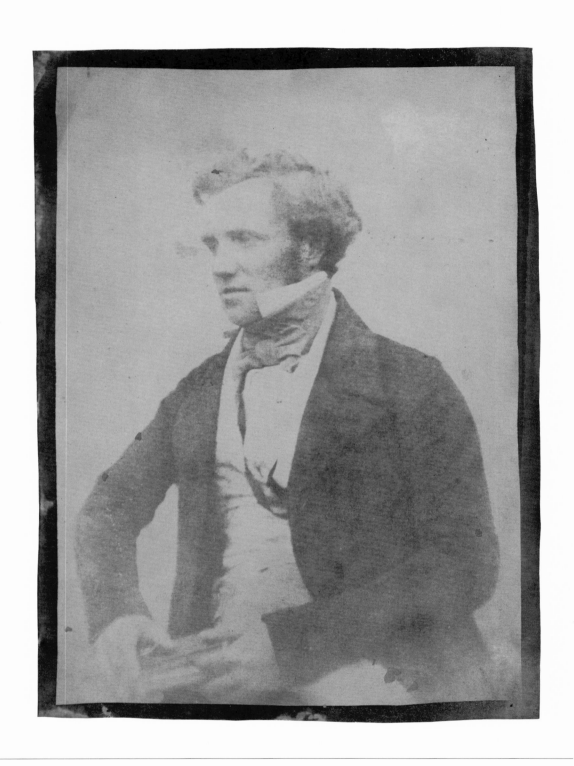

Figure 38. J. ADAMSON, *Michael Pakenham Edgeworth*, 1843/45. Brewster Album (.25).

Figure 39. NEVIL STORY-MASKELYNE, *Basset Down House*, 1846. Brewster Album (.156).

graphs in their lives." Maskelyne gave Talbot the photograph he admired and sent him the negative the following day. Perhaps he gave Sir David the two photographs in the Brewster Album at the same time. Certainly, Brewster "did more than admire." He gave Maskelyne a calotype portrait of himself and offered to support him in the competition for the chair of natural philosophy at St. Andrews, should he wish to be considered for the position.[186]

The Brewster Album contains four photographs connected with Henry Collen, to whom Talbot sold a license to calotype professionally in London in August 1841 (.19, .43, .130, .141).[187] In a letter written to Talbot in March 1842, Brewster reports that Collen had sent him a calotype "which has astonished me and all who have seen it."[188] He mentions Collen again in a letter dated October 29, 1842: "I cannot understand Mr Collen's Process. His faces are beautiful, & his drapery the worst possible. Why are his drawings like Chinese Ink ones? He must like his positives with diff[eren]ᵗ nitrites[?] from those we use."[189] As we have seen, Brewster exhibited a "series of calotype portraits

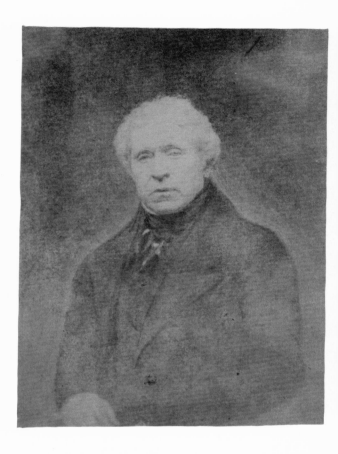

Figure 40. HENRY COLLEN, *Bust-Length Portrait of a Man, Possibly Sir David Brewster*, circa 1843. Brewster Album (.43).

Figure 41. SIR DAVID BREWSTER COPIED FROM COLLEN, *Sir David Brewster*, 1843/44; 1845. Brewster Album (.141).

. . . executed by Mr. Henry Collen London" at the meeting of the St. Andrews Literary and Philosophical Society for May 1843.[190] A miniaturist and a member of the Royal Academy, Collen retouched, over-painted, and sometimes varnished his portraits, transforming them into rich, painterly miniatures. Brewster recognized and described these characteristics in his article in the *Edinburgh Review* for January 1843:

> Mr Henry Collen, a distinguished miniature-painter, has quitted his own beautiful art, and devoted his whole time to the calotype process. The portraits which he has produced, one of which is now before us, are infinitely superior to the finest miniatures that have ever been painted. Devoting his chief attention to the correct and agreeable delineation of the face by the

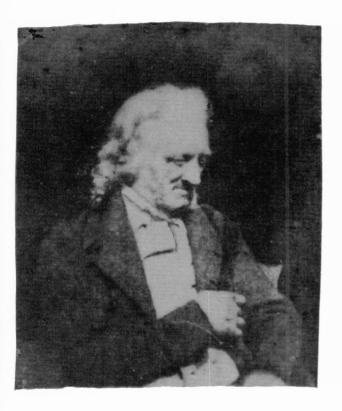

Figure 42. Sir D. Brewster copied from Collen, *John Henning*, circa 1845. Brewster Album (.19).

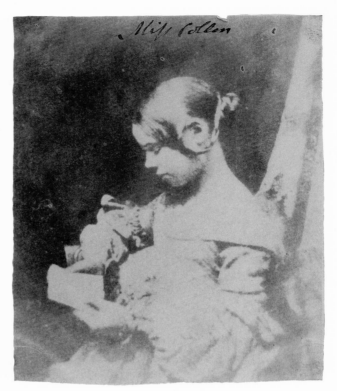

Figure 43. Sir D. Brewster copied from Collen, *Miss Collen*, circa 1845. Brewster Album (.130).

action of light alone, he corrects any imperfection in the drapery, or supplies any defects in the figure, by his professional skill; so that his works have an entirely different aspect from those of the amateur, who must generally speaking, be content with the result that the process gives him.[191]

On the rare occasions that Collen's photographs are well preserved, the effect can be remarkably beautiful. This is the case, for example, with a portrait of an unidentified man in the Brewster Album (fig. 40 [.43]). Of course, Collen's approach was essentially opposed to Talbot's severe but elegant scientific aesthetic, according to which the subject was portrayed "by the agency of Light alone, without any aid whatever from the artist's pencil."[192]

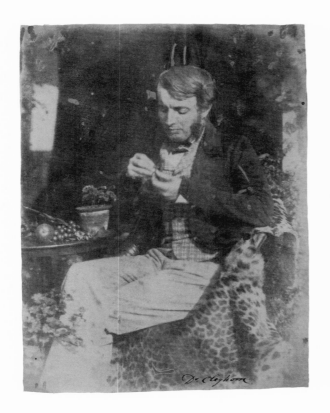

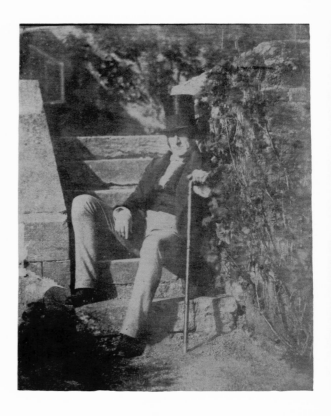

Figure 44. UNIDENTIFIED PHOTOGRAPHER, *Dr. Cleghorn*, circa 1850. Brewster Album (.7).

Figure 45. UNIDENTIFIED PHOTOGRAPHER, *Mr. Evelyn Denison*, circa 1850. Brewster Album (.139).

Collen's name appears in a letter from Brewster to Talbot dated February 25, 1845: "D[r] Methven and I have been occupied today in taking a negative from a Positive Calotype of me by Collen which is mounted and waxed[?]. We have taken it both by the positive and the negative Process, and think the positive the best. Which do you consider the best way, which is the best form of process?" Apparently, Talbot did not respond immediately, since Brewster returned to the topic in a letter dated March 4, 1845.[193] Three of the photographs in the Brewster Album can be connected with these experiments. One, a portrait of Brewster annotated *DB. Copied from a Phot. of Mr Collen / London* (fig. 41 [.141]), may be the one referred to in the correspondence.[194] The second

Plate 9. SIR JOHN HERSCHEL, *Engraved Portrait of a Young Woman*, 1842. Brewster Album (.84).

Cyanotype
By Sir John Herschel

is a portrait of the sculptor John Henning, who was renowned for his copies of the Elgin Marbles (fig. 42 [.19]).[195] The inscription *DB. Copied from Collens Phot* appears below this print. The third photograph, a charming portrait of a young girl (fig. 43 [.130]), is annotated *copied from Collen Phot*.[196] The portrait of Brewster shows signs of retouching and strengthening, but because the original was relatively fresh, these are less apparent than in most of Collen's surviving photographs. The portraits of Henning and the young girl are stronger still and presumably give a good sense of the original appearance of his photographs.

Among the fine unattributed portraits, group portraits, and architectural views in the Brewster Album are two splendid likenesses identified as Dr. Cleghorn (fig. 44 [.7]) and Mr. Evelyn Denison M.P. (fig. 45 [.139]), respectively. The son of Peter Cleghorn, Esq., of Stravithy, near St. Andrews, Hugh Francis Clarke Cleghorn was born in India in 1822.[197] As a young man he studied classics at St. Andrews and then took a degree in medicine at Edinburgh University. In Edinburgh he was one of the early members of the Botanical Society. Cleghorn returned to India in 1842 as an assistant surgeon in the East India Company.[198] Subsequently, he became professor of botany at Madras Medical College and conservator of forests in the Madras Presidency. He published several articles in botanical periodicals on the plants of India and sent home many specimens to the museum of the Botanical Gardens in Edinburgh. These interests are clearly brought out in the portrait, which must have been taken during a furlough in Scotland about 1850. The leopard skin draped over his chair is an exotic detail consistent with his career in India.

John Evelyn Denison, later Viscount Ossington, had a long and distinguished life in politics. He first entered Parliament in 1823 and, with only brief interruptions, continued to sit in the House of Commons until he took his seat in the House of Lords in February 1872. He was speaker in the House of Commons from April 30, 1857, until February 13, 1872.[199] Like Brewster, who was appointed principal of the United Colleges by the Melbourne government, Denison was a Whig. In this case politics rather than photography or science may have been the link between the two men and may provide the explanation for the presence of Denison's portrait in the Brewster Album. It appears to date from about 1850 and certainly was taken before Denison's election as speaker.[200]

An especially fine unattributed group portrait in the album represents Sir

Plate 10. UNIDENTIFIED PHOTOGRAPHER, *Mrs. Adair Craigie, Mrs. James Brewster, Adair Craigie, and Sir David Brewster*, circa 1847. Brewster Album (.58).

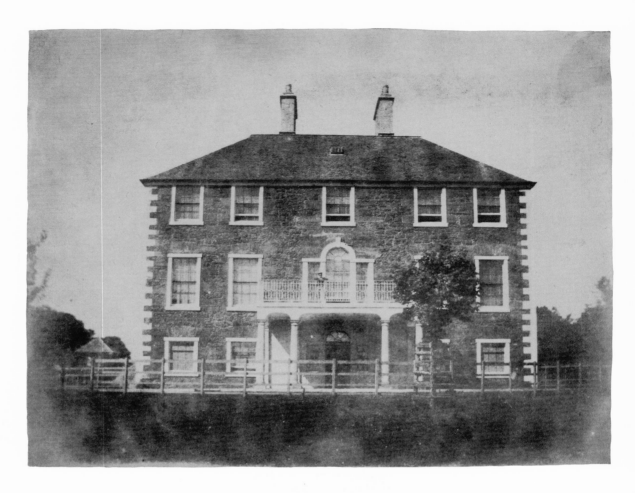

Figure 46. UNIDENTIFIED PHOTOGRAPHER, *Lathallan House*, 1845/50. Brewster Album (.33).

David Brewster, Mrs. James Brewster (wife of his eldest son), and Mr. and Mrs. Adair Craigie in what appears to be the garden of St. Leonards (pl. 10 [.58]).[201] Appointed to the Bengal Civil Service in 1829, John Adair Craigie is recorded as joint magistrate and collector at Bolundshuler or Boolundshahir in the *East-India Register and Army List* for 1849.[202] Evidently, the photograph was taken when Adair Craigie was on leave in Scotland. In fact, he is listed as having been on furlough from Bengal in 1847,[203] so the photograph probably was taken in 1846 or 1847. Similarly, Mrs. Brewster's presence in the group establishes that the photograph cannot have been made earlier than the spring or summer of 1845, after her marriage in February 1845.[204] As a member of the Bengal Civil Service, receiving his first appointment in 1831, James Brewster almost certainly provided the link between Mr. and Mrs. Craigie and Sir David. He is listed in

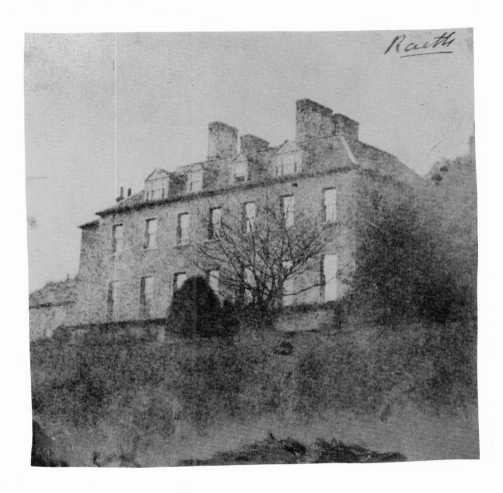

Figure 47. SIR D. BREWSTER, *Raith House*, circa 1843. Brewster Album (.116).

the *East-India Register* for 1849 as magistrate and deputy collector at Paneeput, North Division.[205] It therefore is likely that he and Adair Craigie knew each other in India and is also understandable that they would have visited each other while on furlough.[206]

Among the unattributed architectural views in the Brewster Album is a large photograph of a handsome three-story stone building with a Doric entrance porch and a Serlian window overlooking a balcony on the second story (fig. 46 [.33]). A solitary figure on the balcony appears to be wearing a military cap. A note below the photograph gives the name Lathallan, identifying the building as the home of the Lumsdaine family in the East Neuk of Fife.[207] A smaller, evidently earlier architectural photograph shows the south facade of Raith House, Fife (fig. 47 [.116]).[208] Interestingly, this view is attributed to Brewster himself by the annotation *DB. Phot.* The size and character of the

image suggest a date circa 1843. This photograph may have been taken at a calotyping house party of the kind Robert Graham describes as taking place at the earl of Kinnaird's Rossie Priory in his well-known article on the early history of photography, published in 1874.[209] Graham gives a lively description of Sir David's energy and enthusiasm at those early photography workshops, writing: "Sir David was our teacher . . . and a most patient and painstaking teacher he was, showing us how the different parts of the manipulation were to be performed, and taking his full share of all the dirty and disagreeable work." The experimental and improvisational character of these early photographic efforts and the excitement they generated are vividly evoked by Graham:

> Know, ye modern photographers, who have manipulated nothing but the clean and comfortable working collection, and who can buy almost everything requisite prepared and ready to hand, that a quarter of a century ago you could do nothing of the kind. In those days it was expedient to *divest* yourself of your coat, and *invest* yourself in a blouse or old greatcoat, to save your garments from the greenish-black stains and smudgings they were sure otherwise to receive. All available tubs, buckets, foot-pails, wash-hand basins, and every sort of vessel which would contain water, were laid hold of for the frequent washings and soakings which were required. Every room which could be darkened was needed for the drying in the dark. The region of every domestic in a household was invaded, and servants were kept running perpetually with pails of hot and cold water, warm smoothing-irons &c. The whole establishment was turned topsy-turvy while its superiors were bent on photographic studies.[210]

Even allowing for an element of fantasy and theater,[211] these passages nicely suggest the catalytic nature of Sir David's role in the promotion and establishment of negative–positive paper photography in and around St. Andrews and further afield in the 1840s.

Epilogue

The Brewster Album is one of a small group of albums of photographs that commemorate and document the experimental years of negative–positive paper photography in Great Britain. Another is the Tartan Album, the small presentation volume containing eighteen photographs that John Adamson sent to Talbot in November 1842 "in testimony of the great pleasure" he and his brother had "derived" from Talbot's discovery.[212] Comparable in size to the Brewster volume are the Adamson Album and Adamson Scrapbook.[213] Compiled and annotated by John Adamson, the former contains some three hundred pages of photographs by Talbot, John and Robert Adamson, Hill and Adamson, Thomas Rodger, and others. It appears to have been organized much more carefully than the Brewster Album, however, the photographs being mounted more or less chronologically. Moreover, the accompanying notes by John Adamson, especially the earlier ones, have a didactic character. This is evident, for example, in the detailed commentary accompanying the negative Adamson identified as "the first calotype portrait taken in Scotland" and in the pedagogical presentation on one page of two negatives and, on the facing page, "positive[s] from the opposite negative[s]."[214] The Adamson Scrapbook is rather different. A volume of some 170 pages, it contains more than three hundred images by John or Robert Adamson, most of which are datable to 1842 or 1843. Its focus is almost exclusively on the earliest, experimental period of photography in St. Andrews, and it lacks the formality and didactic character of the Adamson Album. Similar to the latter in its range of images, although more modest in size, is the Govan Album in St. Andrews University Library.[215] Compiled and annotated by Alexander Govan, a druggist in St. Andrews and himself a member of the early circle of photographers there, it contains almost three hundred photographs taken in and around the town by the Adamsons, Playfair, Rodger, and others.[216]

The Brewster Album is distinguished from each of these albums in certain significant respects. Clearly, it is not a presentation album of the type the Adamsons sent to Talbot. Rather, it is a scrapbook containing a miscellany of images by an assortment of early photographers. In this it more closely resembles the Adamson Album and Scrapbook and the Govan Album, though it is differentiated from those by being less exclusively Scottish. The Brewster Album contains more than sixty photographs by Talbot and a significant number of images taken by other early photographers in England and Ireland, whereas the Adamson Album contains only two pages with a total of eight photographs identified as by Talbot.[217] With a few exceptions, photographs appear to have been mounted in the Brewster Album in an essentially random fashion. Similarly,

Brewster's inscriptions generally give only the subject of the photograph and the identity of the photographer and do not comment on the significance of the images in the history of the medium.

The most important feature distinguishing the Brewster Album from the other albums related to it is the way in which it casually interweaves several chapters in the early history of negative–positive paper photography in Britain. On the one hand, the photogenic drawings and calotypes by Talbot provide a visual accompaniment to the history of his invention and development of the "new art" between 1839 and 1843 or 1844. On the other, they document the narrative history of Talbot's transmission of his discoveries to Brewster in St. Andrews. Similarly, the photographs by the Adamsons and those by Major Playfair and Captain Brewster form a visual complement to the history of the earliest experimental period of paper photography in Scotland. Other, smaller groups of photographs illustrate what might be termed mini-chapters in the early history of experimental photography. Among those are the series of photographs taken in Ireland by Henry Craigie Brewster and Michael Pakenham Edgeworth and the pair of photographs taken in Wiltshire by Nevil Story-Maskelyne. In addition, a significant number of photographs in the Brewster Album demonstrate John Adamson's lively continuation of the early history of photography in St. Andrews after his brother moved to Edinburgh in May 1843 "to practise the art professionally in [the] northern metropolis,"[218] thus ushering in a new era.

Finally, the photographs collected in the Brewster Album provide an unusual and perhaps surprising record of the overlapping interests and activities of several intellectual and social groups in Victorian Britain. Although Talbot, Brewster, Playfair, Maskelyne, Edgeworth, and the Adamsons all belonged to the educated classes, they occupied very different social strata. Clearly, their shared interest in the sciences and their particular engagement in the new art of photography produced a certain unity, spirit of exchange, and semblance of classlessness. If the emergence of an organized study of the sciences is one strand connecting the individuals who contributed to the album, another is provided by the East India Company, which was frequently the element through which individual connections were made. In sum, the Brewster Album accurately reflects the activities and interactions of certain emergent and established classes in Victorian society while also providing a visual history of the first years of negative–positive paper photography in Britain.

NOTES

1. For an introduction to the Scottish Enlightenment, see D. Daiches, P. Jones, and J. Jones, eds., *A Hotbed of Genius: The Scottish Enlightenment, 1730–90* (Edinburgh, 1986).

2. On the Disruption, see T. Brown, *Annals of the Disruption* (Edinburgh, 1893).

3. These topics are treated in separate studies in Alison D. Morrison-Low and J. R. R. Christie, eds., *"Martyr of Science": Sir David Brewster 1781–1868* (Edinburgh, 1984).

4. On Brewster's diverse spheres of activity, see ibid.

5. [Margaret Maria] Gordon, *The Home Life of Sir David Brewster*, 2nd edn. (Edinburgh, 1870), pp. 171–172.

6. See G. Smith, "Magnesium Light Portraits," *History of Photography* 12 (1988), pp. 88–89. Brewster was president of the Photographic Society of Scotland when the portrait was taken.

7. 76/154, pp. 309–344.

8. See, for example, Sara Stevenson, *David Octavius Hill and Robert Adamson: Catalogue of Their Calotypes Taken between 1843 and 1847 in the Collection of the Scottish National Portrait Gallery* (Edinburgh, 1981), pp. 5–32. For an examination of the motives underlying the partnership, see R. L. Harley, "The Partnership Motive of D. O. Hill and Robert Adamson," *History of Photography* 10 (1986), pp. 303–312.

9. Gordon (note 5), p. 168.

10. In 1984 the album was acquired by the Getty Museum from Bruno Bischofberger, Zurich. When or how it left the Brewster family is not known. Indeed, it is surprising that the album has survived, since most of Brewster's books, papers, and scientific instruments were destroyed in 1903 in a disastrous fire at Belleville or Balavil, the family estate by Kingussie (see Morrison-Low, "Brewster and Scientific Instruments," in Morrison-Low and Christie [note 3], p. 59). The album is mentioned briefly among acquisitions made by the Department of Photographs in 1984 (*J. Paul Getty Museum Journal* 13 [1985], p. 228, nos. 2, 4) and again in the *Handbook of the Collections* ([Malibu, 1986; 1988], pp. 198–199). It was recently discussed more extensively by Alison D. Morrison-Low in "Sir David Brewster and Photography," *Review of Scottish Culture* 4 (1988), pp. 63–73.

11. In the photogenic drawing process both the negative and positive images were fully printed out by the action of the sun on light-sensitive paper. In the calotype process an invisible or latent image was chemically developed after exposing light-sensitive paper to sunlight for a relatively brief period. Talbot discovered the invisible or latent image and the possibility of developing it chemically in September 1840 and patented the process in February 1841, giving it the name *calotype*. Talbot's discovery of the calotype process is discussed in more detail on pp. 24–26 below.

12. London, Science Museum Library, Brewster to Talbot, October 22, 1842.

13. This is the case, for example, with the inscription below a portrait of John Evelyn Denison (.139). The second line—*now Speaker of the H. of Commons*—evidently was added after Denison's election as speaker on April 30, 1857.

14. More than forty letters from Brewster to Talbot are preserved in the Science Museum Library, London. Others are still at Lacock Abbey. Unfortunately, Talbot's letters to Brewster no longer survive, presumably having been destroyed in the 1903 fire at the

Brewster estate (see Morrison-Low, "Scientific Apparatus Associated with Sir David Brewster," in Morrison-Low and Christie [note 3], p. 99, no. 30).

15. John Ward has traced what he calls "the English preoccupation with light" to the publication of Sir Isaac Newton's *Opticks* in 1704 (John Ward and Sara Stevenson, *Printed Light: The Scientific Art of William Henry Fox Talbot and David Octavius Hill with Robert Adamson* [Edinburgh, 1986], p. 22).

16. Ibid.

17. On the relationship between Herschel and Talbot, see Larry Schaaf, "Herschel, Talbot and Photography: Spring 1831 and Spring 1839," *History of Photography* 4 (1980), pp. 181–204.

18. Quoted from Larry Schaaf, *Sir John Herschel and the Invention of Photography* (n.p., 1981), unpaginated.

19. Part 1 of *The Pencil of Nature*, which contains Talbot's "account of [his] first discovery of the Art," was published in June 1844. A reprint of *The Pencil of Nature*, edited and with an introduction by Beaumont Newhall, was published by Da Capo Press, New York, in 1969. A facsimile edition with scholarly apparatus was published in January 1989 to celebrate the sesquicentennial of photography; see Larry Schaaf with Hans P. Kraus, Jr., *H. Fox Talbot's* The Pencil of Nature, *Anniversary Facsimile* (New York).

20. In the nineteenth century the camera lucida and camera obscura both were used by artists to assist them in drawing. Essentially, the camera lucida is a prism that can direct a reflected image onto a sheet of paper. In theory, the artist can then copy the reflected image. The portable camera obscura is a closed box with a lens at one end that can project an image onto a glass screen set into the top surface of the box. Using tracing paper, the artist supposedly can copy the reflected image from the glass screen. In practice, both instruments are extremely difficult to use effectively.

21. H. J. P. Arnold, *William Henry Fox Talbot: Pioneer of Photography and Man of Science* (London, 1977), p. 97. The following day François Arago made a formal announcement to the Académie des Sciences. The first scientific notice of Daguerre's discovery was Arago's "Fixation des images qui se forment au foyer d'une chambre obscure," published in *Comptes rendus* (Schaaf [note 17], p. 204, n. 17).

22. Quoted from Ward and Stevenson (note 15), p. 12.

23. Quoted from Schaaf (note 17), p. 185. My account of Talbot's relations with Herschel is drawn from this article.

24. St. Andrews University Library, Phillips to Forbes, March 1, 1839.

25. Ward and Stevenson (note 15), p. 15.

26. 84.XM.260.5. What appears to be the negative for this view is also in the Getty Museum (84.XM.1002.33).

27. See Hans P. Kraus, Jr., with Larry Schaaf, *Sun Pictures: Catalogue One* ([New York], n.d.), no. 1.

28. Quoted from Arnold (note 21), p. 134.

29. Quoted from Gail Buckland, *Fox Talbot and the Invention of Photography* (Boston, 1980), p. 54.

30. Pl. 20.

31. The nature and date of these images are established by an inscription in Talbot's hand on the verso of a positive example in the Brewster Album (.2): *from old painted glass. / H. F. Talbot photogr. / May 1839.*

32. Malibu, The J. Paul Getty Museum, Lady Elisabeth Fox-Strangways [Lady Elisabeth Feilding] to Lady Dunraven, June 22, 1845.

33. On Talbot's purchases of cameras, see Arnold (note 21), pp. 123–124.

34. Quoted from Arnold (note 21), p. 126.

35. The notebook is preserved in the Lacock Abbey Collection.

36. The *Patroclus* appears on January 13 and 14, February 27 and 29, April 9, 19, and 28, and August 9, while the *Sabines* is listed

twice on April 30, once on May 1, and once on August 9.

37. Quoted from Arnold (note 21), p. 126.

38. 84.XM.150.11, .24, .30, .35, .47.

39. 84.XM.1002.31.

40. 84.XM.478.15.

41. Quoted from Buckland (note 29), p. 61.

42. *C's portrait, 5* [minutes] *without sun,* October 8; *C standing in garden 3* [minutes], October 9; *C's portrait,* October 9; *C's portrait, 30* [seconds] *blue glass,* October 10; *C*[onstance] *E*[la] *& R*[osamund] *1* [minute] *30* [seconds], October 13.

43. The waxed negative from which this image was printed is reproduced in H. P. Kraus, Jr., with Larry Schaaf, *Sun Pictures: Catalogue Three* (New York, 1987), p. 20, · fig. 17.

44. André Jammes, *William H. Fox Talbot: Inventor of the Negative–Positive Process* (New York, 1973), p. 11.

45. The pages from Talbot's notebook for September 23 and 24, 1840, recording the experiments that led to the calotype process are reproduced and transcribed in a supplement to the Royal Photographic Society Historical Group's *Newsletter* (July 1977). The notebook is preserved in the Science Museum, London.

46. Quoted from Jammes (note 44), pp. 10–11.

47. Quoted from Arnold (note 21), p. 132.

48. For an invaluable account of the first years of photography in Scotland, see Alison D. Morrison-Low, "Dr. John and Robert Adamson: An Early Partnership in Scottish Photography," *Photographic Collector* 4 (1983), pp. 199–214.

49. See Brewster's letters to his wife, written from Lacock Abbey, in Gordon (note 5), pp. 164–165. Brewster refers to the "ruins grey" of Lacock Abbey in a letter accepting an invitation to revisit Talbot (London, Science Museum Library, Brewster to Talbot, August 28, 1836).

50. London, Science Museum Library, Brewster to Talbot, February 12, 1839. The Lord Gray mentioned in the letter presumably was Francis, fourteenth Lord Gray, who died in August 1842 (see Sir J. B. Paul, *The Scots Peerage,* vol. 4 [Edinburgh, 1907], p. 294). Several of Brewster's contemporaries shared his enthusiasm for Talbot's photographs of fragments of lace. In April 1839 Queen Victoria praised the "exactness of similitude" of a photogenic drawing of a gauze ribbon, describing it as "very curious," and proclaimed herself ready to try to do some herself (quoted from Ward and Stevenson [note 15], p. 77).

51. The figures in parentheses at this and subsequent points in the text refer to the number identifying the photograph in the checklist of images at the end of this book (see pp. 97–161 below). Item .54 is similar but not identical to figure 3 above, dated 1839 by Talbot himself.

52. London, Science Museum Library, Brewster to Talbot, March 14, 1839. James David Forbes was professor of natural philosophy at Edinburgh University and a friend and sometime rival of Brewster, with whom he had competed for the Edinburgh chair. Brief biographies of Forbes are included in L. Stephen, ed., *The Dictionary of National Biography,* vol. 19 (London, 1889), pp. 398–400; C. C. Gillispie, ed., *Dictionary of Scientific Biography,* vol. 5 (New York, 1972), pp. 68–69. The fundamental study remains J. C. Shairp, P. G. Tait, and A. Adams-Reilly, *Life and Letters of James David Forbes, F.R.S.* (London, 1873). Forbes's correspondence and papers in St. Andrews University Library are catalogued in *An Index to the Correspondence and Papers of James David Forbes (1809–1868)* (St. Andrews, 1968). On Forbes, Talbot, and photography, see Graham Smith, "James David Forbes and the Early History of Photography," in *Shadow and Substance: Essays in the History of Photography* (Bloomfield Hills, 1990).

53. Brewster presumably is alluding here to the character of the photogenic drawing negatives.

54. St. Andrews, University Library, Brewster to Forbes, February 23, 1839. Kinfauns Castle at Scone, near Perth, was the seat of Lord Gray.

55. St. Andrews, University Library, MS Minutes of the St. Andrews Literary and Philosophical Society, March 4, 1839.

56. St. Andrews, University Library, MS Minutes of the Literary and Philosophical Society, April 16, 1838.

57. Ibid., November 5, 1838.

58. Reproduced in Morrison-Low (note 48), fig. 5, d.

59. On Davidson, see ibid., pp. 203–204.

60. Arnold (note 21), pp. 137–138. In the summer of 1844 Claudet and Talbot made a formal agreement whereby Claudet was to take calotype portraits at his London studio (ibid., pp. 141–142).

61. Two smaller portraits of Playfair are also preserved in the Brewster Album (.10, .42).

62. On Playfair, see M. F. Conolly, *Biographical Dictionary of Eminent Men of Fife* (Cupar and Edinburgh, 1866), pp. 363–365; H. Playfair, *The Playfair Family* (n.p., 1984), pp. 57–58; *Hugh Lyon Playfair (1786–1861): Provost of St. Andrews (1842–1861)* (Leslie, Fife, 1986).

63. Quoted from Conolly (note 62), p. 365.

64. Ibid., p. 364.

65. Gordon (note 5), p. 168.

66. See R. Anderson, "Brewster and the Reform of the Scottish Universities," in Morrison-Low and Christie (note 3), pp. 31–34.

67. *Circuit Journeys*, reprint edn. (Edinburgh, 1975), p. 234.

68. See Graham Smith, "Hill and Adamson at St. Andrews: The Fishergate Calotypes," *Print Collector's Newsletter* 12 (1981), pp. 34–36.

69. Quoted from Conolly (note 62), p. 365.

70. See "Sir Hugh Lyon Playfair's Garden," in *Fletcher's Guide to St. Andrews* (St. Andrews, [1859]), pp. 44–46.

71. On Burnside, see Graham Smith, "Hill and Adamson: St. Andrews, Burnside, and the Rock and Spindle," *Print Collector's Newsletter* 10 (1979), pp. 45–48.

72. See, for example, the four views in the Royal Scottish Museum, Edinburgh, gathered in 1942.1.2, p. 125 (reproduced in ibid., fig. 3).

73. On John Adamson, see Morrison-Low (note 48), p. 201.

74. *St. Andrews Gazette*, August 27, 1870. The letter is signed *P*.

75. London, Science Museum Library, Brewster to Talbot, August 15, 1842. For a judicious discussion of Robert Adamson's personality and his relationship to David Octavius Hill, see Stevenson (note 8), pp. 16–20.

76. London, Science Museum Library, Brewster to Talbot, August 15, 1842.

77. This photograph, preserved in the Graphic Arts Collection, Princeton University Library, is identified as a self-portrait by the annotations *Capt. Brewster 76th* and *Capt. Brewster Phot.*, which appear on the verso (see Graham Smith, "A Group of Early Scottish Calotypes," *Princeton University Library Chronicle* 46 [1984], pp. 81–82, fig. 2). There is a very faint example of this portrait in the Brewster Album (.148). Captain Brewster also appears in a group portrait in the album depicting Sir David and four women (.189).

78. St. Andrews, University Library, MS Minutes of the Literary and Philosophical Society, November 2, 1840.

79. London, Science Museum Library, Brewster to Talbot, July 22, 1842.

80. See above (note 7), pp. 327–328. Brewster mentioned that he had before him "a collection of admirable photographs executed at St. Andrew's [*sic*], by Dr. and Mr.

Robert Adamson, Major Playfair, and Captain Brewster." He continued, "Several of these have all the force and beauty of the sketches of Rembrandt, and some of them have been pronounced by Mr. Talbot himself to be among the best he has seen." With the exception of Sir David himself, this notice names Talbot's principal disciples in St. Andrews.

81. Two such drawings are preserved in the Brewster Album (.161A, .187B).

82. *The Official Army List for the Quarter Ending 31st December, 1899* (London, 1900), p. 1636.

83. St. Andrews, University Library, MS Minutes of the Literary and Philosophical Society, July 1, 1839.

84. Ibid., July 6, 1840.

85. Ibid., November 2, 1840.

86. The size and composition of the image may suggest that it is closer in date to the view of the *Patroclus* published in part 1 of *The Pencil of Nature* (as plate 5) and dated August 9, 1842, in the negative.

87. A very similar view in an album from Lacock Abbey (now in the Science Museum, London) is dated October 16, 1840, by Talbot (1937-366 [2]).

88. St. Andrews, University Library, MS Minutes of the Literary and Philosophical Society, March 1, 1841.

89. Ibid., April 5, 1841.

90. Ibid., May 3, 1841.

91. Ibid., July 5, 1841.

92. Ibid., October 4, 1841.

93. Ibid., November 1, 1841.

94. London, Science Museum Library, Brewster to Talbot, November 15, 1841.

95. St. Andrews, University Library, MS Minutes of the Literary and Philosophical Society, January 3, 1842.

96. Ibid., February 7, 1842.

97. Ibid., November 7, 1842.

98. Ibid., April 3, 1843.

99. I am indebted to Robert N. Smart, Keeper of Manuscripts and University Muniments, University Library, St. Andrews, for this information. On Furlong, see also Graham Smith, "W. Holland Furlong, St. Andrews, and the Origins of Photography in Scotland," *History of Photography* 13 (1989), pp. 139–143.

100. See pp. 42–45 below.

101. Smith (note 99), fig. 1.

102. 2 (1856), pp. 135–136.

103. In his letter to the *Journal of the Photographic Society*, Furlong also mentions that "an abstract of my paper, *with its date*, will be found in 'Chamber's Instruction [*sic*] for the People.'" In the article on photography in *Chamber's Information for the People*, under the heading "The Talbotype," reference is made to a "process proposed by Mr. William Furlong," but the date given is 1844 (vol. 2 [Philadelphia, 1857], p. 735). John Adamson is believed to be the author of this article.

104. 1 (1856), pp. x–xiii. I am indebted to Sara Stevenson for this reference.

105. St. Andrews, University Library, MS Minutes of the Literary and Philosophical Society, May 1, 1843.

106. Ibid., February 5, 1844. On February 15 the *Fifeshire Herald* reported that "Dr. Adamson exhibited some very beautiful calotypes, executed by his brother, Mr Robert Adamson."

107. St. Andrews, University Library, MS Minutes of the Literary and Philosophical Society, April 1845. Presumably, views in the Brewster Album of Rouen, Paris, Fontainebleau, Chambord, and Orléans (.34, .119, .171, .172, .178, .180, .185, .188), taken by Talbot in May and June 1843, were among the calotypes inspected by the members of the Literary and Philosophical Society at their meeting in April 1845.

108. London, Science Museum Library, Brewster to Talbot, January 20, 1840.

109. Ibid., Brewster to Talbot, October 18, 1840.

110. Ibid., Brewster to Talbot, May 5,

1841; May 15, 1841.

111. Ibid., Brewster to Talbot, July 26, 1841.

112. Ibid., Brewster to Talbot, July 27, 1841.

113. Ibid., Brewster to Talbot, October 14, 1841.

114. Ibid., Brewster to Talbot, October 27, 1841. Morrison-Low (note 48), p. 206, proposes that the chemistry assistant was Thomas Rodger, who established a photographic studio in St. Andrews in 1849 on John Adamson's recommendation. In a recent article she correctly identifies him as Furlong, however ("Sir David Brewster and Photography" [note 10], pp. 70–71). In fact, Brewster clearly identified Connell's assistant as Furlong, writing that "Mr. Furlong the gentleman [to whom] I allude executed an admirable portrait of a relative in Ireland which I have seen."

115. London, Science Museum Library, Brewster to Talbot, November 7, 1841.

116. Lacock, Fox Talbot Museum, MS LA 42-11, Furlong to Talbot, March 1842. Sara Stevenson kindly brought this letter to my attention. The letter is partially quoted in Ward and Stevenson (note 15), p. 19.

117. London, Science Museum Library, Brewster to Talbot, March 29, 1842.

118. Ibid., November 10, 1841.

119. Lacock, Fox Talbot Museum, MS LA 36–58, Constance Talbot to Lady Elisabeth Feilding, "Monday." Joanna Lindgren Harley, "Talbot's Plan for a Photographic Expedition to Kenilworth," *History of Photography* 12 (1988), pp. 223–225, established that this letter must be dated in July 1842 rather than August 1836, as was generally believed. Also see London, Science Museum Library, Brewster to Talbot, July 22, 1842.

120. London, Science Museum Library, Brewster to Talbot, August 20, 1842.

121. Ibid., MS Memorandum by Playfair, August 15, 1842.

122. Ibid., MS note, Playfair to Brewster, n.d. Brewster evidently forwarded this note to Talbot along with Playfair's memorandum on the calotype in St. Andrews.

123. Perhaps this photograph should be identified with the self-portrait of Henry Craigie Brewster reproduced above (fig. 11). See London, Science Museum Library, Brewster to Talbot, October 22, 1842.

124. London, Science Museum Library, Brewster to Talbot, November 2, 1842.

125. Lacock, Fox Talbot Museum, MS LA 42–77, John Adamson to Talbot, November 9, 1842.

126. Reproduced in Ralph L. Harley, Jr., and Joanne Lindgren Harley, "The 'Tartan Album' by John and Robert Adamson," *History of Photography* 12 (1988), pl. 1. The portrait of Brewster and five other photographs from the Tartan Album were reproduced for the first time in A. Scharf, *Pioneers of Photography* (New York, 1976), pp. 54–55.

127. See above (note 7), p. 327.

128. Lacock, Fox Talbot Museum, MS LA 43–55, Brewster to Talbot, May 9, 1843.

129. London, Science Museum Library, Brewster to Talbot, July 3, 1843 (see Ward and Stevenson [note 15], pp. 30–31).

130. London, Science Museum Library, Brewster to Talbot, October 23, 1840.

131. Useful introductions to St. Andrews are provided by D. Hay Fleming, *Guide to St. Andrews* (St. Andrews, 1977); *St. Andrews: The Handbook of the St. Andrews Preservation Trust to the City and Its Buildings* (St. Andrews, 1975). See also *Inventories and Reports of the Royal Commission on Ancient and Historical Monuments, Scotland: Fife, Kinross, and Clackmannan* (Edinburgh, 1933) and the individual guidebooks for the cathedral and the castle published by Her Majesty's Stationery Office. On the University of St. Andrews, see R. G. Cant, *The University of St. Andrews: A Short History* (Edinburgh and London, 1970).

132. St. Andrews, University Library, MS Minutes of the Literary and Philosophical Society, December 27, 1839. The minutes

record the text of a petition forwarded to the Commissioners of Her Majesty's Woods and Forests.

133. See above (note 67), p. 228.

134. Ibid., pp. 230–231. Cockburn compares St. Andrews and Pompeii again in a description of Stirling written on September 7, 1845 (ibid., pp. 270–271): "Except St. Andrews, I can't recollect any other place of such exclusive historical interest. They have both been Pompeiied, saved by circumstances from being superseded or dissipated by modern change."

135. Quoted from Conolly (note 62), p. 365.

136. Ibid.

137. Another example of this view is preserved in the Adamson Album (Edinburgh, National Museums of Scotland 1942.1.2, p. 87.2). A similar but not identical image, by Robert Adamson, was included in the album sent to Talbot in November 1842 (Harley and Harley [note 126], pl. 8).

138. This statement, made by the painter David Wilkie in 1818, expresses nicely the Romantic view of the relationship between history and topography (quoted from H. Miles, "Wilkie and the Murder of Archbishop Sharp," *Record of the Art Museum, Princeton University* 40 [1981], p. 4).

139. Hay Fleming (note 131), p. 51.

140. The negative for .85 is preserved in the Graphic Arts Collection, Princeton University Library (reproduced in Smith [note 77], fig. 4). Five larger views of St. Andrews (.97, .115, .118, .133, .144) are identical to, or close variants of, images included in Hill and Adamson's *Series of Calotype Views of St. Andrews*, published in 1846 (reprod. in Graham Smith, "'Calotype Views of St. Andrews' by David Octavius Hill and Robert Adamson," *History of Photography* 7 [1983], figs. 6, 12, 14, 25).

141. Hay Fleming (note 131), p. 54.

142. A similar but nearer view of the old Town Hall, in the Govan Album in St.

Andrews University Library, is attributed to John Adamson by Andrew Govan (Album 6, p. 46). A small early view, datable to 1842/43, is preserved in the Adamson Scrapbook (Edinburgh, National Museums of Scotland 1942.1.2, p. 149).

143. 1942.1.1, p. 29.

144. See Smith (note 68), pp. 34–36. North Street is described as "the region of putridity and stagnation" by C. Rodger, in *History of St. Andrews, with a Full Account of the Recent Improvements in the City* (St. Andrews, 1849), p. 170.

145. Rodger (note 144), p. 166.

146. Similarly, Playfair's experience during his earlier career in India must have made him extremely conscious of such health hazards.

147. 1942.1.2, p. 151.

148. 1942.1.2, pp. 87.3, 99.1, 99.2, 125. The view of the Rock and Spindle is reproduced in Smith (note 140), fig. 36.

149. Talbot had to address similar problems when taking the views for *Sun Pictures in Scotland* (see Ward and Stevenson [note 15], p. 118).

150. *North Street from [St. Regulus] tower 12 o'clock* is one of the *Views of St. Andrews to be taken* listed by John Adamson inside the cover of the Adamson Scrapbook in the National Museums of Scotland (1942.1.2). So, Furlong was not the only member of the St. Andrews group to scale St. Regulus Tower with his camera. In prephotographic days Sir Walter Scott also climbed the tower (see Smith [note 140], p. 236, n. 30).

151. For illustrations of Hill and Adamson's portraits, see Stevenson (note 8), pp. 37–183. Also see C. Ford and R. Strong, *An Early Victorian Album: The Photographic Masterpieces (1843–1847) of David Octavius Hill and Robert Adamson* (New York, 1976).

152. 1942.1.2, pp. 33, 119.

153. London, Science Museum Library, Brewster to Talbot, October 29, 1842.

154. 1942.1.1, pp. 25.1, 41.3; 1942.1.2, p.

75.1. This photograph also appears in the Tartan Album at Lacock Abbey (reprod. in Harley and Harley [note 126], pl. 14).

155. See Conolly (note 62), pp. 106–107. On Baron Campbell, see also L. Stephen, ed., *The Dictionary of National Biography*, vol. 8 (London, 1886), pp. 379–386.

156. Stephen (note 155), p. 385.

157. Ibid.

158. Conolly (note 62), p. 107.

159. The quotations are drawn from a critical notice of daguerreotype portraits that appeared in *Blackwood's Magazine* in 1842 (quoted from D. B. Thomas, *The First Negatives: An Account of the Discovery and Early Use of the Negative-Positive Photographic Process* [London, 1964], p. 24).

160. See Schaaf (note 17), p. 199.

161. Conolly (note 62), p. 107.

162. I am indebted to Alison Morrison-Low for this suggestion.

163. St. Andrews, University Library, MS Minutes of the Literary and Philosophical Society, April 3, 1843.

164. *Miss Thomson and Miss M. Thomson / daughters of Dr. Thomson, St. Andrews* (reproduced in Harley and Harley (note 126), pl. 15). Another example of the image is preserved in the Adamson Scrapbook in the National Museums of Scotland (1942.1.2, p. 3). In the same album there is also a small portrait of Isabella which must have been taken about the same time (p. 27).

165. The Adamson Album contains a slightly later, large-format photograph depicting all three Thomson sisters (1942.1.1, p. 79).

166. See L. Wolk, "Calotype Portraits of Elizabeth Rigby by David Octavius Hill and Robert Adamson," *History of Photography* 7 (1983), figs. 3, 4. In accordance with the conventions of keepsake images, Isabella is shown full length, seated pensively by a table on which are placed a book and vase of flowers. She wears a silk off-the-shoulders dress that complements the fashionable whiteness of her arms and shoulders and establishes her as a society beauty, even if her society was a comparatively provincial one.

167. In another example of the portrait, in the Adamson Album (1942.1.1, p. 50), the image is cropped at the top and retouched at the right so that the ad hoc nature of the arrangement is less evident. In the Edinburgh version the sitter is identified as *Mrs. Macadam née Isabella Thompson*.

168. 1942.1.1, p. 75. Hill and Adamson's life study of Dr. George Bell probably was also intended as a model for painters (Ward and Stevenson [note 15], p. 164, fig. 184).

169. 1942.1.2, p. 169. Another example of this portrait, formerly in the Harold White collection, is inscribed by Sir David Brewster *Portrait of Dr. Adamson. Capt. Brewster Cal., Sept^r 1842* (reprod. in Hans P. Kraus, Jr., with Larry Schaaf, *Sun Pictures: Catalogue Four* [New York, 1987], p. 9, no. 3). Schaaf makes the interesting suggestion (p. 8, no. 3) that the White example may be a calotype positive, meaning that the image was partly developed out rather than being fully printed out.

170. London, Science Museum Library, Brewster to Talbot, October 22, 1842.

171. Technically, the photographs vary a great deal. Most of the images appear to have been fixed in a sodium chloride solution and are lilac in color. Some are yellowish brown or purplish brown, however, suggesting that they were fixed in potassium iodide or potassium bromide solutions.

172. I am grateful to Lieutenant Colonel (Retired) W. Robins, O.B.E., Regimental Secretary, The Duke of Wellington's Regiment, for this information, which is drawn from the *Digest of Service of Officers of the 76th*.

173. At the time of his death Martin held the rank of lieutenant colonel (Smith [note 77], p. 81, n. 2). Other examples of this portrait are in Princeton (ibid., fig. 1) and in a private collection in England.

174. A view of the houses outside Buttevant Barracks also shows the buildings under

snow (.22).

175. Developed by Herschel in 1842 and published free of patent restrictions, the cyanotype, or blueprint, process provided a simple, inexpensive, and permanent photographic process that is still in use today (see Schaaf [note 18]).

176. London, Science Museum Library, Brewster to Talbot, November 18, 1843.

177. On the Edgeworths, see L. Stephen, ed., *The Dictionary of National Biography*, vol. 6 (London, 1911), pp. 379–384. *The East-India Register and Army List for 1847* (London, 1847), p. 10, gives Edgeworth's "season of appointment" as 1830.

178. On Anna Atkins, see L. Schaaf, *Sun Gardens: Victorian Photograms by Anna Atkins* (Verona, 1985).

179. On St. Leonards, see Gordon (note 5), pp. 167–169. The house is numbered 15 and identified as "House occupied by George Buchanan" in John Wood's *Plan of the City of St. Andrews*, published in Edinburgh in 1820. Buchanan was the tutor of James VI and one of the principals in the Scottish Reformation.

180. See above (note 5), p. 111.

181. Ibid., p. 137. Brewster also referred to a visit to Edgeworthstown and Miss Edgeworth in a letter written to Talbot on January 7, 1837 (London, Science Museum Library).

182. Stephen (note 177), p. 382.

183. Quoted from M. Arnold-Forster, *Basset Down: An Old Country House* (London, n.d.), p. 60. On Maskelyne, see also D. Allison, "Nevil Story-Maskelyne: Photographer," *Photographic Collector* 2/2 (1981), pp. 16–36; Hans P. Kraus, Jr., with Larry Schaaf, *Sun Pictures: Catalogue Two* (New York, n.d.).

184. Another example of the photograph is annotated on the mount by Maskelyne *1846—Bromide of Silver (my process) / N. M.* (Kraus with Schaaf [note 183], p. 15, 1ll.).

185. See Allison (note 183), p. 19.

186. The quotations are extracted from a letter from Maskelyne informing his father of Brewster's offer of the St. Andrews chair

(ibid., pp. 19–22).

187. On Collen, see Larry Schaaf, "Henry Collen and the Treaty of Nanking," *History of Photography* 6 (1982), pp. 353–366; "Addenda to Henry Collen and the Treaty of Nanking," *History of Photography* 7 (1983), pp. 163–165. Most recently, see Kraus with Schaaf (note 169), pp. 14–15.

188. London, Science Museum Library, Brewster to Talbot, March 22, 1842.

189. Ibid., October 29, 1842.

190. St. Andrews, University Library, MS Minutes of the Literary and Philosophical Society, May 1, 1843.

191. See above (note 7), p. 327. Brewster adds the following caveat: "In making this comparison we do not intend to convey the idea, that *perfect pictures*, both landscapes and portraits, cannot be produced without additional touches from the pencil of the artist."

192. Quoted from the *Notice to the Reader* inserted by Talbot into copies of *The Pencil of Nature*.

193. London, Science Museum Library, Brewster to Talbot, February 25, 1845; March 4, 1845.

194. The original from which this photograph was copied may have been taken in July 1842, when Brewster was in England for the meeting of the British Association at Manchester. He also visited Cambridge and Lacock and may have gone to Collen's studio in London. A fainter version of the portrait is preserved in the Maitland Album in the Getty Museum (85.XZ.262.18).

195. On Henning, see D. Bruce, *Sun Pictures: The Hill-Adamson Calotypes* (London, 1973), p. 69; John Malden, *John Henning 1771–1851* (Paisley, 1977).

196. Originally, another copy of a photograph by Collen was mounted above the portrait of the girl. This is indicated by the annotation *Copied from Collen Phot Mr Collen Phot.* that appears below the missing photograph.

197. Biographical information on Cleg-

horn is drawn from Conolly (note 62), p. 123.

198. F. Clark, ed., *The East-India Register and Army List for 1847* (London, 1847), "Madras," pp. 116, 156.

199. On Denison, see L. Stephen and L. Lee, eds., *The Dictionary of National Biography*, vol. 5 (London, 1911), pp. 803–804.

200. The annotation *now Speaker of the H. of Commons* that appears below the identifying inscription *Mʳ Evelyn Denison M.P.* seems to have been added later and implies that Denison was not speaker when the portrait was taken.

201. The album contains a second group portrait (.140) and a single portrait of Adair Craigie (.65) which clearly were taken at the same time as .58.

202. (London, 1849), pp. 9, 20.

203. *East-India Register and Army List* (London, 1847), p. 10.

204. Gordon (note 5), p. 193.

205. Pp. 10, 20.

206. Gordon (note 5), p. 193, mentions that James Brewster married Catherine Heriot Maitland in February 1845 while he was "at home on furlough from his duties in the Bengal Civil Service." Brewster himself mentions his son's marriage in a letter written to Talbot on March 4, 1845 (London, Science Museum Library).

207. See W. Wood, *The East Neuk of Fife: Its History and Antiquities* (Edinburgh, 1887), pp. 147–148. I am indebted to Robert N. Smart for identifying Lathallan.

208. On Raith House, see *The New Statistical Account of Scotland* 9, *Fife–Kinross* (Edinburgh, 1845), pp. 152–154; J. Macaulay, *The Classical Country House in Scotland, 1660–1800* (London, 1987), pp. 32–35.

209. "The Early History of Photography," *Good Words for 1874*, ed. Reverend Donald Macleod (London, 1874), pp. 450–453. (Graham's article is reprinted in *History of Photography* 8 [1984], pp. 231–235, with three early photographs taken at Rossie Priory [the text on p. 232 properly should appear after that on p. 234].)

210. Ibid., p. 450. It is evident from Sir David's letters and Mrs. Gordon's biography that Brewster's most usual photographic activity was to take positives from his colleagues' negatives or to copy their photographs. It is difficult to believe that he did not occasionally take photographs of his own, however.

211. Morrison-Low (note 48), p. 202, rightly identifies chronological inaccuracies in Graham's account and cautions against an uncritical reading of it.

212. All the photographs in the Tartan Album are reproduced in Harley and Harley (note 126).

213. On the Adamson Album and Scrapbook, see Morrison-Low (note 48), p. 200; Morrison-Low in Morrison-Low and Christie (note 3), pp. 96–97.

214. 1942.1.1, pp. 16–17, 19.

215. Album 6. On this album, see Graham Smith, "The First American Calotypes?" *History of Photography* 6 (1982), pp. 349–352. St. Andrews University Library also houses a similar album compiled by William Smith, founder of Smith and Govan (Album 7).

216. Also noteworthy is the Maitland Album in the Getty Museum (85.XZ.262), which deserves a separate study. An album that can be identified as this one is described briefly by Morrison-Low in Morrison-Low and Christie (note 3), Appendix I (a), p. 97, n. 6. According to Morrison-Low, the album was "annotated, compiled and possibly photographed by Brewster." A number of photographs in the Maitland Album are duplicates of images in the Brewster and Adamson albums. It contains several photographs by Talbot and the pioneering St. Andrews group, but most of the photographs date after the first experimental period. Of special interest are a number of pictures ascribed to Sir David Brewster or Brewster with Thomas Rodger. Particularly impressive

are two series of large views ascribed to Captain Henry King and Sir James Dunlop, respectively. The album also contains many nonphotographic items.

217. 1942.1.1, pp. 20, 21. The pages bear the following inscriptions by John Adamson: *early calotypes / by the discoverer of / the process. Mr. F. Talbot. / sent to me in 1841 / JA. / they are partially / fixed only— / by Bromide of / potassium—and / were probably taken / in 1840.* [p. 20]; *early calotypes by Mr. Fox Talbot—the discoverer of the process— / sent to me in 1841* [p. 21]. The principal photograph on p. 21 is a portrait of Brewster, presumably taken by Talbot at Lacock Abbey in July 1842 (on Brewster's visit to Lacock Abbey in 1842, see Harley [note 119], pp. 224–225).

218. See above (note 7), p. 327, n.

THE BREWSTER ALBUM: A CHECKLIST

The Brewster Album is a quarto volume, 23.5 by 19 centimeters (9¼ by 7⅜ inches), composed of eighty-three cream-colored leaves and several that are lilac, gray, or tan. The watermark *J. Green and Son / 1833* is visible on page 4. The album is bound in full green leather, now darkened, and is decorated with gilt fillets and foliate ornaments on the sides and spine. It contains one hundred and ninety photographs by at least fifteen individual photographers and one partnership, as well as a few etchings, several drawings in ink or pencil, and one watercolor. Lines from works by Burns, Byron, Thomas Campbell, Robert Graham, Southey, Henry Kirke White, and a Mrs. Henson have been inscribed on several pages in a hand that may be Juliet Brewster's. Most of these quotations are concealed by photographs mounted over them. The photographs themselves range in date from 1839 to circa 1850 and are by these identified makers: John Adamson, Robert Adamson, Sir David Brewster, Henry Brewster, Henry Collen, Michael Pakenham Edgeworth, Nicolaas Henneman, Sir John Herschel, David Octavius Hill with Robert Adamson, J. W. Lawrance, Frances Monteith, Ashley George John Ponsonby, Thomas Rodger, Nevil Story-Maskelyne, and William Henry Fox Talbot.

The images in the Brewster Album were given individual accession numbers when the album entered the Getty Museum's collections in 1984. These accession numbers extend from 84.XZ.574.1 through 84.XZ.574.190. In this checklist the first number in each entry (that preceded by a period) refers to the last numeral(s) in the Museum's accession number. The figure in parentheses immediately following is the number of the album page on which the photograph is mounted.

The titles given here have been assigned by the author on the basis of the subjects of the photographs and/or any accompanying inscriptions. All photographs are salt prints from calotype negatives unless otherwise indicated. Throughout, the dimensions given are of the images.

All inscriptions or annotations are on the image in ink unless indicated to the contrary. Annotations are believed to be by Sir David Brewster himself unless otherwise indicated.

When it is evident that a photograph has been removed from the album or that the present image replaces another photograph, this has been mentioned. All such alterations took place prior to the album's acquisition by the Museum.

To avoid repetition, photographs discussed and illustrated in the body of the text are not discussed or illustrated here. Blank pages and illegible, redundant, or nonphotographic images have not been reproduced.

.1A
Unidentified draftsman
A Man's Head
Pencil
H: 9.5 cm (3¾ in.); W: 9.9 cm (4⅛ in.)
Unillustrated

.1 (1)
William Henry Fox Talbot (English,
1800–1877)
Unrecognizable image, 1839/40
Salt print from photogenic drawing
negative(?)
H: 9.4 cm (3¾ in.); W: 16.2 cm (6⅜ in.)
Below image at right corner, *H. F. Talbot Phot*
Unillustrated

.2A (2)
Unidentified artist
A Young Girl with a Lyre
Watercolor
H: 10.5 cm (4³⁄₁₆ in.); W: 9.3 cm (3⅝ in.)
Unillustrated

.2 (3)
Talbot
Head of Christ, May 1839
Salt print from photogenic drawing negative
H: 21.1 cm (8¼ in.); W: 17 cm (8¾ in.)
At bottom right, *H. F. Talbot Phot*; on verso at
top left, in Talbot's handwriting, *from old
painted glass*; at center, in Talbot's handwriting, *H. F. Talbot photogr. / May 1839*

Apart from this photograph, there are
four photogenic negatives and one positive
print of this image in the Museum's Department of Photographs (84.XM.1002.42–.44,
.45 [the positive], .46).
See fig. 12.

.3 (4)
Talbot
*The Radcliffe Quadrangle, University College,
Oxford*, 1841/43
H: 16 cm (6⁵⁄₁₆ in.); W: 19.9 cm (7¹³⁄₁₆ in.)
Below image at bottom right corner, *H. F.*

Talbot Phot.

This photograph depicts a corner of the
Radcliffe Quadrangle, built in the early
eighteenth century from a bequest by Dr.
John Radcliffe, physician to Queen Anne.
The statue over the entrance archway portrays him. See A. R. Woolley, *Oxford: University
and City* (London, 1951), p. 97.

(4)
Lines from *Graham's Sabbath* are transcribed
on this page.
Unillustrated

(5)
Image(s) removed
Unillustrated

.4 (6)
Unidentified photographer
Major Hugh Lyon Playfair, circa 1843
H: 14.5 cm (5¾ in.); W: 9 cm (3⁹⁄₁₆ in.)
Below image at bottom right corner, *Major
Playfair / St. Leonards*
See fig. 9.

.5 (7)
Thomas Rodger (Scottish, 1833–1883)
*Group Portrait with Sir David Brewster, Mrs.
Jones, and Brigadier General Colin Mackenzie*,
circa 1850
H: 9.8 cm (3¹³⁄₁₆ in.); W: 13.1 cm (5⁵⁄₃₂ in.)
On image at top left, *DB*; on image at right,
Brig. Genl Colin Mackenzie; on image at left,
Mrs Jones; above image, *DB Mʳˢ Jones* [illegible]
Capᵗ Colin Mackenzie

Another example of this photograph is in
the Maitland Album in the Getty Museum
(85.XZ.262.9). A pencil inscription below
that image gives Mackenzie the rank of
colonel and describes the photograph as "by
Rodgers." Another portrait of Mackenzie is
preserved in the Brewster Album (.134).
See pl. 3.

.6 (7)
John or Robert Adamson (Scottish,
1810–1870; 1821–1848)
*The South Entrance to St. Salvator's College
Chapel, St. Andrews*, 1842/43
H: 9.6 cm (3 13⁄16 in.); W: 9.9 cm (3 15⁄16 in.)
Below image at left, *St. Salvators Chapel*;
below image at right bottom corner, partially
erased, *Part*[?] *of* [illegible] / *H. F. Talbot*
See pl. 3.

.7 (8)
Unidentified photographer
Dr. Cleghorn, circa 1850
H: 20.7 cm (8 1⁄8 in.); W: 15.8 cm (6 13⁄16 in.)
On image at bottom right, *D*ʳ *Cleghorn*
 A variant of this portrait is preserved in
the Adamson Album (Edinburgh, National
Museums of Scotland 1942.1.1, p. 77). There
are also several small portraits of Hugh
Cleghorn, taken circa 1842, in the Adamson
Album and Adamson Scrapbook (1942.1.1,
pp. 43, 48; 1942.1.2, p. 29). A portrait of
Hugh Cleghorn's father, Peter Cleghorn of
Stravithy, is also in the Adamson Album
(p. 47.4).
See fig. 44.

.8 (9)
J. or R. Adamson
Sir George Campbell and His Son, George, 1842
H: 9.9 cm (3 15⁄16 in.); W: 9.6 cm (3 13⁄16 in.)
To right of image below bottom right corner
in an unidentified hand, *Sir G Campbell / & his
Son. / George*
See fig. 27.

.9 (9)
Talbot
A Bust of Venus, November 1840
Salt print from photogenic drawing negative
or calotype negative
H: 10.5 cm (4 1⁄8 in.); W. 7.4 cm (2 15⁄16 in.)
To right of image, above center, *H. F. Talbot /
Phot*
The negative for this photograph, preserved

in the Getty Museum (84.XM.1002.37), is
inscribed *Nov. 26. 1840* in Talbot's hand. A
variant image in an album in the Science
Museum, London, is dated *Jan. 28, 1841* by
Talbot (1937-366, vol. 2).

.10 (10)
Unidentified photographer
Major Hugh Lyon Playfair, 1842/43
H: 9.4 cm (3 3⁄4 in.); W: 6.8 cm (2 5⁄8 in.)
Centered below image, *Major Playfair*.

.11 (10)
Unidentified photographer
Unrecognizable image
H: 9.4 cm (3 3⁄4 in.); W: 6.8 cm (2 5⁄8 in.)
Centered below image, *Miss Playfair*
Unillustrated

(10)
Image removed
Unillustrated

.12 (10)
Unidentified photographer
Mrs. James Brewster, circa 1845
H: 12.5 cm (5 in.); W: 16.9 cm (6 3⁄4 in.)
Centered below image, *M*ʳˢ *Jas Brewster*
 Sir David Brewster's eldest son, James,
married Catherine Heriot Maitland, a
daughter of James Heriot Maitland of
Ramornie, Fife, in February 1845 while on
furlough from the Bengal Civil Service
(Gordon [note 5], p. 193). She also appears
in a double portrait with her mother in
the Brewster Album (.170). Photographs
depicting James Brewster and his wife with
their two daughters are preserved in the
Maitland Album in the Getty Museum
(85.XZ.262.10, .11). According to a pencil
annotation the latter are by Sir David himself.
The Maitland Album also contains two
unattributed portrait photographs of Mrs.
James Brewster and a portrait-silhouette
inscribed *Kate* and further identified as *M*ʳˢ
James Brewster (85.XZ.262.41, .42, .51).

.13 (11)
Henry Craigie Brewster (Scottish, 1816–1905)
Cork Barracks, circa 1843
H: 10.2 cm (4^{7}/16 in.); W: 17.8 cm (6^{15}/16 in.)
Centered above image, *Irish Barracks*; below image at right, *Capt Henry Brewster Phot.*; below image at left, *Guard Room of Cork Barracks*
See fig. 32.

.14A (12)
J. Carr or Caw
St. Leonard's Church, St. Andrews, 1841
Pen and ink
H: 12.5 cm (5 in.); W: 16.9 cm (6¾ in.)
In image at right bottom corner, *sketch J. Caw or Carr 1841*; centered below image, *Remains of the ancient Parish Church of St Leonards. / St Andrews* [underlined]
Unillustrated
 St. Leonard's Church, or Chapel, was adjacent to Brewster's house in St. Andrews.

.14 (13)
H. Brewster
Buttevant, circa 1843
H: 10.4 cm. (4⅛ in.); W: 17.8 cm (7^{1}/16 in.)
On image at lower right, *H.*; below image at right, *Houses outside of Barracks at Buttevant*
See fig. 33.

.15 (14)
Talbot
Objects of Sculpture on Three Shelves, circa 1843
H: 13.2 cm (5^{5}/16 in.); W: 13.8 cm (5½ in.)
Inscribed in negative at top left corner of image by Talbot, *12*; below image at right, *H. F. Talbot Phot.*

(14)
There is a pen sketch of a sheep on this page below the photograph.
Unillustrated

.16 (15)
Unidentified photographer
Group Portrait with Eight Figures, 1845/50
H: 9.1 cm (3⅝ in.); W: 14.3 cm (5⅝ in.)
On image at top left, *The Ramornie Family*
 Other examples of this photograph can be found in this album (.168) and in the Maitland Album (85.XZ.262.66). A pencil inscription below the latter example identifies the figures as Captain Archibald O. Dalgleish, Captain W. Heriot Maitland (see .53), and Miss Joanna Makgill (standing left to right) and Mrs. Makgill, Lady Playfair (see .28), Mrs. Heriot [Maitland] of Ramornie, Mrs. James Ogilvy Dalgleish, and Captain James Ogilvy Dalgleish (seated left to right). The Brewster and Maitland families were related through James Brewster's marriage to Catherine Heriot Maitland (see .12). (On the Maitland and Dalgleish families, see Conolly [note 62], pp. 318–319.) The Maitland Album contains a photograph and two watercolors of a country house that can be identified as Ramornie (85.XZ.262.13, .99, .101). The photograph, which is identified as *Old Ramornie*, is attributed to Captain Henry King R.N., who appears to have been married to Ella, one of the three Maitland daughters.

.17 (15)
J. or R. Adamson
Dr. Argyle Robertson, 1842/43
H: 9.9 cm (3⅞ in.); W: 8.6 cm (3^{7}/16 in.)
On image at top right, *Dr Argyle Robertso*[n]
 Another example of this portrait is in the Scottish National Portrait Gallery (reprod. in Stevenson [note 8], p. 128, Unknown Man 157). The same figure appears with other medical men, among them Dr. John Reid and Dr. David Skae, in group portraits in the Adamson Album (1942.1.1, p. 67) and in the Govan Album (St. Andrews University Library Album 6, p. 31).

.18A (16)
J. Mackenzie
Sir George Mackenzie with a Dead Stag
Pencil
H: 14.8 cm (5⅞ in.); W: 12.3 cm (4¹³⁄₁₆ in.)
Centered below image, *Sir George Mackenzie Bart / J. Mackenzie Del. / Coal*[?]; with pencil below image, *Sir G. Mackenzie Bart by Mʳ J. Mackenzie / Coal*[?]
Unillustrated

.18 (17)
Talbot
Section of the South Front of Lacock Abbey, March 1840
Salt print from photogenic drawing negative
H: 8.9 cm (3⁹⁄₁₆ in.); W: 7.7 cm (3¹⁄₃₂ in.)
Below image at bottom left corner, *Part of Laycock* [sic] *Abbey / H. F. Talbot*

The obituary of Talbot that appeared in the *Times* on September 25, 1877, also employed the variant spelling *Laycock*.

.19 (17)
Sir David Brewster (Scottish, 1781–1868) copied from Henry Collen (English, 1800–1879)
John Henning, 1842/43 (original); circa 1845 (copy)
H: 9.2 cm (3⅝ in.); W: 7.5 cm (2¹⁵⁄₁₆ in.)
Centered above image, *Mr Henning Sculptor.*; below image, *DB. Copied from Collens Phot*
See fig. 42.

.20 (17)
John Adamson
Mr. James Dalgliesh, 1842/43
H: 10.3 cm (4¹⁄₁₆ in.); W: 8.6 cm (3⅜ in.)
Below image left of center, *Mʳ James Dalgliesh;* below image at bottom right corner, *Dʳ Adamson Phot.*

Dalgliesh, who appears again in the Brewster Album in a group portrait with Brewster and a Mrs. Lyon (.44), may be the same as Captain James Ogilvy Dalgliesh in .16. The Brewster and Dalgliesh families were related through James Brewster's marriage to Catherine Heriot Maitland, whose mother was a Dalgleish (see Conolly [note 62], p. 319).

.21 (18)
Talbot
Photogenic Drawing of a Fragment of Lace, 1839
Photogenic drawing negative
H: 21.1 cm (8¹⁵⁄₁₆ in.); W: 18.1 cm (7³⁄₁₆ in.)
Below image at right, *H. F. Talbot*

Item .106 appears to be a positive taken from this negative.

.21A (18)
Unidentified artist
Blackfriars Chapel, St. Andrews
Etching
H: 10.5 cm (4 in.); W: 13.1 cm (5⅛ in.)
Below image at bottom right corner, *Mrs. Small*
Unillustrated

.22 (19)
H. Brewster
Houses Outside the Barracks at Buttevant in Snow, circa 1843
H: 11.6 cm (4⁹⁄₁₆ in.); W: 18.1 cm (7³⁄₁₆ in.)
Below image at bottom right corner, *Capt. Brewster Phot.*; below image to right of center, *Houses outside of / The Barracks at Buttevant in Snow*
Unillustrated

This photograph is a faint duplicate of .14 (see fig. 33).

.23 (20)
H. Brewster
Mr. Barton, circa 1843
H: 13.2 cm (5¼ in.); W: 9.4 cm (3¾ in.)
Centered above image, *Mʳ Barton 76ᵗʰ Regᵗ*; below image at right, *Capᵗ Henry Brewster Phot*

.24 (21)
J. Adamson
St. Salvator's College Chapel, St. Andrews, from the Southeast, 1843/44

H: 11.7 cm (4⅝ in.); W: 16.7 cm (6⅝ in.)
To left of image parallel to left edge, *St. Salvator's College Chapel Sᵗ Andrews*; centered below image, *Sᵗ Salvator's Chapel Sᵗ Andrews*; at bottom right corner, *Dʳ Adamson Phot*; to right of image parallel to right edge, *view from* [indecipherable] *of Sir D* [indecipherable] (probably referring to a photograph since detached)

.25 (22)
J. Adamson
Michael Pakenham Edgeworth, 1843/45
H: 16.9 cm (6¹¹⁄₁₆ in.); W: 12 cm (4¾ in.)
Below photograph at left, *Dʳ Adamson Phot.*; below photograph at bottom right corner, *Pakenham*; below photograph at bottom right corner in an unidentified hand, *M*[ichae]ˡ *Pakenham* [inserted above] *Edgeworth*
See fig. 38.

.26 (23)
J. or R. Adamson
Isabella and Margaret Thomson, 1842
H: 10.2 cm (3¾ in.); W: 8.5 cm (3⅜ in.)
Below image to right of center, *Capt. Brewster Phot*; below and to right of image in an unidentified hand, *The Miss Thomsons*

.27 (23)
Talbot
The Breakfast Table, March/May 1840
Salt print from photogenic drawing negative
H: 9.2 cm (3¹¹⁄₁₆ in.); W: 8.5 cm (3⅜ in.)
Below image to right of center, *H. F. Talbot Phot*

.28 (24)
Sir D. Brewster copied from Hugh Lyon Playfair (Scottish, 1776–1861)
Mrs. Hugh Playfair, 1845/50
H: 14 cm (5½ in.); W: 9.2 cm (3⅝ in.)
On image at bottom right corner, *Mʳˢ H. Playfair*; below image, *DB Copied from Major Playfair Phot*; to left of image, referring to a photograph since detached (fragments of

corners still visible), *Chain Bridge at Melrose*
In this portrait Mrs. Playfair wears the same dress she has on in the group portrait of the Ramornie family (.16).

.29 (25)
Unidentified photographer
A Group of Five Dogs, 1840s
H: 18.4 cm (7¼ in.); W: 14.3 cm (5⅝ in.)
Unillustrated
This photograph is taken from a print after Sir Edwin Landseer (1802–1873), the great Victorian animal painter. Landseer's name is inscribed below the image at the left. An inscription below the image at the right indicates that the composition was engraved by Thomas Landseer (1795–1880), the artist's brother. According to another inscription, barely legible below the image, the print was published in London by John Murray.

.30 (26)
Unidentified photographer
Portrait of a Man, 1842/43
Trimmed around the contours of a seated figure
H. 8.9 cm (3½ in.); W: 6.5 cm (2½ in.) (max.)
Below image, *Jaˢ Thomson 62 Regᵗ of Fᵗ*[?]
The Adamson Album contains a similar small, silhouetted portrait whose subject is identified as *Col. Jas. Thompson* (1942.1.1, p. 43).

.31 (26)
J. Adamson
A. Ross, 1842/43
Trimmed around the contours of the figure
H: 4.2 cm (1¹¹⁄₁₆ in.); W: 5.3 cm (2⅛ in.) (max.)
Below image, *A. Ross Junʳ*; to right of image at right bottom corner, *Dʳ A*
This figure may be the same as that in .49.

.32 (26)
J. Adamson
Mr. Caw, 1842/43
Trimmed around the contours of the figure
H: 6.4 cm (2 1/16 in.); W: 5.4 cm (2 7/16 in.)
(max.)
Below image, *Mr Caw*; to right of image at
bottom right corner, *D^r A*.

An untrimmed example of this portrait
was in the Harold White collection (reprod.
in Kraus with Schaaf [note 169], no. 6, where
it is attributed to Captain Henry Brewster).
Caw was a portrait painter and writer on the
visual arts.

.33 (27)
Unidentified photographer
Lathallan House, 1845/50
H: 16.3 cm (6 3/8 in.); W: 20.7 cm (8 3/16 in.)
Below image near bottom right corner,
Lathallan.

Lathallan House (now destroyed), located
in the East Neuk of Fife, was the home of the
Lumsdaine family (see Wood [note 207], pp.
147–148). The photograph evidently was
placed over another image that has since
been removed. To judge from the inscription
M^r Barton 76^th Regt legible below the present
image, the removed image may have been
another portrait of Barton by Henry Craigie
Brewster.
See fig. 46.

.34 (28)
Talbot
Fontainebleau, May/June 1843
H: 14.9 cm (5 7/8 in.); W: 18.7 cm (8 1/4 in.)
At top left, *H. F. Talbot Phot*; at bottom right
Fontaineblau [*sic*]

(28)
A drawing on this page is almost entirely
covered by the photograph.
Unillustrated

.35 (29)
J. Adamson
Distant View of St. Andrews from the East, circa
1845
H: 14.3 cm (5 5/8 in.); W: 18.6 cm (7 5/16 in.)
On image along lower edge left of center, *S^t.*
Andrews from / the East; below image at right,
D^r Adamson
See pl. 4.

.36 (30)
J. Adamson
Sir David Brewster's Garden with the West Tower
of the Cathedral in the Background, 1843/44
H: 8.7 cm (3 1/2 in.); W: 13.8 cm (5 7/16 in.)
Above image at top left corner, *Back of Sir*
DB. House; centered above image, *St Leonards*
Coll; below image at bottom right corner,
D^r Adamson Phot

This is a duplicate of .103.

.37 (30)
J. Adamson
Dr. Mudie, 1842/43
H: 9.9 cm (3 7/8 in.); W: 8 cm (3 3/16 in.)
Below image at bottom right corner, *D^r*
Adamson; centered below image, *D^r Mudie*

A small portrait in the Adamson Scrapbook
appears to be a duplicate of this image
(1942.1.2, p. 71.4). What appears to be a
variant view is preserved in the Smith Album
(St. Andrews University Library Album 7,
p. 28). Patrick Mudie seems to have been a
physician in St. Andrews.

.38 (31)
J. Adamson
Lord Campbell and Sir George Campbell, 1842
H: 10.2 cm (4 in.); W: 10 cm (3 15/16 in.)
Below image at left, *Lord Campbell*; below
image at right, *Sir George Campbell*; to right of
image at bottom right corner, *D^r Ad. Phot*

Another example of this image, preserved
in the Adamson Scrapbook (1942.1.2, p.

93.1), is inscribed *RA* and dated *1842* in the negative at the bottom left corner. See fig. 26.

.39 (31)
J. Adamson
Unrecognizable image
H: 9.7 cm (3⅞ in.); W: 8.6 cm (3⅜ in.)
Centered below image, *Dr Adamson*
Unillustrated

.40 (32)
H. Brewster
Miss Mary Playfair, 1842
H: 12.1 cm (4¾ in.); W: 8.6 cm (3⅜ in.)
On image at bottom right, *Miss Mary Playfair*; below image at bottom right corner, *Henry Brewster Phot*; below image at right of center in an unidentified hand, *Miss M. Playfair*; below image at right of center, *Mrs Murray*
Unillustrated

.41 (33)
Unidentified photographer
The Entrance Gate and West Front of St. Andrews Cathedral, 1845/50
H: 10.2 cm (3¹⁵⁄₁₆ in.); W: 5.1 cm (5¹⁵⁄₁₆ in.)
On image at bottom right corner, *Part of Cathedral / St Andrews*; below image at right of center, *Golden Gate St Andrews*

.42 (33)
Unidentified photographer
Major Hugh Lyon Playfair, 1842/43
Mounted on card
H: 9.5 cm (3¾ in.); W: 7 cm (2¾ in.)
On image centered at bottom, *Major Playfair*

.43 (34)
Collen
Bust-Length Portrait of a Man, Possibly Sir David Brewster, circa 1843
Varnished, mounted on card
H: 10.6 (4³⁄₁₆ in.); W: 8.4 cm (3⁵⁄₁₆ in.)
Centered above image, *Mr. Collen*; centered below image, *Mr Collen London Del*
See fig. 40.

.44 (35)
Unidentified photographer
James Dalgleish, Mrs. Lyon, and Sir David Brewster, circa 1845
H: 8.8 cm (3⁷⁄₁₆ in.); W: 10.9 cm (4⁵⁄₁₆ in.)
On image along top edge, *Mr Jas Dalgliesh Mrs Capt Lyon DB*

Another example of this image is in the Adamson Album (1942.1.1, p. 48.2). Also see .16.

.45 (35)
J. or R. Adamson
The East Gable of St. Andrews Cathedral and St. Regulus Tower from the Northwest, 1842
H: 8.2 cm (3¼ in.); W: 9.6 cm (3¹³⁄₁₆ in.)
Above image, *Cathedral St Andrews*

This view is plate 6 in the Tartan Album in the Lacock Abbey Collection (Harley and Harley [note 126], pl. 6). Other examples are in the Adamson Album and Adamson Scrapbook (1942.1.1, p. 27; 1942.1.2, p. 13).

.46 (36)
Talbot
Melrose Abbey, September 1844
H: 16.7 cm (6⁹⁄₁₆ in.); W: 20.8 cm (8³⁄₁₆ in.)
At center, along bottom edge, between vertical dotted lines, *Sir D. B. / Burying Ground*; right of center, along bottom edge, *Melrose Abbey*

This image is plate 9 in Talbot's *Sun Pictures in Scotland*, published in July 1845. In a letter in the *Literary Gazette* in November 1852, Talbot mentioned that he had taken a series of views of Abbotsford, "the residence

of Sir Walter Scott," in September 1844 (Ward and Stevenson [note 15], p. 118). The views of Melrose Abbey, which is in the immediate vicinity of Abbotsford, probably were taken on the same expedition. In a letter to Talbot dated October 27, 1847 (London, Science Museum Library), Brewster asks for "a copy or two" of Talbot's views of Melrose Abbey, explaining, "The burying ground of my family is close to the South Front of the Nave, and as I am about to erect a monumental tablet to one of my sons who perished while bathing in the Tweed, the Talbotype would enable me to decide on the nature and place of the tablet." (Sir David's second son, Charles Macpherson, drowned in 1828, according to Gordon [note 5], p. 140.) This photograph may be one of the views requested by Brewster. The blurred appearance may indicate that it was copied, perhaps by Sir David himself, from an example of *Sun Pictures in Scotland* in St. Andrews University Library. In a letter to Talbot dated July 25, 1845 (London, Science Museum Library), Brewster mentions, "I have just had your Photographic Work on Scotland put down in the list of books to be ordered for our University Library." This copy is still preserved in the library at St. Andrews (reproduced in Graham Smith, "William Henry Fox Talbot's Views of Loch Katrine," *Bulletin: Museums of Art and Archaeology, The University of Michigan* 8 [1984–85], pp. 72–77). Item .123, a view of Abbotsford from *Sun Pictures in Scotland*, is annotated *DB. Copied from Mr. Talbots Phot.*

(36)

There is a pencil sketch depicting a mourning woman seated by a tree and entitled *The Deserted* on this page below the photograph.
Unillustrated

.47 (37)
Talbot
A Sculpture of Diogenes in an Architectural Niche, September/October 1840
Salt print from photogenic drawing negative
H: 11.9 cm (4 11/16 in.); W: 10.9 cm (4 5/16 in.)
Below image at bottom right corner, *H. F. Talbot Fecit*

This may be the small *Diogenes* Talbot recorded as taken *without sun*, with an exposure of seventeen minutes, on October 6, 1840 (Lacock Abbey MS). The *Diogenes* was also photographed on September 29, however. The sculpture is a terracotta figure in one of the niches of the Hall of Lacock Abbey, executed in 1776 by an Austrian sculptor, Victor Alexander Sederbach (see *Lacock Abbey, Wiltshire* [The National Trust, 1979], p. 8). I am indebted to Gordon Baldwin for this identification and information. See fig. 13.

.48 (38)
Talbot
The South Front of Lacock Abbey with Sharington's Tower, 1839/40
Salt print from photogenic drawing negative
H: 16.9 cm (6 5/8 in.); W: 19.5 cm (7 11/16 in.)
On image at top left corner in an unidentified hand, *Laycock [sic] Abbey.*; on image at bottom right, *Lacock Abbey*; to right of image parallel to right edge, *H. F. Talbot Phot.*

For the variant spelling of Lacock, see .18. See fig. 17.

(38)

A passage from Byron's *Childe Harold's Pilgrimage* (1812) is transcribed on this page below the photograph.
Unillustrated

.49 (39)
J. or R. Adamson(?)
Mr. Ross and His Son, 1842/43
H: 10.4 cm (4 1/16 in.); W: 10.3 cm (4 1/16 in.)
Below image at bottom right corner, *Mr Ross*

& his Son / Gov. Gen¹· Indi. [added below *Mr Ross*]

Alexander Ross was named second ordinary member of the Council of India in December 1833, with the appointment to take effect in April 1834, and in December 1835 succeeded William Blunt as governor of the Presidency of Agra (B. B. Misra, *The Administrative History of India 1834–1947* [Oxford, 1970], pp. 256–257, 261). This image is similar to the double portraits *Sir George Campbell and His Son, George* and *Lord Campbell and Sir George Campbell* (.8, .38) by the Adamsons and most likely is close in date to them.
Unillustrated

(40)
Photographs detached, corners remaining
Centered above larger image, *DB.;* below larger image at right bottom corner, *H. F. Talbot Fecit / Lacock Abbey*
Unillustrated

.50 (41)
Talbot
A Harp, October 1840
Salt print from photogenic drawing negative
H: 13.2 cm (5³⁄₁₆ in.); W: 12.5 cm (4¹⁵⁄₁₆ in.)
Below image at bottom right corner, *H. F. Talbot*

A variant of this image in an album in the Science Museum, London, is dated *October 16, 1840* by Talbot (1937–366, vol. 2). Talbot's notebook entry for October 16, 1840, records two photographs of a harp taken with exposures of twenty-one and twenty minutes, respectively (Lacock Abbey MS).

.51 (42)
Talbot
Lady Elisabeth Feilding, August 1841
H: 15.6 cm (6⅛ in.); W: 9.2 cm (3⅝ in.)
Below image at right, *H. F. Talbot;* below image at right in an unidentified hand, *Lady Elizabeth Fielding / Mr Talbots Mother*

The correct spelling of Talbot's mother's name is *Elisabeth Feilding.* However, her Christian name was given as Elizabeth in the obituary of Talbot published in *The Times* on September 25, 1877. The date *August 1841* is legible on another example of this image, preserved in the Lacock Abbey Collection and reproduced in H. von Amelunxen and M. Gray, *Die aufgehobene Zeit: Der Erfindung der Photographie durch William Henry Fox Talbot* (Berlin, 1988), p. 12. The negative for the image is reproduced in R. E. Lassam and M. Gray, *The Romantic Era: La Calotipia in Italia 1845–1860* (Bath, 1988), p. 19, where it is dated 1841. The location of the negative is not given, but it appears to be from the Lacock Abbey Collection. A negative for a similar portrait, in the Science Museum, London (album entitled *Earliest Photographs,* no. 82), is dated *August 21, 1841* on the verso (not in Talbot's handwriting).
See pl. 2.

.52 (43)
J. or R. Adamson
Sir George Campbell, 1842 (the calotype from which this image is derived)
H: 11.1 cm (4⅜ in.); W: 12.6 cm (4¹⁵⁄₁₆ in.)
Centered below image, *Sir George Campbell*

This image appears to be an enlargement from the double portrait *Lord Campbell and Sir George Campbell* (.38). Presumably, Sir George was rephotographed from the double portrait and this positive contact printed from the second negative.
See pl. 5.

.53 (44)
Sir D. Brewster(?) copied from Sir D. Brewster
Captain W. Heriot Maitland, circa 1850
H: 18.8 cm (7⁷⁄₁₆ in.); W: 14 cm (5½ in.)
On image at bottom left, *Capt Maitland;* centered below image, *DB Copied from*

A clearer version of this image is preserved in the Maitland Album (85.XZ.262.1). The

pencil inscription below that example gives the information *by Sir David Brewster* and *Cap^t W. Heriot Maitland / afterwards Admiral Maitland Dougall.* Maitland served as lieutenant with several ships in China, being "much injured" in an attack on Amoy. He first received a commander's appointment in 1842. His last appointment was in January 1846 to the command of the *Electra*, from which he was invalided in March 1847 (see Conolly [note 62], p. 319). Presumably, this photograph was taken after Maitland's retirement from the navy.

.54 (45)
Talbot
A Fragment of Lace with Three Sprigs of Moss, 1839
Photogenic drawing negative
H: 15.9 cm (6¼ in.); W: 16.6 cm (6½ in.)
Below image at bottom right corner, *H. F. Talbot*

A close variant of this image, also in the Getty Museum (85.XM.150.10), is inscribed on the verso in Talbot's handwriting *H. F. Talbot photogr:1839*

.55 (46)
Talbot
The Bust of Patroclus, August 9, 1843
H: 14.9 cm (5⅞ in.); W: 14.5 cm (5¹¹⁄₁₆ in.)
Inscribed by Talbot in negative, *9 Aug. 1843*; with pencil on photograph below image at bottom right corner, *H. F. Talbot Phot*

This image was selected for plate 17 of *The Pencil of Nature.*

(46)
The text on this page is transcribed from Robert Southey.
Unillustrated

.56 (47)
Talbot
Detail of the Cloisters at Lacock Abbey, 1840
Salt print from photogenic drawing

negative(?)
H: 12.1 cm (4¾ in.); W: 12.9 cm (5¹⁄₁₆ in.)
Below image at bottom right corner in an unidentified hand, *Grotto at* [struck out] / *Laycock* [*sic*] *Abbey*; below image at right bottom corner, *H. F. Talbot Phot*

This may be the small view of the cloisters of Lacock Abbey that Talbot recorded in his notebook as taken on August 29, 1840 (Lacock Abbey MS). On the spelling of *Laycock,* see .18.

.57 (48)
Unidentified photographer (Talbot?)
The Holy Family with Three Cherubim, 1840s
H: 22.7 cm (8¹⁵⁄₁₆ in.); W: 16.5 cm (6½ in.)

This photograph probably was taken from a lithographic reproduction of a drawing. The Parmigianinesque style of the drawing and motifs such as the treatment of Mary's veil relate the composition to works by or after Guido Reni (see, for example, V. Birke, *The Illustrated Bartsch,* vol. 40, *Italian Masters of the Sixteenth and Seventeenth Centuries* [New York, 1987], pp. 148–150, nos. 2–4; 157–159, nos. 9–11).

(48)
The text on this page is transcribed from Robert Southey's *Curse of Kehama,* first published in 1810.
Unillustrated

.58 (49)
Unidentified photographer
Mrs. Adair Craigie, Mrs. James Brewster, Adair Craigie, and Sir David Brewster, circa 1847
H: 13.9 cm (5½ in.); W: 18.8 cm (7⁷⁄₁₆ in.)
Below image, *M^rs. A. Craigie Mrs. J. B. Adair Craigie DB*; to left of image (partially erased), *Scene at Lacock Abbey*; to right of image, *H. F. Talbot Phot*

This calotype must have been taken on the same occasion as .65 and .140. Craigie wears the same clothes in all three photographs and in .65 he is seated in the chair occupied

by Brewster in the present photograph. The inscriptions regarding Lacock Abbey and Talbot evidently refer to another photograph that was mounted on this page prior to the present one.
See pl. 10.

.59 (50)
Talbot
A Vase, 1840
Salt print from photogenic drawing negative
H: 13.9 cm (5⁷⁄₁₆ in.); W: 9.2 cm (3⅝ in.)
Below image at bottom right corner, *H. F. Talbot Phot*

The negative for this photograph is in the Science Museum, London (album entitled *Earliest Photographs*, no. 53).

.60 (51)
Unidentified photographer
Major Playfair's Garden and Pagoda with St. Andrews Cathedral in the Background, 1842/43
H: 8.2 cm (3¼ in.); W: 10.3 cm (4¹⁄₁₆ in.)
Above image at top left corner, *Sir D. B's House*; above image at right, *Priory*; centered below image, *Major Playfairs Garden*

.61 (52)
Talbot
Lady Elisabeth Feilding or *Horatia Feilding*, April 20, 1842
H: 12.4 cm (4⅞ in.); W: 16.4 cm (6⁷⁄₁₆ in.)
Below image at right, *H. F. Talbot Phot.*; below image at right in an unidentified hand, *Lady E Fielding* [*sic*]

Buckland ([note 29], p. 137) reproduces an example of this image which is inscribed in the negative in Talbot's handwriting *20 April 1842*. John Ward, in Ward and Stevenson (note 15), p. 18, fig. 10, identifies the woman as Horatia Feilding, Talbot's half-sister.

.62 (53)
Talbot
Section of the South Front of Lacock Abbey, March 21, 1840
Salt print from photogenic drawing negative
H: 9 cm (3⁹⁄₁₆ in.); W: 7.7 cm (3¹⁄₁₆ in.)
Centered above image, *Part of Lacock Abbey*; to right of image at bottom right corner, *H. F. Talbot Phot*

This almost certainly is the view of the *Middle window S. front* recorded by Talbot in his notebook on March 21, 1840 (Lacock Abbey, MS).
See fig. 14.

.63 (53)
H. Brewster
Officers of the 76th Regiment of Foot at Cork Barracks, 1842/43
H: 9.5 cm (3¾ in.); W: 15.6 cm (6³⁄₁₆ in.)
On image centered along top edge, *Officers of the 76ᵗʰ*; on image along top edge at right, *Cork Barracks*; on image at top right corner, *Capt Brewst*

.64 (54)
Talbot
Workman at Lacock, April 9, 1842
H: 14.2 cm (5⅝ in.); W: 17.1 cm (6¾ in.)
Above image, centered, *Scene at Lacock Abbey*; below image, left of center, *At Lacock Abbey*; below image at right, *H. F. Talbot Phot*

The dated negative for this image is in the Science Museum, London (album entitled *Earliest Photographs*, no. 82, dated *9 April/42* on the verso in pencil by Talbot).

.65 (55)
Unidentified photographer
Mr. Adair Craigie, circa 1847
H: 19.1 cm (7½ in.); W: 14.3 cm (5⅝ in.)
Centered below image, *Mʳ Adair Craigie*
See .58.

(55)

There appears to have been another image mounted on this page below the present photograph. The inscription *Captain Hopkins* remains.
Unillustrated

.66 (56)
Talbot
Bust of Patroclus, 1841/42
On J. Whatman Turkey Mill paper
Watermark *J. WHATMAN / 1840*
H: 16 cm (6⁵⁄₁₆ in.); W: 14.1 cm (5⁹⁄₁₆ in.)
On image at bottom right corner, *H. F. Talbot*; below image left of center, *Patroclus*

The *Patroclus* was one of Talbot's most frequently photographed subjects. He photographed it on eight separate occasions in 1840 and returned to it in 1841 and 1842. The present photograph, which is a salt-fixed salt print, is similar to that taken on August 9, 1842, and subsequently incorporated into *The Pencil of Nature* as plate 5.

.67 (57)
J. Adamson
Isabella Thomson, circa 1845
H: 19.8 cm (7¹³⁄₁₆ in.); W: 14.2 cm (5⅝ in.)
On image at bottom left corner, *Miss Thomson / St Andrews*; centered above image, *Miss Thomson St Andrews*
See jacket, pl. 6.

.68 (58)
Talbot
Buildings in Oxford, July 29, 1842
H: 13.6 cm (5⅜ in.); W: 17.1 cm (6¾ in.)
Below image at left in an unidentified hand, *Oxford*; below image at left, *Opposite the Angel Inn*; below image at right, *H. F. Talbot*

The Angel Inn was an old coaching inn opposite Queen's College, Oxford. In fact, the view of Queen's College selected by Talbot for plate 1 of *The Pencil of Nature* was taken from a room above the Angel Inn (see Schaaf with Kraus [note 19], p. 46). The building at the extreme left in the present view appears to be the continuation of that at the right edge of plate 1 in *The Pencil of Nature*. The negative for the present photograph is in the Science Museum, London (album entitled *Earliest Photographs*, no. 41). A variant negative showing the same building from a slightly different viewpoint, also in the Science Museum (ibid., no. 81), is dated *29 July/42* by Talbot in pencil on the verso. This date may suggest that the view of Queen's College also was taken in July 1842 rather than in September as suggested by Schaaf ([note 19], pp. 45–46).

.69 (59)
Talbot
Bowood, April 1840
Salt print from photogenic drawing negative
H: 16.4 cm (6½ in.); W: 20.8 cm (8³⁄₁₆ in.)
At bottom right corner, *H. F. Talbot*; centered below image, *Bowood—Seat of the Marquis of Lansdowne*

The photograph represents the portico facade of Bowood, Wiltshire, seat of the marquess of Lansdowne (see A. T. Bolton, *The Architecture of Robert and James Adam*, vol. 1 [London, 1758], pp. 192–215). The marquess of Lansdowne was Talbot's uncle. This section of the property was demolished in 1955/56 (see N. Pevsner, *The Buildings of England: Wiltshire* [Harmondsworth, 1963], pp. 109–111). In his notebook preserved at Lacock Abbey, Talbot records taking photographs of Bowood on April 14 and April 25, 1840. One of those taken on the later date is listed as *Bowood, entrance front*.

.70 (60)
Talbot
Bowood, April 1840
Salt print from photogenic drawing negative
H: 16.3 cm (6⁷⁄₁₆ in.); W: 21.6 cm (8½ in.)
At top left, *Bowood.*; at lower right, *H. F. Talbot*; on verso at lower right, *H. F. Talbot phot*

The image, no longer visible, may have depicted the side view of Bowood recorded by Talbot in his second entry for April 25, 1840 (see .69).
Unillustrated

.71 (61)
H. Brewster
Portrait of a Young Boy, 1842/43
H: 12.8 cm (5 1/16 in.); W: 8.7 cm (3 7/16 in.)
Below image at right bottom corner, *Capt Brewster Phot.*

.72 (61)
H. Brewster
Mr. Barton, 1842/43
H: 12.5 cm (4 7/8 in.); W: 9.1 cm (3 5/8 in.)
Centered above image, *M^r Barton 76^th Reg^t*; below image at bottom right corner, *Cap^t Brewster Phot.*

.73 (62)
Unidentified photographer
The West Front and South Aisle of St. Andrews Cathedral from the Northeast, circa 1843
H: 16.3 cm (6 7/16 in.); W: 11.9 cm (4 11/16 in.)
Centered above image, *Part of Cathedral St Andrews*
See fig. 18.

.74 (63)
Unidentified photographer
Portrait Group at the Golf Club, St. Andrews, circa 1850
H: 11.3 cm (4 1/2 in.); W: 18 cm (7 in.)
Centered along bottom edge, *Golf Club St Andrews*; above image along top edge, partially obscured and presumably referring to a photograph since removed, *Back Brewster House St. Leonards College St. Andrews*; centered below image, *Mr. H. Maitland* [cancelled]; below image at right, *Miss* [indecipherable] [both words cancelled]

.75 (63)
J. Adamson
View at Burnside, 1842/43
H: 8.3 cm (3 1/4 in.); W: 9.5 cm (3 3/4 in.)
Centered below image, *Bridge on the Kenly / M^r R. Adamson M^r Furlong*

.76 (64)
Unidentified photographer
The Reverend Adam Forman, circa 1844
H: 15.1 cm (5 15/16 in.); W: 11.8 cm (4 11/16 in.)
Centered above image, *Rev^d Adam Forman Leven*; centered below image, *Rev^d Mr Foreman Leven*

Adam Forman, M.A., became the first minister of the Free Church congregation at Leven in 1843 or 1844 and held that post until his death in 1865 (*Annals of the Free Church of Scotland*, ed. the Reverend W. Ewing [Edinburgh, 1914], vols. 1, p. 158; 2, p. 146).

.77 (65)
Attributed to J. Adamson
Market Street, St. Andrews, with the Old Tollbooth, Looking West, circa 1843
H: 11.5 cm (4 1/2 in.); W: 16.3 cm (6 7/16 in.)
On image centered at bottom edge, *Market Street St Andrews*; above image left of center, *Market Street St Andrews—Town Hall*

A similar but nearer view of the Tollbooth is preserved in the Govan Album (Album 6, p. 46). An annotation by Govan identifies the scene as *Town Hall / Market St. S^t Andrews* and the photographer as *J.A.* A small, near view of the Tollbooth in the Adamson Scrapbook is datable circa 1842 (1942.1.2, p. 149). See fig. 21.

.78 (65)
Unidentified photographer
St. Leonard's College Garden with St. Regulus Tower and the Cathedral in the Background, 1842/43
H: 7.7 cm (3 1/16 in.); W: 9.8 cm (3 13/16 in.)
Below image right of center, *S^t Leonards College Garden*; below image at bottom left corner, *House now / taken down*

.79 (66)
Unidentified photographer (Rodger?)
Captain Hawkes or Hawkers and His Daughters, circa 1850
H: 12.1 cm (4 3/4 in.); W: 18.7 cm (7 1/4 in.)
Centered below image, *Cap^t Hawker[?]s and Daughters*

An inscription partially visible along the top edge of the present image indicates that there once was another photograph on this page.

.80 (66)
R. Adamson
St. Salvator's College Chapel from the Southeast, 1842
H: 8.4 cm (3 5/16 in.); W: 8.2 cm (3 1/4 in.)
On image centered along bottom edge, *S^t Salvators Chapel*

This appears to be a trimmed example of plate 7 in the Tartan Album (Harley and Harley [note 126], pl. 7).

.81 (67)
Unidentified photographer
St. Salvator's College Chapel, St. Andrews from the Southeast, 1843/45
H: 11.3 cm (4 1/2 in.); W: 16.1 cm (6 5/16 in.)
Above image, *S^t Salvator's Chapel S^t Andrews*
See .24.

.82 (67)
Talbot
A Man Standing in a Doorway, 1840/41
H: 8.8 cm (3 1/2 in.); W: 7.6 cm (3 in.)
At bottom right corner, *H. F. Talbot*; above image, *Scene at Lacock*

.83 (68)
Talbot
Lacock Abbey, The West Front, 1842/43
H: 11.3 cm (4 7/16 in.); W: 18.6 cm (7 5/16 in.)
Centered above image, *Entrance Hall—Lacock Abbey*; below image at bottom right corner, *H. F. Talbot*

.84 (69)
Sir John Herschel (English, 1792–1871)
Engraved Portrait of a Young Woman, 1842
Cyanotype negative
H: 10.2 cm (4 in.); W: 7.8 cm (3 1/16 in.)
Centered above image, *Cyanotype / By Sir John Herschel*

Two other versions of this image are preserved in the Herschel Collection in the Museum of the History of Science, Oxford. One is a positive cyanotype with white highlights and edges. The other is a negative "chrysotype"—a process invented by Herschel at the same time as the cyanotype. The engraving from which the photographs were taken is not preserved in the Herschel Collection. The solid blue border, overall color, and roughly cut edges of the present photograph appear to connect it with another cyanotype negative, also in that collection, taken from an engraving depicting a woman with a harp. (I am extremely grateful to A. V. Simcock, Librarian, Museum of the History of Science, for this information.)
See pl. 9.

.85 (70)
Attributed to William Holland Furlong (Irish, active circa 1840–circa 1857)
The East Gable and South Aisle of St. Andrews Cathedral with St. Regulus Tower, from the North-

west, circa 1843
H: 12 cm (4¹¹⁄₁₆ in.); W: 16.8 cm (6⅝ in.)
Above image at left, *Cathedral St Andrews*;
above image at top right corner, *St Regulus's
Tower*

The calotype negative for this photograph
is preserved in the Graphic Arts Collection,
Firestone Library, Princeton University
(see Smith [note 77], fig. 4).
See fig. 19.

(70)
Image removed
Centered below missing image, *DB*.
Unillustrated

.86 (71)
Talbot
Merton Chapel Tower, Oxford, 1841/42
H: 9.9 cm (3⅞ in.); W: 8.2 cm (3³⁄₁₆ in.)
On image along top edge in an unidentified
hand, *Oriel Merton Corpus Ox*; below image
at right, *H.F.T*

.87 (71)
Talbot
The Courtyard at Lacock Abbey, 1841/42
H: 8.8 cm (3½ in.); W: 8.3 cm (3¼ in.)
Centered below image, *Lacock Abbey H.F.T.*

Kraus with Schaaf (note 43), no. 27, repro-
duces a similar view, although horizontal
rather than vertical in format, formerly in
the Harold White collection.
See fig. 15.

.88 (72)
Talbot
*The Porch in the Front Quad of Oriel College,
Oxford*, 1841/42
H: 9.1 cm (3⁹⁄₁₆ in.); W: 8 cm (3⅛ in.)
On image at bottom left corner in Talbot's(?)
handwriting, *Oriel Coll. Oxford*; below image
at right, *H.F.T.*; with pencil below image at
right (partially erased), *Oriel Coll. Oxford*

.89 (73)
Michael Pakenham Edgeworth (Irish, 1812–
1881)
Edgeworth House, 1843/44
H: 11.3 cm (4⁷⁄₁₆ in.); W: 13 cm (5⅛ in.)
Centered above image, *Edgeworthstown*; below
image at bottom right corner, *M.P. Edgeworth
Phot*

.90 (73)
Edgeworth
Edgeworth House, 1843/44
H: 7.5 cm (3 in.); W: 9.9 cm (3⅞ in.)
Centered above image, *Edgeworthstown*; below
image at bottom right corner, *M.P. Edgeworth
Phot.*
See fig. 35.

.91 (74)
Edgeworth
The Church at Edgeworthstown, 1843/44
H: 9.2 cm (3⅝ in.); W: 12.5 cm (4¹⁵⁄₁₆ in.)
Centered above image, *Church at Edgeworths-
town*; below image at bottom right corner,
M.P. Edgeworth Phot
See fig. 36.

.92 (74)
Edgeworth
Edgeworth House(?), 1843/44
H: 6.6 cm (2⅝ in.); W: 10.2 cm (4 in.)
Centered above image, *Edgeworthstown*; below
image at bottom right corner, *M.P. Edgeworth
Phot.*

.93 (75)
Edgeworth
Beech Tree at Edgeworthstown, 1843/44
H: 10.7 cm (4³⁄₁₆ in.); W: 15.5 cm (6⅛ in.)
Centered above image, *Beech Tree at Edge-
worthstown*; below image at bottom right
corner, *M.P. Edgeworth*
See fig. 37.

.94 (75)
Edgeworth
Edgeworthstown House(?), 1843/44
H: 9.9 cm (3⅞ in.); W: 12.9 cm (5 1/16 in.)
Centered above image, *Edgeworthstown*; below
image at bottom right corner, *M.P E*

.95 (76)
Talbot
*Engraved View of a "Moorish" Church and
Adjacent Buildings*, 1845/46
H: 15.9 cm (6¼ in.); W: 20.3 cm (8 in.)
On image at top left corner in Talbot's(?)
handwriting, *diminished*; on image at top
right corner, *H. F. T.*; on image at bottom
edge left of center, *From Engraving*; on image
at bottom right corner, *H. F. Talbot*

Two negatives for this image are preserved
in the Science Museum, London (Album 3,
p. 39). The same album also contains seven
positive prints of it (p. 38).

.96 (77)
Unidentified photographer
Mrs Henry Brewster Farney, circa 1850
H: 17.3 cm (6 13/16 in.); W: 11.6 cm (4 9/16 in.)
On image centered at bottom edge, *M*ʳˢ *Henry
Brewster Farney*

Henry Brewster married Anne Catherine
Inglis, second daughter of J. C. Inglis, Esq.,
of Cramond, on January 2, 1852 (see Gordon
[note 5], p. 230).

.97 (78)
David Octavius Hill (Scottish, 1802–1870)
and R. Adamson or R. Adamson alone
*The West End of St. Andrews Cathedral and the
Cathedral Precinct from the Northeast*, circa 1845
H: 14.8 cm (5⅞ in.); W: 18.6 cm (7 5/16 in.)

This view is identical to one of the plates
included in some copies of *A Series of Calotype
Views of St. Andrews*, published by Hill and
Adamson in Edinburgh in 1846 (see Smith
[note 140], fig. 12; Stevenson [note 8], St
Andrews 21, p. 204).

.98 (79)
Frances Monteith (Scottish, active circa
1845/50)
Mr. Monteith, circa 1845
H: 10.5 cm (4⅛ in.); W: 9.7 cm (3 13/16 in.)
On image centered at bottom, *M*ʳ *Erle Mon-
teith*; centered above image, *Mr Monteith*;
to right of image at right bottom corner, *M*ʳˢ
Monteith Phot.

Born Frances Dunlop, Mrs. Monteith was
the wife of Alexander Earle Monteith (1793–
1861), an Edinburgh advocate (see J. Law-
son, "Sir James Dunlop, A Photographic
Prodigy?" *Scottish Photography Bulletin*
[Autumn 1986], p. 12). As sheriff of Fife,
Monteith's "high personal character, his
kindly courtesy, and his zeal in the promotion
of every beneficent object connected with
the county, gained him the confidence,
esteem, and regard of all classes of the com-
munity." He was also a prominent and highly
respected figure in the establishment of the
Free Church of Scotland (Connolly [note 62],
pp. 334–337). Monteith appears with Brew-
ster and others in a group portrait by Robert
Adamson, possibly with David Octavius
Hill, in the present album (.125) and in three
presbytery groups by Hill and Adamson in
the Scottish National Portrait Gallery (Ste-
venson [note 8], Presbytery Groups 12–
14, pp. 182–183). According to Connolly
(ibid., p. 336), Monteith "kept well up with
the reading of the day in literature, science,
and art, and cultivated the society of men
eminent in these branches." Together with
his connections with Brewster, this would
explain his and his wife's interest in
photography.

.99 (79)
Monteith
Mrs. Brown, circa 1845
H: 9.2 cm (3⅝ in.); W: 8.6 cm (3⅜ in.)
To right of image at bottom right corner, *M*ʳˢ
Monteith / Phot. [underlined]; centered below

image, *M^rs Brown*

The inscriptions *Queen's College Oxford* and *H. F. Talbot Phot.* legible below the present image indicate that this spot was once occupied by a photograph by Talbot.

.100 (80)
Unidentified photographer (R. Adamson?)
Inverleith Grounds, 1843
H: 11.1 cm (4⅜ in.); W: 13 cm (5⅛ in.)
Centered at bottom of image, *Inverleith Grounds*; above image at right, *Scene at Inverleith House*; to right of image with pencil in an unidentified hand, *Nr. 100*

This photograph is probably a view of the grounds of Inverleith House in Edinburgh (see J. Gifford, C. McWilliam, and D. Walker, *Edinburgh* [Harmondsworth, 1984], pp. 575–576). The Royal Botanic Garden was established on the east side of the Inverleith estate in 1822. A similar small view by John or Robert Adamson depicting a range of trees silhouetted against the sky is preserved in the Adamson Scrapbook (1942.1.2, p. 99).

.101 (80)
Monteith
Sir James Dunlop, circa 1845
H: 10.9 cm (4⁵⁄₁₆ in.); W: 9.5 cm (3¾ in.)
To right of image at bottom right corner, *M^rs Monteith / Phot.*; below image at left, *Sir James Dunlop—Bart*

Sir James Dunlop of Dunlop (1830–1858) was Mrs. Monteith's nephew (Lawson [see .98], pp. 11–13). Educated at Edinburgh Academy, he served "with distinction" with the Coldstream Guards in the Crimean War, being decorated for his part in the battles of Alma, Balaclava, Inkerman, and Sebastopol. He resigned his commission in 1857 and died in the south of France one year later. Sir James Dunlop is given as the author of several architectural views taken in Italy preserved in the Maitland Album (85.XZ.262.16, Colosseum; .25, Forum; .44, Arch of Constantine; and probably .78,

Paestum). Other calotypes by Dunlop are preserved in the Scottish National Portrait Gallery, Edinburgh, and in an album in the Edinburgh Central Library (Lawson [see .98], p. 11, n. 1). Sir James Dunlop appears to have traveled on the Continent in 1847, and it is likely that those photographs were taken then (ibid., p. 13, n. 5). An inscription partly visible below the lower edge of the present photograph suggests that this space was originally occupied by a view of Oxford, perhaps by Talbot.

.102 (81)
Furlong
St. Regulus Tower and the East Gable of St. Andrews Cathedral from the Northwest, 1843/44
H: 11.6 cm (4⁹⁄₁₆ in.); W: 17.7 cm (6¹⁵⁄₁₆ in.)
Above image, *Cathedral St Andrews St Regulus's Tower*; below image at bottom right corner, *H. Furlong Phot* [this annotation may refer to .103, which is mounted below it]
See fig. 20.

.103 (81)
Unidentified photographer
Sir David Brewster's Garden with the West Tower of the Cathedral in the Background, 1843/44
H: 8.8 cm (3⁷⁄₁₆ in.); W: 14 cm (5½ in.)
Unillustrated

This is a duplicate of .36.

.104 (82)
Talbot
Gardening Tools against a Wall, March 1843
H: 17.1 cm (6¹¹⁄₁₆ in.); W: 21.2 cm (8⁷⁄₁₆ in.)
On image at bottom left, *H. F. Talbot*

The negative for this image is in the Getty Museum (84.XM.260.6). The negative for a similar composition in the Science Museum, London (album entitled *Earliest Photographs*, no. 440), is dated *18 March/43* by Talbot. Some lines of verse are visible under the photograph.

.105 (83)
Hill and Adamson or R. Adamson alone
St. Regulus Tower and the East Gable of St. Andrews from the Northwest, circa 1845
H: 14.5 cm (5¹¹/₁₆ in.); W: 19.2 cm (7⁹/₁₆ in.)

This view is among those published in Hill and Adamson's *Series of Calotype Views of St. Andrews* in 1846 (Stevenson [note 8], St Andrews 15, p. 203). Some lines of verse are visible under the photograph.

.106 (84)
Talbot
A Fragment of Lace, circa 1839
Salt print from photogenic drawing negative
H: 18.3 cm (7³/₁₆ in.); W: 20.8 cm (8³/₁₆ in.)
On image near bottom left corner, *H.F.T*; partially on image at top left corner, blind stamp, *super fine satin*
Compare .21.

.107 (85)
Talbot
Fern, 1839/40
Photogenic drawing negative
H: 22.2 cm (8¹¹/₁₆ in.); W: 17.8 cm (7 in.)
Below image at left, *H.F.T*

(86)
Image removed
Centered above missing image, *Capt Evans 76ᵗʰ Regᵗ*
Unillustrated

.108 (87)
H. Brewster
Mr. Barton, circa 1843
H: 12.9 cm (5¹/₁₆ in.); W: 10.8 cm (4¼ in.)
Centered above image, *Mʳ Barton 76ᵗʰ Regᵗ*; below image at right, *Capt. Brewster Phot*
See fig. 30.

.109 (88)
Sir D. Brewster copied from Hill and Adamson
A Group of Men at the South Entrance to York Minster, September/October 1844 (the calotype from which this photograph is copied)
H: 18.4 cm (7¼ in.); W: 13.8 cm (5⁷/₁₆ in.)
On image at bottom left corner, *Mr Adamson*; on image along bottom edge, right of center, *Gate of York Minster*; below image, left of center, *DB. Copied*

This is a detail from a photograph taken by Hill and Adamson, possibly with Talbot's assistance, at the meeting of the British Association held in York at the end of September and beginning of October 1844 (see K. Michaelson, "The First Photographic Record of a Scientific Conference," *One Hundred Years of Photographic History: Essays in Honor of Beaumont Newhall*, ed. Van Deren Coke [Albuquerque, 1975], pp. 109–116; the full view is reproduced there as fig. 72, p. 115, and in Ward and Stevenson [note 15], p. 167). Presumably, Brewster rephotographed the central portion of Hill and Adamson's image to make the print in the album. This would account for the photograph's blurred and grainy appearance.

(89)
Image removed
Centered above lost image, *Mʳ Murray*
Unillustrated

.110 (90)
H. Brewster
Army Barracks, circa 1843
H: 11.3 cm (4⁷/₁₆ in.); W: 17.4 cm (6⅞ in.)
Centered above image, [indecipherable] *Barracks*; below image at right, *Capt. Brewster Phot*

.111 (90)
H. Brewster
Buttevant Barracks, circa 1843
H: 9.4 cm (3¹¹/₁₆ in.); W: 18 cm (7⅛ in.)
At bottom left corner, *Phot. / Capt Brewster*; above image at center, *Buttevant Barracks*
See fig. 34.

.112 (91)
H. Brewster
Major Martin, circa 1843
H: 16 cm (6⁵/₁₆ in.); W: 12.7 cm (5 in.)
Above image at right of center, *Major Martin 76ᵗʰ Regᵗ*; below image at bottom right corner, *Capt. Brewster Phot*

Another example of this portrait is in the Graphic Arts Collection, Princeton University Library (Smith [note 77], fig. 1, n. 2). See fig. 31.

.113 (92)
H. Brewster
Captain Fenwick, circa 1843
H: 16.5 cm (6½ in.); W: 12.7 cm (5 in.)
Above image, *Capt. Fenwick 76ᵗʰ Regᵗ*; below image at right, *Capt. Brewster Phot*

.114 (93)
H. Brewster
Mr. Rutherford, circa 1843
H: 15.9 cm (6¼ in.); W: 12 cm (4¾ in.)
Centered above image, *Mr Rutherford 76ᵗʰ Reg*; below image at right, *Capt. Brewster Phot*

.115 (94)
J. or R. Adamson
St. Andrews Castle from the East, 1843/44
H: 12.4 cm (4⅞ in.); W: 17.2 cm (6¾ in.)

.116 (94)
Sir D. Brewster
Raith House, circa 1843
H: 9 cm (3½ in.); W: 9 cm (3½ in.)
On image at top right corner, *Raith* [underlined]; below image at bottom right corner, *DB. Phot*
See fig. 47.

.117 (95)
H. Brewster
Portrait of Captain Pickard, circa 1843
H: 15.9 cm (6¼ in.); W: 12 cm (4¹¹/₁₆ in.)
Centered above image, *Capt Pickard 76ᵗʰ*; below image at right, *Capᵗ. Brewster Phot*

.118 (96)
Hill and Adamson or R. Adamson
St. Andrews Castle from the Northeast, circa 1845
H: 15.2 cm (6 in.); W: 19.9 cm (7¹³/₁₆ in.)
Centered along bottom edge, *Castle St Andrews from Sea*

Like .97, .105, and .133, this photograph is related to Hill and Adamson's album of views of St. Andrews (Stevenson [note 8], St Andrews 9, p. 203).

.119 (97)
Talbot
The Harbor at Rouen, May 1843
H: 16 cm (5⁵/₁₆ in.); W: 12.3 cm (4⅞ in.)
On image at top right corner in an unidentified hand, *Rouen*; below image, right, *H.F.T*

.120 (98)
Unidentified photographer (J. Adamson?)
Sir David Brewster with Miss Mary Playfair, Lady Brewster, Mr. Pakenham Edgeworth, and Miss Brewster, 1843/46
H: 11 cm (4⁵/₁₆ in.); W: 14.6 cm (5¾ in.)
Below image at left bottom corner, *Sir DB / Mary Playfair / Lady B / Pakenham Edgeworth / Miss B*

.121 (99)
Unidentified photographer
The Church of the Holy Sepulchre and St. Andrew, Cambridge, after 1841
Salt print from photogenic drawing negative(?)
H: 15.6 cm (6⅛ in.); W: 18.2 cm (7⅛ in.)
Centered below image, *Cambridge*

The photograph reproduces a print depicting the twelfth-century Church of the Holy Sepulchre and St. Andrew in Cam-

bridge after its restoration by the Cambridge Camden Society in 1841 (see T. D. Atkinson, *Cambridge Described and Illustrated* [London and Cambridge, 1897], pp. 164–167).

.122 (100)
H. Brewster
Portrait of Mr. Barton, October 1843/45
H: 16.4 cm (6⁷⁄₁₆ in.); W: 11 cm (4⁵⁄₁₆ in.)
Centered above image, *M^r Barton 76^th Reg^t*; below image at right, *Capt. Brewster Phot*

The length and thickness of Barton's shoulder tassels indicate that he was a lieutenant at the time the photograph was taken. This provides a terminus post quem for the photograph of October 6, 1843. The design of the crossbelt plate gives a terminus ante quem of 1845, when this type was replaced by another. (I am indebted to Lieutenant Colonel [Retired] W. Robins, O.B.E., Regimental Secretary, The Duke of Wellington's Regiment, for this information.)
See fig. 29.

.123 (101)
Sir D. Brewster copied from Talbot
Abbotsford, September 1844 (the negative of the calotype from which this is copied)
H: 15.1 cm (5¹⁵⁄₁₆ in.); W: 21.8 cm (8⁹⁄₁₆ in.)
Centered above image, *Abbotsford*; below image right of center, *DB. Copied from Mr. Talbots Phot*

This image appears as plate 3 in Talbot's *Sun Pictures in Scotland* (see .46).

.124 (102)
H. Brewster
Portrait of a Young Boy, circa 1845
H: 14.5 cm (5¹¹⁄₁₆ in.); W: 10 cm (3¹⁵⁄₁₆ in.)
Below image at right bottom corner, *Capt. Brewster Phot*

.125 (103)
R. Adamson
Group Portrait with Sir David Brewster and Others, October 1843

H: 14.3 cm (5⁵⁄₈ in.); W: 18.6 cm (7⁵⁄₁₆ in.)
Near top edge of image, from left to right, *Lord Breadallan Sir DB D^r Welsh Mr Hamilton Mr Monteith*; below image at bottom right corner, *R. Adamson Phot. at the / meeting of the Free Ch^h assembly / in Glasgow in*

A trimmed version of this image is in the collection of the Scottish National Portrait Gallery, Edinburgh (Stevenson [note 8], Group 42, p. 158). Several of the presbytery groups taken at the Glasgow Assembly bear similar annotations and are dated October 21 or 22, 1843 (Stevenson [note 8], Presbytery Groups 4, 8–11, 18, pp. 182–183).

.126 (104)
Talbot
Cast of the Rape of the Sabines by Giambologna, 1840/41
Salt print from photogenic drawing negative
Watermark *J WH[ATMAN] / TURK[EY MIll]*
H: 15.2 cm (6 in.); W: 9.4 cm (3¾ in.)

Talbot recorded photographing a cast of Giambologna's *Rape of the Sabines* twice on April 30, 1840, once on May 1 and once on August 9. The sepia color of the present image indicates that it is fixed by hyposulphite of soda and would suggest that this positive is rather later. Another example, smaller but dependent on the same negative, is in the Maitland Album (85.XZ.262.89).

.127 (105)
Unidentified photographer
Mrs. Charles Stewart, 1843/44
H: 12.2 cm (4¹³⁄₁₆ in.); W: 11.1 cm (4⅜ in.)
Centered above image, *M^rs Charles Stewart*

.128 (105)
R. Adamson
Nelson Monument, Calton Hill, Edinburgh, 1843
H: 9.6 cm (3¾ in.); W: 8.2 cm (3¼ in.)
On image centered at bottom, *Nelson's Monument*

This monument was erected on Calton

Hill between 1807 and 1815. Rock House, where Robert Adamson established his studio in May 1843, is halfway up Calton Hill in the immediate vicinity of the Nelson Monument. A similar but not identical view forms the frontispiece to the Tulloch Album in St. Andrews University Library (Album 24). An inscription by John Adamson on that page identifies the photographs in the album as *Calotypes taken at Calton Stairs Edin / in / 1843 / 1844 / 1845 / by R. Adamson & D. O. Hill.*

.129 (106)
Talbot
Carclew House, near Truro, Cornwall, August 1841
H: 15.2 cm (5¹⁵⁄₁₆ in.); W: 19.4 cm (7⅝ in.)
Along bottom edge left of center, *Sir Charles Lemons House*; at bottom right corner, *H. F. Talbot*

Sir Charles Lemon, a landowner in Cornwall, was Lady Elisabeth Feilding's brother-in-law and Talbot's uncle by marriage (Arnold [note 21], p. 56). He invited Talbot to a house party at Carclew in August 1841, when this and other photographs were taken (see A. Lanyon, "The First Cornish Photographs?" *History of Photography* 8 [1984], pp. 333–336). The photograph depicts the main front of Carclew, which was destroyed by fire in 1934 (on Carclew, see L. Weaver, "Carclew, Cornwall, The Seat of Captain Charles H. Tremayne," *Country Life* 39 [1916], pp. 590–594; Anon., "Carclew, Cornwall, The Seat of Captain Charles H. Tremayne," ibid., 75 [1934], pp. 378–382).

(107)
Image removed
Centered below missing image, *Copied from Collen Phot Mr Collen Phot.*
Unillustrated

.130 (107)
Sir D. Brewster copied from Collen
Miss Collen, circa 1845 (copy)
H: 9.8 cm (3⅞ in.); W: 7.8 cm (3⅛ in.)
On image at top center, *Miss Collen*; below image, *copied from Collen Phot*

Henry Collen's monogram is legible on the left side of an example of this portrait in the Hans P. Kraus, Jr., collection, New York. See fig. 43.

.131 (108)
Talbot
Bonnets (The Milliner's Window), 1843/46
H: 14.3 cm (5⅝ in.); W: 19.5 cm (7¹¹⁄₁₆ in.)
Below image at right, *H. F Talbot*

This image is similar to those entitled *Articles of China* and *Articles of Glass* in part 1 of *The Pencil of Nature* (pls. 3, 4), which was published in June 1844. Another example, in the Lacock Abbey Collection, is dated 1846 by Robert Lassam (*Fox Talbot Photographer* [Tisbury, 1979]).

.132 (109)
J. Adamson
Miss Brewster, 1845/50
H: 14.2 cm (5⁹⁄₁₆ in.); W: 10.4 cm (4⅛ in.)
Centered below image, *Miss Brewster Leven*

This portrait is identical to the left half of a photograph preserved in the Adamson Scrapbook (1942.1.2, p. 83). According to a manuscript note in the xerox copy of the scrapbook in the National Museums of Scotland, the negative is preserved in the Scottish National Portrait Gallery. In the negative the left-hand sitter is identified as *Miss B* and the photographer as *J.A.* The same table appears in several early portraits by the Adamsons in the Adamson Scrapbook (1942.1.2, pp. 89.1, 91.1). It also can be recognized in .135.

.133 (110)
Hill and Adamson or R. Adamson alone
The West End of St. Andrews Cathedral and the

Cathedral Precinct from the Northeast, circa 1845
H: 14.1 cm (5%16 in.); W: 18.6 cm (7⁵⁄16 in.)
Centered below image, *Part of Cathedral
St Andrews*
Compare .97.

.134 (111)
J. Adamson
Captain Colin Mackenzie, 1845/50
H: 16.8 cm (6⅝ in.); W: 12.3 cm (4⅞ in.)
Below image right of center, *Capᵗ. Colin
Mackenzie / Taken at St Andrews by Dʳ Adamson*
 Colin Mackenzie appears with Brewster
and a Mrs. Jones in .5.

.135 (112)
J. Adamson
Mrs. Major Bell, circa 1847
H: 11.3 cm (4⁷⁄16 in.); W: 9.6 cm (3¾ in.)
Centered below image, *Mʳˢ Major Bell*
 Mrs. Bell, née Isabella Adamson, was the
sister of John and Robert Adamson. Accord-
ing to Stevenson (note 8), p. 42, she married
Oswald Bell in 1847. She and her husband
were photographed singly by Hill and
Adamson (ibid., pp. 42, 132). She also
appears in two group portraits of the Adam-
son family (ibid., Groups 7, 8, p. 156). Later
portraits of Isabella Adamson and her sisters
by John Adamson are grouped on a page in
the Adamson Album (see Alison D. Morrison-
Low, "The Alexander Sisters by John Adam-
son: Portrait of a Woman's Place in Victorian
Society," *Bulletin of the Scottish Society for the
History of Photography* [Spring 1986], p. 32,
back cover).

.136 (113)
Hill and Adamson
Rev. Dr. James Brewster, circa 1844
H: 18.4 cm (7¼ in.); W: 14.7 cm (5¹³⁄16 in.)
 James Brewster (1777–1847) of Craig was
a minister of the Free Church and the elder
brother of Sir David Brewster (see Stevenson
[note 8], p. 44). Item .175 is a duplicate of
this image.

.137 (114)
Unidentified photographer
Professor John Reid, 1843/45
H: 15.1 cm (6 in.); W: 9.5 cm (3¾ in.)
Below image at center, *Dʳ Reid*
 John Reid was professor of anatomy at the
University of St. Andrews from March 1841
to his death in July 1849 (see Conolly [note
62], p. 377). A portrait of Reid by Hill and
Adamson is in the Scottish National Portrait
Gallery, Edinburgh (reprod. in Stevenson
[note 8], p. 100). The sculpted bust on the
table at Reid's left also appears in .138.

.138 (115)
Unidentified photographer
Mrs. Hugh Lyon Playfair, circa 1845
H: 21 cm (8¼ in.); W: 14.8 cm (5¹³⁄16 in.)
Below image, *Mʳˢ Playfair*
 On the bust that appears in this portrait,
see .137.

.139 (116)
Unidentified photographer (J. Adamson or
T. Rodger?)
Mr. Evelyn Denison, circa 1850
H: 19 cm (7½ in.); W: 14.7 cm (5¾ in.)
Below image at center, *Mʳ Evelyn Denison
M.P. / now Speaker of the H. of Commons*
 The same setting appears in a double
portrait, identified as representing *Capᵗ R.
Methven Dʳ Wᵐ Methven* and dated *1850*,
in the Adamson Album (1942.1.1, p. 82).
See fig. 45.

.140 (117)
Unidentified photographer (J. Adamson?)
*A Group Portrait with Mr. and Mrs. Adair Craigie,
Mrs. James Brewster, and Sir David Brewster*,
circa 1847
H: 11.2 cm (4⅜ in.); W: 16.1 cm (6⅜ in.)
Below image, *Mʳˢ Craigie / Mʳˢ Jas. B / DB. /
Adair Craigie*
See .58.

.141 (118)
Sir D. Brewster copied from Collen
Sir David Brewster, 1843/44 (original negative),
1845 (copy)
H: 14.5 cm (5¹¹/₁₆ in.); W: 10.7 cm (4¼ in.)
Below image at right, *DB. Copied from a Phot.
of Mr Collen / London*
See fig. 41.

.142 (119)
J. Adamson
Dr. William Thomson, circa 1845
H: 18.6 cm (7⁵/₁₆ in.); W: 14.3 cm (5⅝ in.)
Centered below image, *Dʳ Thomson*; below
image at right, *Dʳ Adamson Phot.*
See fig. 28.

.143 (120)
J. Adamson
James Thomson, circa 1845
H: 18.6 cm (7⁵/₁₆ in.); W: 14.3 cm (5⅝ in).
Centered below image, *Mr Thomson*; below
image at right, *Dʳ Adamson Phot*
See pl. 7.

.144 (121)
Hill and Adamson or R. Adamson alone
*The East End of South Street, St. Andrews, with
the Cathedral Ruins in the Distance*, circa 1845
H: 13.9 cm (5⁷/₁₆ in.); W: 18.6 cm (7⅜ in.)
Centered below image, *South Street & Cathedral
St Andrews*
 Like .97, .105, .118, and .133, this photo-
graph is connected with Hill and Adamson's
album of views of St. Andrews (Stevenson
[note 8], St Andrews 48, p. 205).

.145 (122)
J. Adamson
Mrs. Henry King, 1845/50
H: 18.6 cm (7⁵/₁₆ in.); W: 14.5 cm (5¹¹/₁₆ in.)
Centered below image, *Mʳˢ. Capᵗ. Henry King*;
below image at bottom right corner, *Dʳ
Adamson Phot*
 Mrs. Henry King, née Ella Heriot Mait-
land, was the sister of Mrs. James Brewster

(see .12) and so was related to Sir David
Brewster by marriage. This photograph and
.147 probably were taken at the same sitting.

.146 (123)
Sir D. Brewster
Deer Stalking, from an Engraving, 1840s
H: 13.1 cm (5⅛ in.); W: 18.7 cm (7⅜ in.)
Below image left of center, *Deer Stalking*;
below image at right, *DB. from Mr Scropes
Engraving*
 William Scrope (1772–1852) was an ama-
teur painter who published several illustrated
books, among them *Days of Deer-Stalking* (see
Bryan's Dictionary of Painters and Engravers,
reprint of 4th edn., ed. G. C. Williamson, vol.
5 [Port Washington, 1964], p. 60).

.147 (124)
J. Adamson
Mrs. Henry King, 1845/50
H: 14 cm (5½ in.); W: 9.9 cm (3⅞ in.)
Below image at right bottom corner, *Dʳ A.
Phot.*; centered below image, *Mrs. Capt. Henry
King*
 Compare .145. This image is excerpted
from a double portrait in the Maitland
Album (85.XZ.262.27) depicting Ella Heriot
Maitland (Mrs. Henry King) and a Mary
M. M. Crichton. In the Maitland Album the
photograph is attributed to Sir David himself.

(125)
Blank page
Unillustrated

.148 (126)
H. Brewster
Self-Portrait, circa 1843
H: 17.9 cm (7¹/₁₆ in.); W: 12.8 cm (5¹/₁₆ in.)
Centered below image, *Capt. Brewster*; below
image at right, *Capt. B. Phot*

.149 (127)
Unidentified photographer
Dr. Moir, circa 1850
H: 18.6 cm (7⅜ in.); W: 14.2 cm (5⅝ in.)
Centered below image, *D^r Moir*

 In 1877 a Dr. Moir lived in what had been John Adamson's house on South Street, St. Andrews. This information is provided by an inscription by Alexander Govan below a view of the back of the Adamson house preserved in the Govan Album (Album 6, p. 86): *Back of house we live in / (South Street) / then D^r Adamsons / now (1877) D^r John Moirs.*

.150 (128)
Unidentified photographer
Mrs. Moir, circa 1850
H: 18.8 cm (7⅜ in.); W: 14.4 cm (5¹¹⁄₁₆ in.)
Centered below image, *Mrs Moir*; to right of image with pencil in an unidentified hand, *150*

.151 (129)
Nicolaas Henneman (Dutch, 1813–1875)
St. Francis, from an Etching (Supposed To Be Unique) by Murillo, 1845/46
H: 8.5 cm (3⅜ in.); W: 6 cm (2⅜ in.)

 The image is inscribed in the original print *B. Murillo inv. et fecit.* This and the following three images were produced to illustrate Sir William Stirling's *Annals of the Artists of Spain* (London, 1847). The present image, which appears as plate 58, is described as being in the collection of Richard Ford, Esq. The Science Museum in London has several positives of the *St. Francis*, some with the inscription and some without it (Album 3, p. 101).

.152 (129)
Henneman
Santa Teresa de Jesus, 1845/46
H: 7.7 cm (3 in.); W: 5.8 cm (2⁵⁄₁₆ in.)

 This photograph, which represents a bas-relief by the sculptor Juan Martinez Montañes, appears as plate 14 in *Talbotype Illustrations to the Annals of the Artists of Spain* (see .151).

.153 (129)
Henneman
St. John the Baptist with the Lamb, from an Original Drawing by Murillo, 1845/46
H: 6.5 cm (2½ in.); W: 7.2 cm (2⅞ in.)

 This image is plate 57 in *Talbotype Illustrations to the Annals of the Artists of Spain*. In the preface (p. vii) Sir William Stirling describes this drawing and two others, one by Alonso Cano (pl. 41) and the other by Murillo (pl. 57), as "the only original works of these masters ever copied by the sun." This photograph appears to have been taken from a drawing in a private collection in London that is now attributed to an imitator of Murillo (see J. Brown, *Murillo and His Drawings* [Princeton, 1976], p. 40, fig. 20). Several other examples of the present photograph are in the Science Museum, London (Album 3, p. 104).

.154 (129)
Henneman
Our Lord and St. John Baptist, 1845/46
H: 7.8 cm (3¹⁄₁₆ in.); W: 6.1 cm (2⁷⁄₁₆ in.)

 This image, which represents another bas-relief by Montañes, appears as plate 13 in *Talbotype Illustrations to the Annals of the Artists of Spain*. According to Stirling (p. vii), the bas-reliefs, "perhaps the sole specimens of the national Spanish sculpture in England, are probably the first which have as yet been reproduced by a mechanical process."

.155 (130)
Nevil Story-Maskelyne (English, 1823–1911)
Lydiard Tregoz Church, circa 1845
Salt print from paper negative
H: 8.5 cm (3⅜ in.); W: 14.7 cm (5¹³⁄₁₆ in.)

Another example of this image is preserved
in Nevil Story-Maskelyne's Album, now in
the Hans P. Kraus, Jr., collection, New York
(see Kraus with Schaaf [note 183], p. 76,
1.14/A). There the image is identified as
representing Lydiard Tregoz Church (I am
grateful to Mr. Kraus for this information).

.156 (130)
Maskelyne
Basset Down House, 1846
Salt print from paper negative
H: 9.8 cm (3¹⁵⁄₁₆ in.); W: 15.4 cm (6¹⁄₁₆ in.)
Below image at bottom right corner, *Nevil
Story Maskelyne Phot*

Another example of this image, inscribed
and dated by Maskelyne, is reproduced in
Allison (note 183), p. 19, fig. 6. See also
Kraus with Schaaf (note 183), p. 15.
See fig. 39.

(131)
Image removed
Unillustrated

.157 (131)
Unidentified photographer
Portrait of an Unidentified Man, circa 1845
H: 8.1 cm (3³⁄₁₆ in.); W: 6.4 cm (2½ in.)

The figure appears to be the same as the
seated man in .159, as does the chair. The
backdrop can also be associated with that
visible in .159.

(131)
Image removed
Above missing image, *D.B.*
Unillustrated

.158 (132)
Monteith
Mr. Erle Monteith, circa 1850
H: 11.3 cm (4⁷⁄₁₆ in.); W: 10.7 cm (4³⁄₁₆ in.)
On image at top left of center, *Mr Erle Mon-
teith*; below image at bottom left corner,
Mᵣₛ Monteith Phot
On Monteith, see .98.

.159 (132)
Unidentified photographer
Three Men, circa 1850
H: 10.1 cm (4 in.); W: 13.4 cm (5¼ in.) (oval)
See .157.

.160 (133)
Ashley George John Ponsonby (English,
1831–1898)
Hatherton House, circa 1850
H: 16.3 cm (6⁷⁄₁₆ in.); W: 21 cm (8¼ in.)
On image at top right, *Lord Demauley's House*;
to left of image at top left corner parallel to
left edge, *Hatherton House / Lord Demauley*;
below image left of center, *Mᵣ Ashley Ponsonby
Phot*

Ponsonby was the second son of William
Francis Spenser Ponsonby, first baron de
Mauley (*Burke's Peerage*, p. 758). Born in
1831, he served as a captain in the Grenadier
Guards and was M.P. for Cirencester from
1852 to 1857 and from 1859 to 1865.

(133)
Lines of verse by Henry Kirke White are
transcribed on this page.
Unillustrated

.161 (134)
J. W. Lawrance(?) (English[?], active
circa 1850)
Mr. Lawrence's House, Peterborough,
June 1, 1849
H: 10.7 cm (4³⁄₁₆ in.); W: 15.4 cm (6¹⁄₁₆ in.)
In negative at bottom right corner diagonally
in an unidentified hand, *JWL 1st June /
1849–;* above image at top left, *Mr Lawrance's
House Peterborough*

Beneath the photograph are transcribed
twelve lines of verse by Robert Burns.

.161A (134)
H. Brewster
Ionian Isle, 1840s
Pen and ink and wash
H: 8.8 cm (3½ in.); W: 13.6 cm (5³⁄₈ in.)
Above image in pencil, *Ionian Islands by Capᵗ
Brewster;* below image at left over identical
annotation in pencil, *Corfu? Ionian Isle;* below
image at bottom right corner, *Capt H. Brewster*
Unillustrated

(135)
Blank page
Unillustrated

.162 (136)
Unidentified photographer
Mrs. David Brewster, 1850s
H: 9.5 cm (3¹¹⁄₁₆ in.); W: 8.1 cm (3⅛ in.)
Below image to right of center, *Mrs Major
Brewster / Lydia*

According to Gordon (note 5), p. 267, n. 1,
Lydia Julia Blunt married David Edward
Brewster, Sir David's third son, on October 6,
1849. Brewster did not meet his daughter-
in-law until his son returned to Scotland with
his family on furlough from India in 1856.
Presumably, this portrait was taken at that
time.

.163 (136)
Unidentified photographer
James Brewster, circa 1845

H: 9.5 cm (3¾ in.); W: 7.5 cm (2¹⁵⁄₁₆ in.)
Centered below image, *J.B*

James Brewster, Sir David's eldest son, was
a member of the Bengal Civil Service, receiv-
ing his first appointment in 1831. He
appears as magistrate and deputy collector at
Paneeput, North Division, in the *East-India
Register and Army List for 1849* (pp. 10, 20).
He married Catherine Heriot Maitland
in 1845 while on furlough from India (see
.12) and died in India in 1851, leaving a
widow and two daughters (Gordon [note 5],
p. 230). Photographs of James Brewster,
his wife, and their daughters are preserved
in the Maitland Album (85.XZ.262.10, .11).

.164 (136)
Unidentified photographer
Portrait of Two Men, 1850s
H: 10.7 cm (4³⁄₁₆ in.); W: 9.4 cm (3¹¹⁄₁₆ in.)

(137)
Blank page
Unillustrated

(138)
Two images removed
Unillustrated

.165 (138)
Unidentified photographer
Photographic reproduction of an oval minia-
ture, 1840s
H: 5.7 cm (2¼ in.); W: 4.7 cm (1⅞ in.)

This miniature may be a portrait of a
member of the Maitland family (see .166).

.166 (138)
Unidentified photographer
Photographic reproduction of a miniature,
1840s
H: 6.2 cm (2⅜ in.); W: 4.8 cm (1¹⁵⁄₁₆ in.)
On image at top left corner, *Mr Heriot Ramorni*

This figure bears a striking resemblance to
Robert Heriot Maitland of Ramornie, the
brother of Captain William Heriot Maitland

and Catherine Heriot Maitland (see .12, .53), as he appears in two photographs attributed to Sir David Brewster in the Maitland Album (85.XZ.262.12, .24). However, it is also possible that the miniature portrays James Heriot Maitland, the father of Robert and William.

(139)
Blank page
Unillustrated

(140)
Blank page
Unillustrated

.167 (141)
J. Adamson
St. Salvator's College Chapel from the Southeast, 1843/44
H: 12 cm (4 11/16 in.); W: 16.6 cm (6 9/16 in.)
Unillustrated
 This is a duplicate of .24.

.168 (141)
Unidentified photographer
Group Portrait with Seven Figures, 1845/50
H: 8 cm (3 1/8 in.); W: 13.9 cm (5 7/16 in.)
Unillustrated
 This is a slightly trimmed duplicate of .16.

.169 (142)
Hill and Adamson
Group Portrait, 1843/44
H: 11.3 cm (4 7/16 in.); W: 8.6 cm (3 7/16 in.)
On image along top edge from left to right,
Mr Balfour Cap^t Maitland Rob^t Maitlan[d] Mr Fred. Heriot Mr Brown Dougla[s] [?]
 Compare Stevenson (note 8), Group 23, p. 157.

.170 (142)
Unidentified photographer
Mrs. James Brewster and Mrs. Heriot, circa 1845
H: 10.3 cm (4 1/16 in.); W: 8.6 cm (3 7/16 in.)
To left of image, *Mrs Jas Brewster*; to right of image, *Mrs Heriot*
See .163.

.171 (143)
Talbot
Suspension Bridge, Rouen, May 15, 1843
H: 14.9 cm (5 7/8 in.); W: 20.4 cm (8 in.)
At top right corner, *M^r Talbot*

.172 (144)
Talbot
The Hotel Canterbury, Paris, May 1843
H: 16.1 cm (6 5/16 in.); W: 21.3 cm (8 3/8 in.)
At top left corner in an unidentified hand, *Paris*; at bottom right corner, *M^r Talbot*

(144)
On this page are transcribed lines from Mrs. Henson's *Vespers of Palermo*.
Unillustrated

.173 (145)
J. Adamson
An Athlete, circa 1850
H: 17.2 cm (6 13/16 in.); W: 12.8 cm (5 in.)
Below image at bottom right corner,
D^r Adamson Phot.
 There is a closely related image in the Adamson Album (1942.1.1, p. 75).
See pl. 8.

.174 (146)
Sir D. Brewster copied from Talbot
Abbotsford, September 1844 (the calotype
from which this is copied)
H: 15 cm (5 15/16 in.); W: 21.5 cm (8 ½ in.)
At top right inscribed in negative, *Abbotsford*;
below image at center, *D B Copied from Mr
Talbots*; below image at right corner, *Abbotsford*

This photograph is copied from plate 3 of
Sun Pictures in Scotland (reprod. in Kraus with
Schaaf [note 27], no. 12). See .46, esp. Smith,
p. 73.

.175 (147)
Hill and Adamson
Rev. Dr. James Brewster, circa 1844
H: 19.5 cm (7 5/8 in.); W: 15.5 cm (16 ⅛ in.)
Centered below image, *Rev^d D^r Brewster Craig*
Unillustrated

This is a duplicate of .136 and may have
been copied from it.

.176 (148)
Talbot
Photographic reproduction of a print of a
bird, 1840s
H: 19.5 cm (7 5/8 in.); W: 15 cm (5 7/8 in.)
On image at bottom right, *Mr Talbot*

.177 (149)
Unidentified photographer
A Picnic Group, 1845/50
H: 14.5 cm (5 11/16 in.); W: 18.5 cm (7 ¼ in.)
On image at bottom right, *M^rs Campbell
Soddel*[?]; centered below image, *Party at the
Priory S^t Andrews*

The Priory was the Brewsters' house
behind South Street in St. Andrews.

.178 (150)
Talbot
Fontainebleau, May/June 1843
H: 15 cm (5 15/16 in.); W: 19 cm (7 ½ in.)
At bottom left, *H. F. Talbot Copied*; at bottom
right in an unidentified hand, *Fontainebleau*

This print reverses .34.

.179 (151)
Unidentified photographer
Statuettes of Milton and Shakespeare, 1840s
H: 14.7 cm (5 ¾ in.); W: 15.7 cm (6 3/16 in.)
Below image at left, *Milton*; below image at
right, *Shakespeare*

.180 (152)
Talbot
*The Bridge of Orléans, from the South Bank of the
Loire*, June 14, 1843
H: 15.3 cm (6 1/16 in.); W: 20.6 cm (8 ⅛ in.)
At top left corner in an unidentified hand,
Orleans; at bottom right corner, *H. F Talbot*

Talbot included this view as plate 12 in the
second fascicle of *The Pencil of Nature* (for a
detailed discussion of this and a variant view,
see Schaaf [note 16], introductory volume,
pp. 54–55).

.181 (153)
Talbot
Unrecognizable image
H: 8.8 cm (3 7/16 in.); W: 6.7 cm (2 5/8 in.)
To right of image at bottom right corner,
H. F. Talbot
Unillustrated

.182 (153)
Talbot
Nicolaas Henneman, 1842/43
H: 10.7 cm (4 3/16 in.); W: 10.2 cm (4 in.)
To left of image at top left corner, *M^r
Hennem.*; to right of image at bottom right
corner, *H. F. Talbot*
See fig. 16.

.183 (154)
Talbot
Articles of China, 1841/43
H: 12.7 cm (5 in.); W: 16.8 cm (6⅝ in.)
Below image at right, *H. F. Talbot*
Compare plate 3 of *The Pencil of Nature*.

.184 (155)
J. Adamson
Self-Portrait, 1843/44
H: 16 cm (6¹⁵⁄₁₆ in.); W: 12.1 cm (4¾ in.)
Partially on image at lower right corner,
Dʳ Adamson Phot; centered below image,
Dʳ Adamson

The trimmed negative for this photograph
is preserved in the Adamson Album
(1942.1.1, p. 17). A positive from the
trimmed negative is on the opposite page.
See pl. 1.

.185 (156)
Talbot
Carriages before a Paris Residence, May 1843
H: 16.8 cm (6⅝ in.); W: 17.3 cm (6¹³⁄₁₆ in.)
On image at top right corner in an unidenti-
fied hand, *Paris*; below image at bottom
right, *H. F. Talbot*

(157)
Photograph removed, corners remaining
Below missing image, *DB. From Etching
of Rembrandt*
Unillustrated

.186 (158)
Talbot
Books on Four Shelves, 1842/43
H: 14.6 cm (5¾ in.); W: 18 cm (7⅛ in.)
Below image at right, *H. F. Talbot*

This image is related to plate 8 in *The
Pencil of Nature*, entitled *A Scene in the Library*.

.187 (159)
Talbot
Bust of Venus, 1840/41
Salt print from photogenic drawing or

calotype negative
H: 9.4 cm (3¹¹⁄₁₆ in.); W: 6.4 cm (2½ in.)

This is the same bust as that shown in .9
but taken from the side.

.187A (159)
Unidentified draftsman
Sir Charles Napier, 1850s
Pen and ink
H: 7 cm (2¾ in.); W: 7 cm (2¾ in.) (corners
trimmed)
On drawing at top with pencil, *Sir C. Napier*;
on drawing at top over pencil annotation, *Sir
Charles Napier*

Presumably, this is a caricature of Vice-
Admiral Sir Charles ("Mad Charley") Napier
(1786–1860). Napier achieved lasting noto-
riety as commander of the Baltic Fleet at the
beginning of the Crimean War by refusing to
attack the Russian naval base of Kronstadt.
Unillustrated

.187B (159)
H. Brewster
A Catalonian Landscape, 1840s
Pen and ink
H: 9 cm (3⁹⁄₁₆ in.); W: 14.1 cm (5⁹⁄₁₆ in.)
On image at top right corner with pencil,
partially erased, *Capt. Brewst*; on image at top
right corner, *la montagna nera / Catalonia*; an
illegible inscription is visible on verso of
image along top edge; below image at bottom
right corner, *Capt. H. Brewster Delinᵗ*
Unillustrated

.188 (160)
Talbot
The Château of Chambord, May 1843
H: 16 cm (6⁵⁄₁₆ in.); W: 20.5 cm (8⅛ in.)
At top left corner in an unidentified hand,
Chambord; at bottom right corner, *H. F. Talbot*

.189 (161)
Unidentified photographer
*Portrait Group with Sir David Brewster and Four
Others*, 1845/50

H: 13.7 cm (5⅜ in.); W: 16.3 cm (6⅜ in.)
Above image left of center, *DB*; above image
right of center, *Miss B. Capt. H. B*; below
image left of center, *Lady Marg^t Dalrymple*;
below image right of center, *Miss Wilson/ M^rs
Prof Ayton*

.190 (162)
Talbot
Henry VIII Chapel, Westminster Abbey, London,
circa 1844
H: 16.6 cm (6⁹⁄₁₆ in.); W: 11.1 cm (4⅜ in.)
With pencil on photograph above image at
top right corner in Talbot's handwriting,
Westminster; with pencil below photograph at
bottom right corner in an unidentified hand,
190 Phot

For a related view, see Buckland (note 29),
p. 151.

(163)
Image removed
Below lost image, *DB. Phot. / From Drawing by
Lady Warwick*
Unillustrated

(164)
Blank page
Unillustrated

(165)
Blank page
Unillustrated

(166)
With pencil at top left corner, *2 Miss B /
Laycock / Lord C. /* [indecipherable] */ Miss Th*;
with pencil at top center, *College Chapel 2^d
view / o^r spire*[?]; with pencil at bottom left
corner parallel to inside margin, *W No sgl*
Unillustrated

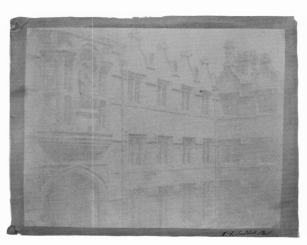

.3

.9

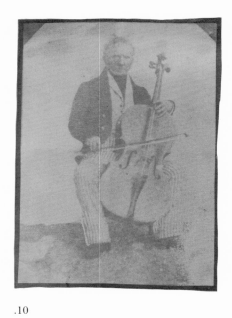

.10

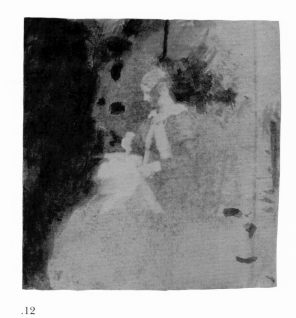

.12

128

.15

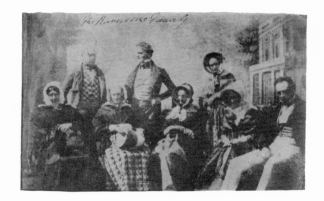

.16

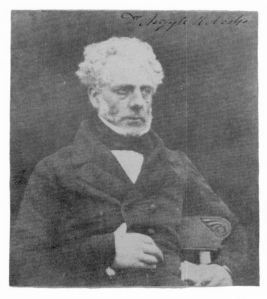

.17

.18

129

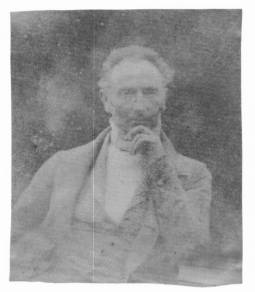

.20

.21

.23

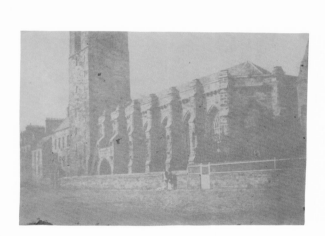

.24

130

.26

.27

.28

.29

131

.30

.31

.32

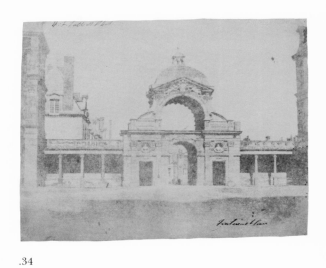

.34

132

.36

.37

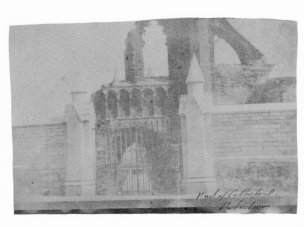

.41

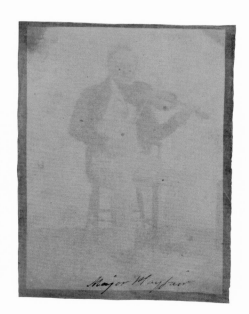

.42

.44

.45

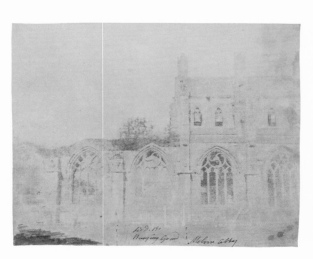

.46

.50

134

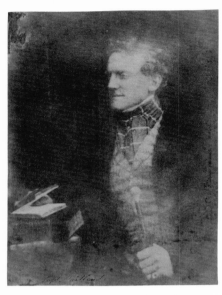

.53

.54

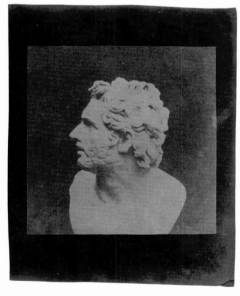

.55

.56

135

.57

.59

.60

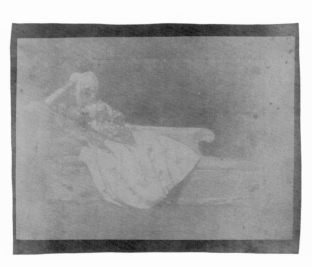

.61

136

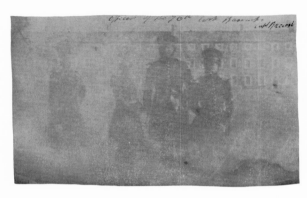

.63

.64

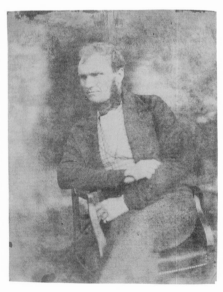

.65

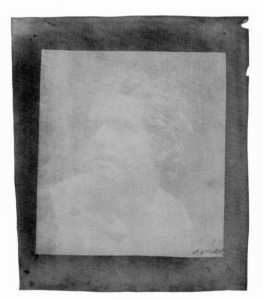

.66

.68

.69

.71

.72

138

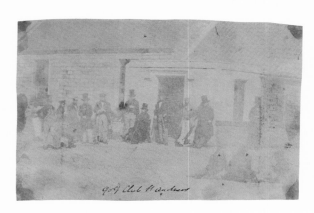

.74

.75

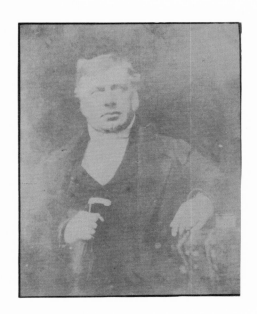

.76

.78

.79

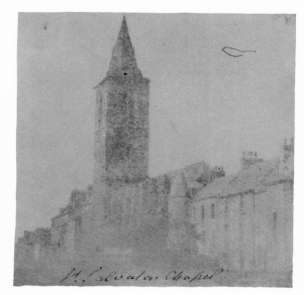

.80

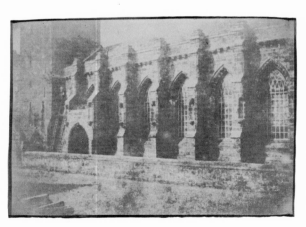

.81

.82

140

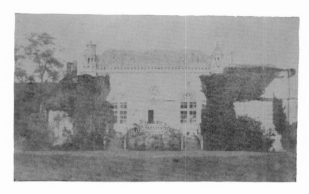

.83

.86

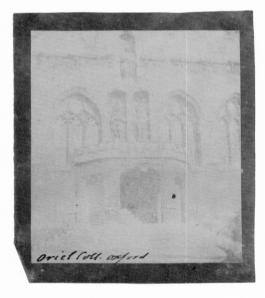

.88

.89

141

.92

.94

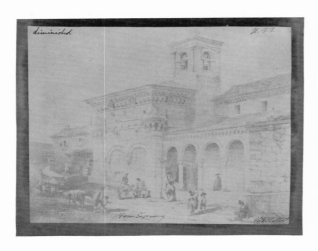

.95

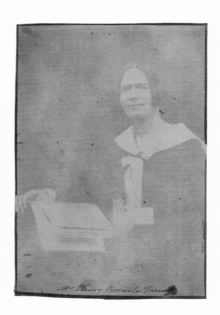

.96

142

.97

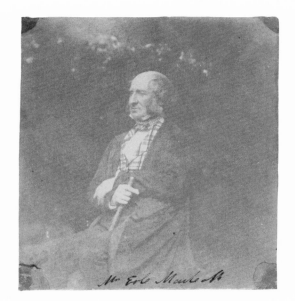

.98

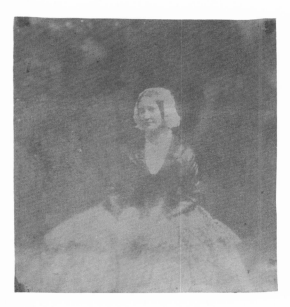

.99

.100

143

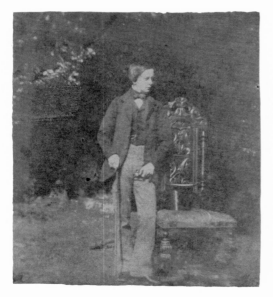

.101

.104

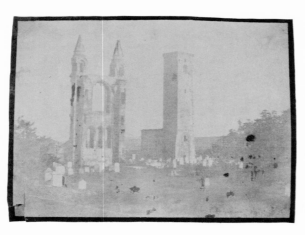

.105

.106

.107

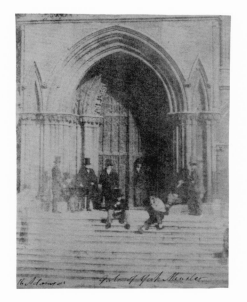

.109

.110

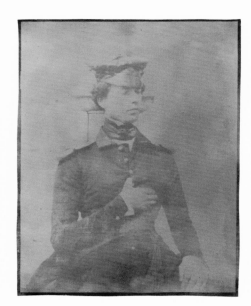

.113

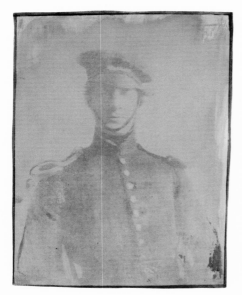

.114

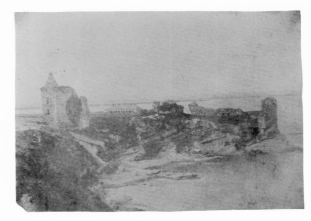

.115

.117

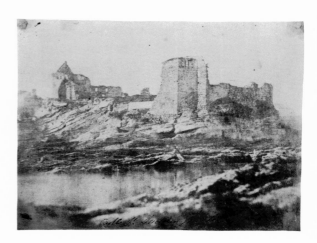

.118

146

.119

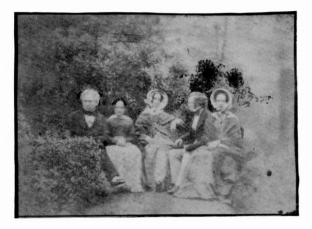

.120

.121

.123

147

.124

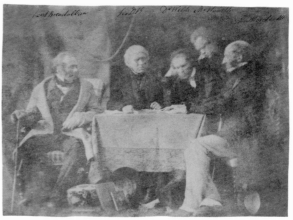

.125

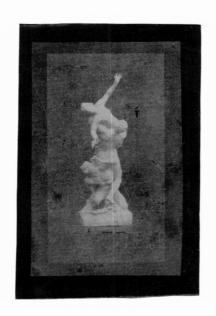

.126

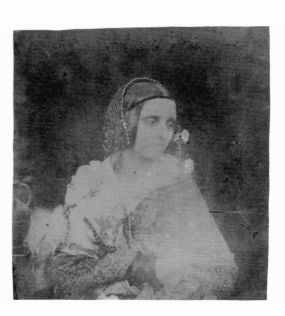

.127

148

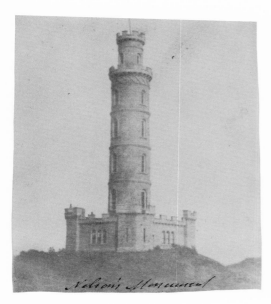

.128

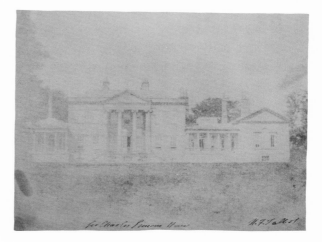

.129

.131

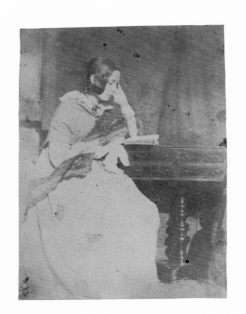

.132

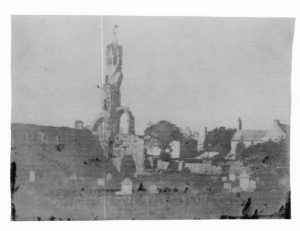

.133

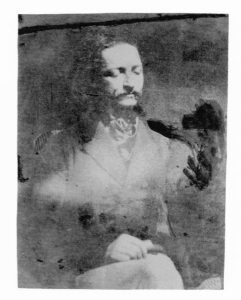

.134

.135

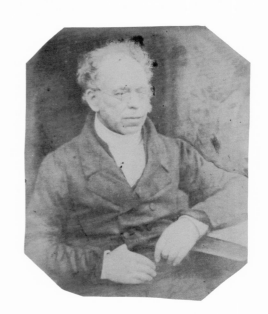

.136

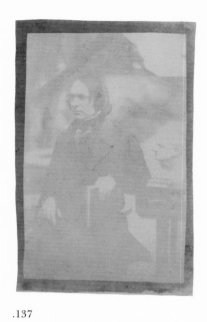

.137

.138

.140

.144

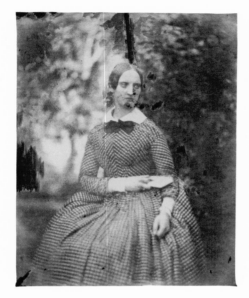

.145

.146

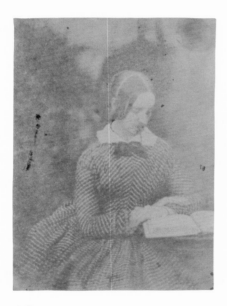

.147

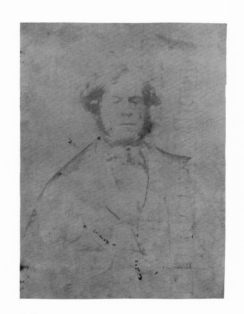

.148

152

.149

.150

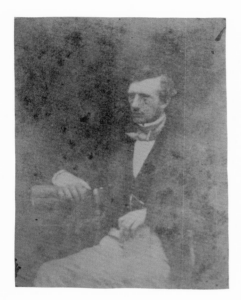

.151

.152

.153

.154

.155

.157

154

.158

.159

.160

.161

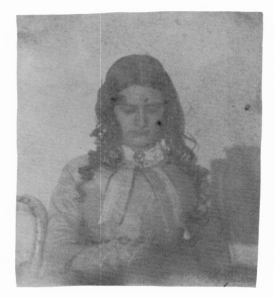

.162

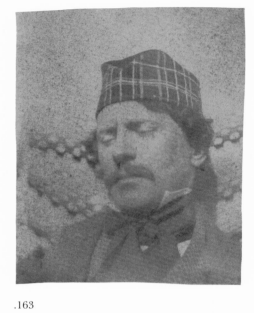

.163

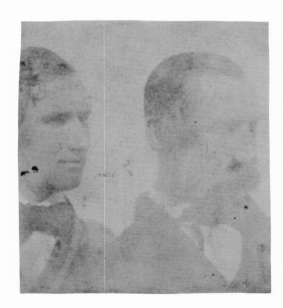

.164

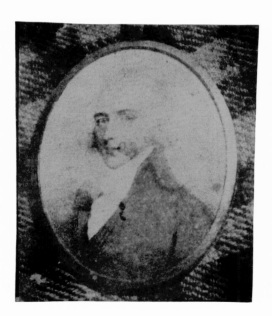

.165

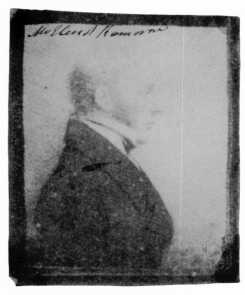

.166

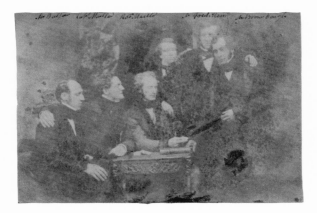

.169

.170

.171

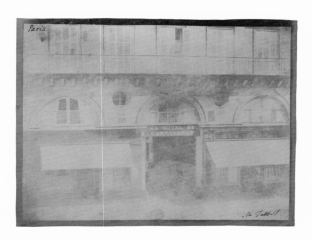

.172

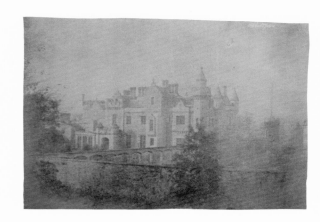

.174

.176

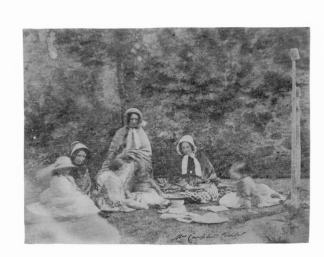

.177

158

.178

.179

.180

.183

159

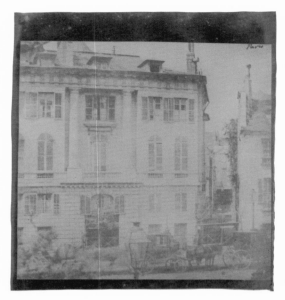

.185

.186

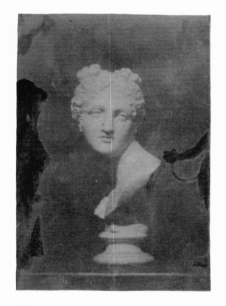

.187

.188

160

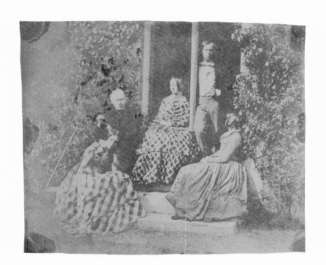

.189

.190

SELECTED BIBLIOGRAPHY

[Adamson, John]. "Photography." In *Chambers's Information for the People*, ed. William and Robert Chambers. Vol. 2. Edinburgh and London, 1857, pp. 779–785.

Arnold, H. J. P. *William Henry Fox Talbot: Pioneer of Photography and Man of Science*. London, 1977.

[Brewster, David]. "Photogenic Drawing, or Drawing by the Agency of Light." *Edinburgh Review* 76 (January 1843), pp. 309–344.

Buckland, Gail. *Fox Talbot and the Invention of Photography*. Boston, 1980.

Furlong, William Holland. "On the Calotype Process." *Photographic Notes* 1 (1856), pp. x–xiii.

Gordon, [Margaret Maria]. *The Home Life of Sir David Brewster*. 2nd edn. Edinburgh, 1870.

Graham, Robert. "The Early History of Photography." *Good Words for 1874*, ed. the Reverend Donald Macleod. London, 1874, pp. 450–453. Reprint. in *History of Photography* 8 (1984), pp. 231–235.

Harley, Joanna Lindgren. "Talbot's Plan for a Photographic Expedition to Kenilworth." *History of Photography* 12 (1988), pp. 223–225.

Harley, Jr., Ralph L., and Joanna Lindgren Harley. "The 'Tartan Album' by John and Robert Adamson." *History of Photography* 12 (1988), pp. 295–316.

Jammes, André. *William Henry Fox Talbot: Inventor of the Negative–Positive Process*. New York, 1973.

Kraus, Jr., Hans P., with Larry Schaaf. *Sun Pictures: Catalogue Four*. New York, 1987.

———. *Sun Pictures: Catalogue One*. [New York], n.d.

———. *Sun Pictures: Catalogue Three*. New York, 1987.

———. *Sun Pictures: Catalogue Two*. New York, n.d.

Michaelson, Katherine. "The First Photographic Record of a Scientific Conference." In *One Hundred Years of Photographic History: Essays in Honor of Beaumont Newhall*, ed. Van Deren Coke. Albuquerque, 1975, pp. 109–116.

Morrison-Low, Alison D. "Dr. John and Robert Adamson: An Early Partnership in Scottish Photography." *Photographic Collector* 4 (1983), pp. 199–214.

———. "Sir David Brewster and Photography." *Review of Scottish Culture* 4 (1988), pp. 63–73.

———, and J. R. R. Christie, eds. *"Martyr of Science": Sir David Brewster 1781–1868*. Edinburgh, 1984.

Newhall, Beaumont, ed. *The Pencil of Nature*. New York, 1969.

Schaaf, Larry. "Addenda to Henry Collen and the Treaty of Nanking." *History of Photography* 7 (1983), pp. 163–165.

———."Henry Collen and the Treaty of Nanking." *History of Photography* 6 (1982), pp. 353–366.

———."Herschel, Talbot and Photography: Spring 1831 and Spring 1839." *History of Photography* 4 (1980), pp. 181–204.

———. *Sir John Herschel and the Invention of Photography*. N.p., 1981.

———."Sir John Herschel's 1839 Royal Society Paper on Photography." *History of Photography* 3 (1979), pp. 47–60.

———, with Hans P. Kraus, Jr. *H. Fox Talbot's The Pencil of Nature, Anniversary Facsimile*. New York, 1989.

Smith, Graham. "A Group of Early Scottish Calotypes." *Princeton University Library Chronicle* 46 (1984), pp. 81–94.

———."An Early Calotype of Blackfriars Chapel in St. Andrews." *Bulletin, Museums of Art and Archaeology, The University of Michigan* 5 (1982–83), pp. 35–41.

———." 'Calotype Views of St. Andrews' by David Octavius Hill and Robert Adamson." *History of Photography* 7 (1983), pp. 207–236.

———."The First American Calotypes?" *History of Photography* 6 (1982), pp. 349–352.

———."Hill and Adamson at St. Andrews: The Fishergate Calotypes." *Print Collector's Newsletter* 12 (1981), pp. 33–37.

———."Hill and Adamson: St. Andrews, Burnside, and the Rock and Spindle." *Print Collector's Newsletter* 10 (1979), pp. 45–48.

———."James David Forbes and the Early History of Photography." In *Shadow and Substance: Essays on the History of Photography*. Bloomfield Hills, 1990.

———."Magnesium Light Portraits." *History of Photography* 12 (1988), pp. 88–89.

———."W. Holland Furlong, St. Andrews, and the Origins of Photography in Scotland." *History of Photography* 13 (1989), pp. 139–143.

———."William Henry Fox Talbot's Views of Loch Katrine." *Bulletin, The Museums of Art and Archaeology, The University of Michigan* 7 (1984–85), pp. 49–77.

Stevenson, Sara. *David Octavius Hill and Robert Adamson: Catalogue of Their Calotypes Taken between 1843 and 1847 in the Collection of the Scottish National Portrait Gallery*. Edinburgh, 1981.

Thomas, D. B. *The First Negatives: An Account of the Discovery and Early Use of the Negative–Positive Photographic Process*. London, 1964.

Ward, John, and Sara Stevenson. *Printed Light: The Scientific Art of William Henry Fox Talbot and David Octavius Hill with Robert Adamson*. Edinburgh, 1986.

Acknowledgments

This study was conceived during a halcyon period as a guest scholar in the Department of Drawings at the J. Paul Getty Museum in the summer of 1985. I remain deeply grateful to John Walsh, Director, and George Goldner, Curator of Drawings, for inviting me to Malibu and Santa Monica. During that visit Weston Naef, Curator of Photographs, made the holdings of his department accessible to me and allowed me to study all the early British materials. When I returned to the Museum in the spring of 1987, as a guest of the Department of Photographs, the present study was formally begun. I am immensely grateful to Mr. Naef for entrusting this project to me, and I deeply appreciate his commitment to its realization. Also in the Photographs department, Judith Keller, Gordon Baldwin, Victoria Blasco, and Louise Stover have been immensely helpful and patient in responding to my frequent requests for assistance.

While preparing this book I drew extensively on the expertise and good will of many friends and colleagues. In Scotland I am particularly indebted to John di Folco, St. Andrews; Alison Morrison-Low, Assistant Keeper, Department of Technology, National Museums of Scotland, Edinburgh; Robert N. Smart, Keeper of Manuscripts and the University Muniments, St. Andrews University Library; and Sara Stevenson, Curator of Photographs, Scottish National Portrait Gallery, Edinburgh. John Ward, Curator of the Photography and Cinematography Collections, Science Museum, London, was extremely helpful in responding to questions relating to William Henry Fox Talbot, as was Harold Lassam, Curator, Fox Talbot Museum, Lacock. Similarly, Julie Lawson, Assistant Curator of Photographs, Scottish National Portrait Gallery, provided important information on Sir James Dunlop. In Ann Arbor I received invaluable research assistance from Brian Boston and Erika Wolf. I am greatly indebted to E. T. Baxter of Leven, Fife, for permission to quote from Sir David Brewster's letters to William Henry Fox Talbot, preserved in the Science Museum Library, London. I am also indebted to the Trustees of the National Museums of Scotland for permission to reproduce five photographs.

As the footnotes and bibliography indicate, my work has been greatly facilitated by the research and publications of a great many scholars. In this regard the writings of Larry Schaaf, Sara Stevenson, and John Ward have been especially valuable. I also want to acknowledge and emphasize the fundamental importance for the present study of Alison Morrison-Low's article "Dr. John and Robert Adamson: An Early Partnership in Scottish Photography," published in the *Photographic Collector* in 1983.

Finally, I am grateful to Christopher Hudson, Head of Publications, The J. Paul Getty Museum; Andrea P. A. Belloli, Consulting Editor; and the Museum's Editorial Committee for their support of this project. I have greatly appreciated Ms. Belloli's sympathetic and intelligent editorial guidance and have often drawn energy and confidence from her enthusiasm for the sometimes cantankerous personalities and fugitive images treated in this book.

G. S.

Index of Personal and Place Names

Thomson, Isabella, 58, 61,
 102, 109; nn. 164–167; pl.
 6
Thomson, James, 61, 102,
 120; pl. 7
Thomson, Laura, 61; n. 165
Thomson, Margaret, 58, 102;
 nn. 164, 165
Thomson, Mr., 12
Truro, 118
Turin, 22

Venice, 18
Victoria (queen of England),
 n. 50

Warwick, Lady, 127
Watt, James, 11
Welsh, Dr., 117
White, Henry Kirke, 97, 122
Wicklow, 42
Wilkie, David, n. 133
Wilson, Miss, 127
Wiltshire, 18, 25, 71, 84, 109

York, 115

Editor: Andrea P. A. Belloli

Designer: Patrick Dooley

Typeset in Baskerville by Wilsted & Taylor, Oakland

3,000 copies were printed on Karma Natural by
Gardner Lithograph, Buena Park

Binding and stamping by Roswell Bookbinding,
Phoenix

All photographs of objects
in the J. Paul Getty Museum
by Stephenie Blakemore and Ellen Rosenbery